THE ARNOLFINI BETROTHAL

CALIFORNIA STUDIES IN THE HISTORY OF ART

Walter Horn, *Founding Editor*
James Marrow, *General Editor*

DISCOVERY SERIES

The publisher gratefully acknowledges
the contribution provided by the Art Book Fund
of the Associates of the University of California Press,
which is supported by a major gift from the
Ahmanson Foundation.

THE ARNOLFINI BETROTHAL

MEDIEVAL MARRIAGE AND THE

ENIGMA OF VAN EYCK'S

DOUBLE PORTRAIT

EDWIN HALL

UNIVERSITY OF CALIFORNIA PRESS

BERKELEY LOS ANGELES LONDON

University of California Press
Berkeley and Los Angeles, California

University of California Press, Ltd.
London, England

First paperback printing 1997

Library of Congress Cataloging-in-Publication Data
Hall, Edwin.
 The Arnolfini betrothal : medieval marriage
and the enigma of Van Eyck's double portrait /
Edwin Hall.
 p. cm.—(California studies in the history
of art.
Discovery series : 3)
 Includes bibliographical references and index.
 ISBN 0-520-21221-5
 1. Eyck, Jan van, 1390–1440. Wedding
portrait of Giovanni Arnolfini and Jeanne
Cenami. 2. Panel painting—15th century—
Flanders—Expertising. I. Title. II. Series.
ND673.E9W44 1994
759.9493—dc20 93-34947

Printed in the United States of America
9 8 7 6 5 4 3 2 1
The paper used in this publication meets the
minimum requirements of American National
Standard for Information Sciences—Permanence of
Paper for Printed Library Materials, ANSI Z39.48-
1984. ∞

· A B O U T T H E D I S C O V E R Y S E R I E S ·

*Innovative and generously illustrated short books
on important works of art or suggestive themes in the history
of art. A discovery book is distinctive for the author's ability to
offer a richness of detail and insight within about one hun-
dred pages of print. Short enough to be read in an evening
and significant enough to be a book.*

CONTENTS

ILLUSTRATIONS

Figures

REHISTORICIZING THE PORTRAIT

Few works of art from before 1500 are as famous today or as familiar as Jan van Eyck's Arnolfini double portrait in the National Gallery, London (Plate 1). Frequently called on to epitomize the entire tradition of early Netherlandish painting in books directed toward a broad public, the picture is also the subject of what may reasonably be called the most widely known modern interpretation of a painting, Panofsky's classic reading of the panel as the depiction of a clandestine marriage. More recently, the painting has been the focus of writers dealing with methodological concerns and has elicited revisionist interpretations representative of postmodernist points of view.

Yet despite all the attention the picture has received (or perhaps more accurately, in part because of it), the meaning of the painting has proved elusive, with opinion presently divided on exactly what the panel depicts. A number of historians in recent discussions of medieval marriage have endorsed Panofsky's clandestine reading,[1] but among art historians the consensus supporting Panofsky's views has weakened, opening the way to renewed conjecture, encouraged in turn by sharply conflicting views on epistemological and methodological problems. In some quarters, for instance, there is skepticism about recovering an artist's original intentions in any particular work.[2]

Our difficulties in understanding the Arnolfini double portrait are exemplified by way of contrast when the London panel is compared with the Mérode *Annunciation* (see Fig. 47), a work of approximately the same date that also depicts two full-length figures engaged in

a specific action in a carefully delineated interior space. In the case of the Mérode *Annunciation* the continuity between the painter's world and our own remains intact after half a millennium, so that many viewers at the end of the twentieth century immediately and unambiguously recognize the subject represented. But in the case of the double portrait this cognitive link between past and present has been severed, and the painting itself has become enigmatic. Bearing witness to this perceptional change, virtually every independent interpretation of the London panel during the past four hundred years, while generally relating the picture to a matrimonial context, has offered a different explanation of what the painting more specifically represents.

In recent writing the Arnolfini portrait's enigmatic qualities are often taken for granted and perceived as intrinsic to the picture and even to the artist's intentions. Thus Mark Roskill begins a discussion of the London panel with the skeptical observation that we "never can hope to know beyond reasonable doubt, what exactly the picture shows," adding as a corollary that this "is part and parcel of the picture's perennial fascination."[3] For Linda Seidel, whose postmodernist reading of the picture is largely dependent on such an assumption, the double portrait is "a visual enigma, a riddle in which nothing is as it appears to be."[4] And in a volume on medieval marriage published in 1989, the British historian Christopher Brooke makes explicit Van Eyck's intent to be mysterious: "We can only be sure that he meant to puzzle us—meant us to enquire, to search, to *think*."[5]

These comments are symptomatic of the progressive dehistoricization of the Arnolfini double portrait, beginning as early as about 1600 and continuing more aggressively since Panofsky's theory of disguised symbolism mystified the picture. Although Panofsky's complex symbolic reading of the London panel was presented as a methodologically sound historical approach, it in fact rests on no more than the assumption that the painting depicts a sacramental marriage rite, and his interpretation of objects in the picture is often undocumented speculation.[6]

The historical alienation of the picture has lately intensified. Whereas earlier writers remained firmly committed to the idea that the painting recorded a specific event,[7] recent readings of the panel as a more generalized image necessarily discount the traditional view that the ritualized gestures of the figures are central to the picture's meaning as the representation of a ceremonial rite. Consequently, what the couple are doing becomes difficult to explain. The problem is exemplified by two proposals made in publications of 1990, one that the male figure "may be raising his right hand to greet the two men who are entering the room and who are reflected in the mirror" and the other, expounded in the context of the supposedly sexual implications of the panel, that "Giovanni Arnolfini discreetly raises

his hand to greet his wife; she responds by lifting her voluminous green gown. She is thus quietly receptive to his advances."[8]

An analysis of the picture in a National Gallery exhibition brochure of 1977 offers an earlier variation of this generalizing approach to the double portrait's meaning.[9] After a concise and informative introduction, the author discards the historical matrix of the picture with a specious argument about the date on the panel and then expounds "the *total* meaning" of "a work of art" that "each modern spectator who is not an art historian has the supreme right to understand or misunderstand . . . in his own way." The man and woman become representative "antitypes" of humanity, the room assumes "an air of the paranormal," and Van Eyck, with "a supernatural clarity," is said to have "forged a universal vision of man and woman, their unification, and their place within Christian philosophy."[10]

Art appreciation of this sort, whatever its merits may be for a larger public, suggests something of the anachronous character that can be imposed on a painting when it is transformed into "a work of art" in modern museum culture. But surely there is no little irony in the careful and costly modern restoration of pictures so as to return them as nearly as possible to their original state, if the same works are then verbally varnished and overpainted with little respect for their integrity as historical objects that can provide the receptive viewer with a more authentic experience.

Compounding the double portrait's historical estrangement, such generalized readings usually ignore the signature inscription and related mirror reflection that assertively imply Van Eyck's presence at an actual event. For by signing the panel on the pictorial surface with the Latin equivalent of "Jan van Eyck was here" and including his own reflected image in the mirror below, the artist compels us to take cognizance of his special relationship to whatever the imagery was intended to represent. By their ritualized gestures, the couple in turn appear to engage in some action not normally encountered in a portrait, its unusual character apparently confirmed by what the signature inscription and reflected mirror image imply: that Van Eyck himself was present at a specific ceremony the painting was meant to record or memorialize.

The thesis of this book is straightforward enough. I start from the basic premise that the subject matter of the double portrait was formerly as accessible to Van Eyck's contemporaries as that of the Mérode *Annunciation* still is for us, and that historical inquiry can legitimately investigate and possibly recover what that meaning was. To carry the analogy between the two pictures a step further, if the meaning of the Mérode panel were now also lost and the object of conflicting opinion, it would be logical to seek its signification in

various standard texts that explain the theological concepts involved, and thus after reading x, y, and z, we could come to a reasonably accurate understanding of what the panel depicts.

Unambiguous to a fifteenth-century viewer, and like "signs" or "signifiers" from a semiotic point of view, the couple's gestures provide the key to the meaning of the double portrait. The failure of modern iconographic scholarship to explain them satisfactorily constitutes in turn the fatal flaw in Panofsky's classic reading of the London panel, for, as he was the first to recognize, what is seen in the picture does not conform to the matrimonial linking of right hands required by his theoretical construct.

Although the interpretative problems of the double portrait are more complex than those of the Mérode *Annunciation,* nonetheless a substantial body of historical material, hitherto unexploited, is available that explains marriage and betrothal customs in relation to the London panel. My aim is to apply to the microcosm of the painting and its problems an inverted version of the "total history" methodology espoused by the French *Annales* school. This approach is now being viewed as a form of microhistory, with Carlo Ginzburg's *Enigma of Piero* cited as an instance of its application to iconographic problems.[11] I establish a broadly comparative, contextual basis for elucidating the panel's original meaning by drawing on texts of Roman and canon law, scholastic theology, ritual service books, literary works, and sources for the social and economic history of the period as well as neglected visual imagery, particularly manuscript illuminations illustrating these same texts. Where possible, I use this contextual material in a comparative way to verify and confirm, or to challenge and invalidate, an interpretation or a conclusion. I also try to be cognizant of the limitations of any historical methodology. Certain questions, although of great interest, cannot be adequately addressed for lack of evidence; in such situations my aim is to avoid unfounded speculation.

Van Eyck's double portrait is now so encumbered by accumulated misunderstandings about both the theory and practice of medieval marriage that it was necessary to start over at the beginning. I took my cue from a remark by E. H. Gombrich to the effect that iconography must begin with a study of institutions rather than symbols.[12] Although Gombrich made this observation humorously in the context of cookery books, it induced me to consider marriage as a social institution in its particular European manifestation.

The problems of relating this material to the double portrait have been complicated by differences in the way the ritual for marriage evolved in Italy and in transalpine Europe during the Middle Ages. The traditional Western marriage ceremony had its origin in the betrothal practices of late antiquity. As these customs developed in the north into a sacra-

mental marriage rite, the ceremony was held at the door of the church, with the priest officiating as public witness to the couple's consent. But in the south—at least for upper-class families—the rite continued to take place in a domestic setting well after the time of Van Eyck, and the public authority who officiated was a notary. Nonetheless, it was the couple's consent to the marriage in the framework of this (for us) seemingly "secular" or "civil" ceremony that came to constitute the sacrament of matrimony from the ecclesiastical point of view.

Since the couple portrayed in the double portrait are believed to have been of Italian descent, the evolution of the Italian rite needs to be considered alongside the marriage practices of medieval Flanders. For although local tradition was supposed to prevail even when the bride or groom came from some other region with different uses, it is hypothetically possible that the families of the presumed sitters, who resided in Bruges and Paris but were originally from Lucca, might not have followed local conventions. And if then the couple had followed Italian rather than Flemish custom, the further possibility presents itself that what is supposedly a clandestine marriage in Panofsky's famous reading might be, not a clandestine affair, but rather a perfectly legitimate Italian marriage ceremony.

Chapters 2 and 3, which set forth this material, are intended as a broad-based account of the development of medieval betrothal and marriage customs in both Italy and northern Europe. Integrated into this narrative is a study of the iconography of marriage between late antiquity and about 1500, including new evidence that challenges widely held assumptions about both the ancient *dextrarum iunctio,* or joining of right hands, as the prototypical marriage gesture of the West and the supposedly civil character of medieval Italian marriage rites witnessed by a notary. Although these two chapters can stand on their own as an independent narrative, the historical perspective they provide is essential for understanding the arguments I present with reference to Van Eyck's Arnolfini double portrait.

My debts to individuals and institutions are so numerous as to preclude individual acknowledgment, but that in no way diminishes my gratitude for help so generously given. I do, however, wish to express my appreciation to Dr. Rudolf Distelberger of the Kunsthistorisches Museum for examining the Flemish betrothal brooch in Vienna to clarify for me the figures' hand gestures. Special thanks are due to those who made the book a reality, including James Marrow as well as Deborah Kirshman, Stephanie Fay, and Nola Burger of the University of California Press, and above all Horst Uhr, without whom it might not have been written.

FROM INVENTORY DESCRIPTION
TO SYMBOLIC READING

Commonly called the "Arnolfini Wedding," in part because of Panofsky's well-known view that the couple are engaged in contracting a clandestine marriage, Jan van Eyck's double portrait in the National Gallery in London depicting a man and a woman in a bourgeois interior (Plate 1) is probably the most widely recognized northern panel painting of the fifteenth century.[1]

The reasons for this celebrity are not difficult to discern. The domestic subject matter doubtless makes the painting psychologically more accessible in a secular age, and the inherent interest this creates for the modern viewer is reinforced by the uniqueness of the picture as the earliest extant representation of two living individuals in a realistically defined interior space. In other respects the "Arnolfini Wedding" is simply a quintessential example of Van Eyck's art. By his consummate mastery of the then recently perfected technique of painting with colors and transparent glazes worked up in an oil medium, Van Eyck transformed the wooden panel into a tour de force of the painter's craft, seldom if ever equaled and certainly never surpassed. Standing before the picture is a riveting experience for any but the most insensitive viewer, and something at least of the spellbinding effect the painting can have on the beholder survives even in photographs and reproductions. Further arousing our fascination and curiosity, the picture is pervaded by a mysterious solemnity that seems accentuated by the extreme realism with which each detail has been rendered. We wonder, for example, what this couple, so rigidly and hieratically posed, is actually

doing; or why the painter tells us so cryptically that "Jan van Eyck was here" by signing the panel with a calligraphic flourish on the rear wall of the chamber: "Johannes de Eyck fuit hic"; or what the single lighted candle in the chandelier can possibly signify in this room so flooded with daylight.

While the sense of enigma doubtless intensifies our interest in the picture, it needs to be emphasized at the outset that nothing in the work suggests that the painter consciously intended to puzzle us, although critics have commonly assumed the contrary. This air of mystery is really no more than an accidental consequence of the passage of time, which severely restricts what a modern viewer readily brings to an intellectual perception of the painting. Van Eyck's equally enigmatic "Timotheos" portrait (Fig. 1), also in London, provides a useful analogy. We will probably never know who this man was, why he was called Timotheos, what the inscription "Leal Souvenir" was intended to convey, or why the picture was signed in a quasi-legal way: "Transacted on the 10th day of October in the year of our Lord 1432 by Jan van Eyck."[2] But we can be virtually certain that what is now so obscure for us was once perfectly clear to both the sitter and the painter.

From early in the sixteenth century until the eve of the French Revolution, the London double portrait is well documented in inventories of Hapsburg collections, giving the painting an unusually secure provenance prior to 1789. Besides preserving important historical information apparently transmitted earlier by an oral tradition, these sources illustrate a deteriorating understanding of what the picture represents.

For a time the panel remained in Flanders, belonging at first to Margaret of Austria and then passing at her death in 1530 into the collection of Mary of Hungary. Respectively a daughter and granddaughter of Mary of Burgundy (the last direct descendent of the Burgundian ducal line), these illustrious women were also the aunt and sister of Charles V, whom they served with considerable distinction, administering in succession the Netherlandish territories of the Hapsburg empire as regent-governor during the first half of the sixteenth century.

The earliest known references to the London panel are found in inventories of 1516 and 1523/24 drawn up while the picture was in Margaret's possession and kept in Malines, where the regent presided over a court whose patronage of the arts and letters extended to Erasmus, among others. The relevant entries establish that the panel was a gift to the regent from Don Diego de Guevara, a prominent figure at Hapsburg courts in both Spain and northern Europe. And because the donor's arms and device are mentioned as being painted on protective shutters then attached to the picture, it is probable that Don Diego owned

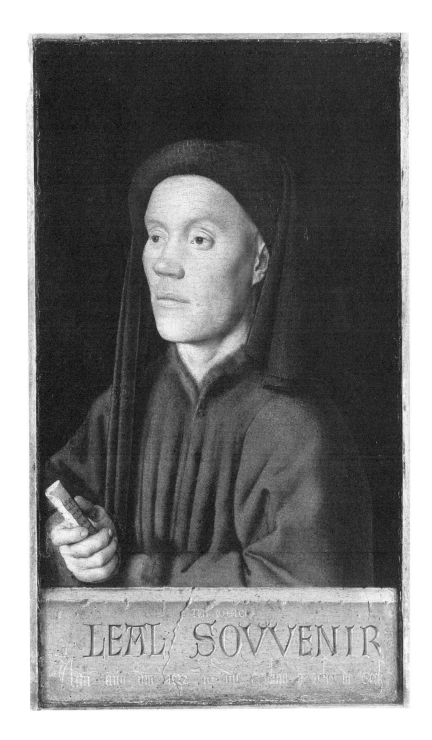

FIGURE 1. Jan van Eyck, "Timotheos" Portrait, 1432.
London, National Gallery.

the painting for more than a short time before presenting it to Margaret, which would establish the provenance back at least to the early years of the century. That Margaret herself was personally concerned for the safekeeping of the panel is apparent from a marginal notation in the 1516 inventory that a lock was to be placed on the shutters as "Madame had ordered." Besides naming the painter, both inventories describe the picture in terms that, though similar, differ enough to indicate that the two entries are textually independent: "a large painting that they call Hernoul le Sin with his wife within a chamber" (1516) and a "most exquisite picture . . . in which are painted a standing man and woman touching the hand of one another . . . the personage being named Arnoult Fin" (1523/24).[3]

The variant spellings of the surname strongly suggest that it was not inscribed on the frame, as has sometimes been argued, but rests instead on an oral transmission of "Arnoul-phin" or "Ernoulphin," the common vernacular forms of the name in contemporary docu-ments, thus strengthening the probability that an authentic tradition identifying the male figure was still current at the beginning of the sixteenth century.[4] In 1857 J. A. Crowe and G. B. Cavalcaselle made the only lasting contribution of nineteenth-century scholarship to our knowledge of the picture by linking the painting described in the inventories of Margaret's collection to the double portrait that was by then in the National Gallery.[5] The widely held modern view that the couple portrayed in the picture are Giovanni di Arrigo Arnolfini and his wife, who is known from other sources to have been named Giovanna Cenami, rests on Crowe and Cavalcaselle's discovery.

The choice of Giovanni di Arrigo rather than any of the other Arnolfini known to have been active in Bruges at the time is plausible simply because he was the most prominent member of the family in the fifteenth century and the one most likely to be called Arnoul-phin without further qualification. A great merchant capitalist who enjoyed close commer-cial and financial ties with the Burgundian court for half a century, Giovanni Arnolfini was eventually also knighted and naturalized as a Frenchman by Louis XI, and he served this king of France as well as Philip the Good and Charles the Bold of Burgundy in various important positions. Along with more than a dozen other families from Lucca, the Arnol-fini and the Cenami had been active in northern commerce and finance since the middle of the fourteenth century. Paris and Bruges were the centers of this activity, which consisted in purveying luxury goods—tapestries, textiles, gold plate, and jewels are mentioned in the sources—and lending money to the French and Burgundian courts as well as to Nether-landish communes such as Bruges. According to a tradition preserved by the Clarisses of Bruges, in whose church Giovanni Arnolfini and his wife were eventually buried, Giovanna

Cenami was born "ex corona Franciae" and could boast of royal blood, perhaps by descent through a bastard line. Although it would be easy to dismiss the tradition as a romantic invention of pious nuns, the pension Louis XI awarded Giovanna Arnolfini shortly after her husband's death, in the form of revenues derived from ships docking in the harbor at Richebourg, seems to confirm it. Since Giovanni di Arrigo and his wife were still well remembered in Bruges in the eighteenth century, it is unlikely that a man so famous could have been forgotten or confused with someone else in the short time that elapsed between his own death in 1472 or that of his widow in 1480 and the early sixteenth-century inventories, especially since during at least part of the interval between 1480 and 1516 the picture was in the hands of the important collector Don Diego de Guevara.[6]

In October 1555, as part of the arrangements made for the breakup of the Hapsburg empire following Charles V's decision to abdicate, the emperor transferred his sovereignty over the Netherlands to his son, Philip II, and Mary relinquished her regency. As a consequence of this development, an inventory was made of Mary of Hungary's movable property in the following year, as the Hapsburg princess prepared to depart for Spain. The principal interest of the 1556 inventory, which also provides the earliest reference to the mirror reflecting the man and woman seen from behind, is an annotation that Mary intended to take the picture with her. And this certainly did happen, for after her death in 1558 the Arnolfini double portrait entered the Spanish royal collection and remained there at least until 1789, when it is documented for the last time as being in the Royal Palace in Madrid.[7]

Some memory of the picture nonetheless lingered on in the Netherlands long after the physical transfer of the panel to Spain. In his book on Netherlandish antiquities first published in 1568, Marcus van Vaernewyck mentions the double portrait as a work by Van Eyck once possessed by Mary of Hungary. And he also describes its subject matter in a brief passage, whose ambiguity can be suggested at the outset by a closely literal translation: "a small panel . . . wherein was depicted an espousal of a man and a woman espoused by *fides.*" Karel van Mander, the earliest biographer of Netherlandish painters, not fully understanding what this meant but trying to make sense out of what he appropriated from Van Vaernewyck, ended up presenting his readers with a mistaken interpretation of a picture he had never seen. According to Van Mander's imaginary reconstruction, the man and woman take each other by the right hand "as in coming together in wedlock" (whereas it is rather the man's left hand that is associated with the woman's right). As for the puzzling reference to *fides,* this in Van Mander's mind became a personification of *Fides,* who offi-

ciated at the couple's wedding and "joined them together." Originally published in 1604, more than a century and a half after the date of the Arnolfini double portrait, Van Mander's interpretation of Van Vaernewyck's description was the first to clearly imply that the London panel was intended to represent a marriage.[8]

The most detailed entry for the double portrait in later inventories of the Spanish royal collection dates from 1700; it provides striking evidence of how completely the original meaning of the picture had been lost by the beginning of the eighteenth century. The female figure is now described as "a pregnant German lady . . . who is giving her hand to a man," in what the redactor of the inventory presumed to be a surreptitious nocturnal event, apparently because of the lighted candle. "They seem to be getting married at night," he says, adding that verses from Ovid on the frame (which unfortunately are not further specified) "declare how they are deceiving one another."[9]

How the panel was pilfered or otherwise alienated from the Spanish crown during the turbulent years of the Napoleonic Wars is obscure. But the Arnolfini double portrait had somehow made its way back to the Netherlands by 1815, when a British army officer, Colonel James Hay, discovered it in the lodgings in Brussels where he was convalescing after being wounded at the battle of Waterloo. Following his recovery, Hay purchased the picture and took it to England, where he apparently tried to arrange for its purchase by the prince regent, for the picture is documented in Carlton House records (part of the time in an attic) between 1816 and 1818. Failing to sell the panel, Hay left it with a friend, who hung it for some years in a bedroom while the colonel pursued his military career abroad. Eventually, in 1842, on the advice of a restorer named Seguier, the National Gallery bought Van Eyck's masterpiece from Hay, by now a major general, for the sum of £630.[10]

In cataloguing the new acquisition shortly thereafter, the National Gallery noted: "The subject of this Picture has not been clearly ascertained."[11] The reserve of that description contrasts sharply with the tenor of interpretations advanced during the 1850s. Assuming that the woman was pregnant, one critic of repute, Louis Viardot, suggested that chiromancy was the theme of the painting: the man, he explained, was trying to read from the woman's hand the future of her unborn infant.[12] With no less ingenuity, the noted historian Léon de Laborde, who discovered and first published some of the basic archival documentation on Van Eyck's life, entitled the picture "La Légitimation," theorizing that the man was swearing an oath acknowledging paternity of the child in the presence of his neighbors, who were shown crowding into the room through the open door.[13] As amusing as these early iconographic interpretations may seem today, they are nonetheless fascinating as

manifestations of an intellectual need to come to terms with the picture's enigmatic quality in the years following the first public exhibition of the work; Laborde's explanation is of further interest as apparently the earliest attempt to interpret the gesture of the man's right hand.

Other nineteenth-century writers were usually more circumspect, contenting themselves with a descriptive analysis of the composition and displaying little concern, beyond recognizing that the artist had depicted a married couple, about the specific action portrayed. Crowe and Cavalcaselle, for instance, after identifying the couple as "Arnoult or Hernoult le Fin" and his wife on the basis of Margaret of Austria's inventories, continued by observing that the picture "represents the union of a man and woman dressed in state and holding each other's hand; the lady wearing a wedding ring half way up her finger, and attended by a terrier of wondrous workmanship."[14]

Only a decade before Crowe and Cavalcaselle first linked the London panel to Giovanni Arnolfini, a different proposal for the identity of the sitters began a new misadventure in the history of the double portrait's interpretation that lasted for more than a century. The artist's signature precipitated this development, even though as a document within the picture itself the inscription "Johannes de Eyck fuit hic" provides the most authentic piece of information there is concerning the panel—namely that, for some reason, in 1434 "Jan van Eyck was here." The 1847 edition of the National Gallery's picture catalogue transcribed the Latin text correctly, but in explaining what it meant, Charles Eastlake, the museum's director, advanced the idea that if translated literally, the inscription signified "John Van Eyck was this (man)." Having construed "hic" as a demonstrative pronoun rather than an adverb, Eastlake was himself disturbed by the implications such a reading seemed to have. Nonetheless he went on to suggest that the picture "may be Van Eyck's own portrait with that of his wife," although if such were the case, he thought her name ought to have been included as well.[15]

John Ruskin endorsed Eastlake's tentative interpretation the following year, expressing the opinion that the panel was "probably the portrait" of the artist.[16] And shortly thereafter Laborde, having used a loupe to examine the picture with the protective glazing removed so as to verify for himself that the verb was indeed "fuit" and not "fecit," accommodated the self-portrait interpretation to his own legitimation theory. Van Eyck, he thought, had in this bizarre but ingenious way formalized "a natural marriage already well advanced," thereby "hallowing his good faith with a masterpiece."[17] In 1854 Gustav Friedrich Waagen, the first director of the Berlin Museum and an early authority on Van Eyck, lent his support

to Eastlake's theory, popularizing the idea in his book *The Treasures of Art in Great Britain*.[18]

A perceived resemblance between the woman in the London panel and Van Eyck's later portrait of his wife, Margaret, in Bruges led to the revival of the Eastlake-Waagen hypothesis in the 1930s. The subject of lively discussion during the next two decades, the theory has no serious supporters today. It is of interest only as another example of how the picture continued to be discussed apart from its historical context, for by the early 1950s the self-portrait hypothesis, in its fully developed form, required nothing less than a rejection of the documentation on the double portrait in the early Hapsburg inventories. Because these established with high probability that the sitter in Margaret of Austria's picture was someone named Arnolfini, it was necessary to argue that the painting in the Spanish royal collection had been destroyed in order to claim that the National Gallery's picture was an entirely different work that had never left the Netherlands. Further compromising the theory was the continuing need to force the signature inscription into the unacceptable reading "Jan van Eyck was this one," which had troubled Eastlake when he first proposed that the picture represented the painter and his wife.[19]

An interesting sidelight to these controversies over the identity of the sitters is the difficulty writers who opted for the Arnolfini alternative had in dealing with the signature inscription. Even W. H. James Weale's important *Hubert and John van Eyck: Their Life and Work* (1908), the earliest scholarship on Van Eyck that remains useful, gives only the Latin text, neither translating nor interpreting it.[20] Max Friedländer's simple statement of 1924, in the first volume of his monumental *Die altniederländische Malerei*, that the inscription was perhaps meant to express the idea "the master was here, he was present, as a witness" is thus something of a watershed in the historiography of the painting, and it seems to have directly inspired a key element in Panofsky's famous interpretation of the London panel.[21]

The modern history and criticism of the Arnolfini double portrait, as well as the common belief that it depicts a clandestine marriage, begin with Erwin Panofsky. In a classic piece of art-historical writing, first published sixty years ago in the *Burlington Magazine* and subsequently reworked in *Early Netherlandish Painting*, Panofsky developed his familiar exposition of the painting's hidden meaning. Since there are significant differences between the two versions, it seems useful to summarize the argument by drawing from both accounts. In Panofsky's reading, before the Council of Trent condemned clandestine marriage, it was possible for two people to "contract a perfectly valid and legitimate marriage whenever and wherever they liked, without any witnesses and independently of any ecclesiastical rite, provided that the essential condition of a 'mutual consent expressed by word

and actions' had been fulfilled." For "according to canon law," Panofsky continues, "marriage was concluded by taking an oath, and this oath (*fides*) implied two actions: that of joining hands (*fides manualis*) and, on the part of the groom, that of raising his forearm (*fides levata,* a gesture still retained by our legal procedure)."

Panofsky further argued that the unusual signature of the painter above the mirror indicated that Van Eyck himself, accompanied by another individual whose image is likewise seen reflected in the mirror, was present to witness an otherwise private ceremony and that thus the "Arnolfini Wedding" not only portrays a couple "in the act of contracting matrimony" but also functions as a "pictorial marriage certificate." Panofsky concluded with an iconographic reading of various objects in the room whose plausibility depends on the painting as the "representation of a sacramental rite." The "sacramental associations" of the marriage, for instance, so hallow this "nuptial chamber" that Panofsky was reminded of the holy ground on which Moses stood during his encounter with the Lord himself in the theophany of the burning bush. And in his final summation of the thesis Panofsky went so far as to claim that in the London double portrait Van Eyck had "demonstrated how the principle of disguised symbolism could abolish the borderline . . . between 'profane' and 'sacred' art." [22]

With his characteristic felicity for combining erudition and eloquence, Panofsky, in a few pages, managed to resolve all the apparent enigmas of the London double portrait in a way that was not only effective and persuasive but also highly satisfying as an intellectual construct. Not surprisingly, his interpretation of the painting soon acquired an authority that few thought to question. Often without specific mention of Panofsky, authors of textbooks and other works directed toward a larger audience have repeated it with only minor variations based on their own predilections or misunderstandings of what Panofsky actually said, so that doubtless many who know all about the "Arnolfini Wedding" would not recognize Panofsky by name. While this accolade may well be the ultimate one for a humanistic scholar in an age of mass culture, the popularization of Panofsky's ingenious explanation has in itself further contributed to the celebrity of the Arnolfini double portrait.

In the more esoteric world of scholarship, Panofsky's view that the picture depicts a clandestine wedding has occasionally been criticized, but generally—until recently—only with a view toward further clarification or modification. [23] More significant, however, since it transcends the interpretation of a single work, the theory of disguised symbolism in early Flemish painting—and the Arnolfini double portrait is the foundation on which the theory was constructed—has had a far-reaching impact on iconographic studies. Because of Pa-

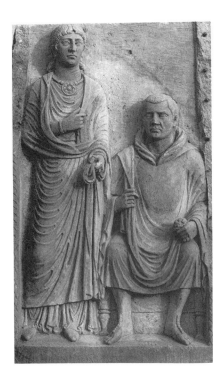

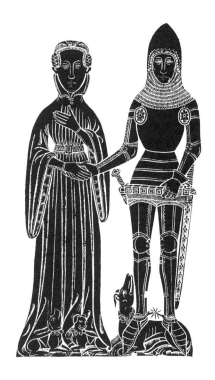

FIGURE 2. Gallo-Roman stele from Weisenau (detail), mid-first century. Mainz, Landesmuseum.

FIGURE 3. Robert de Freville and his wife, Clarice. Monumental brass, c. 1400. Little Shelford, Cambridgeshire. Photo courtesy of the Monumental Brass Society, London.

nofsky's continuing influence, scholars today are divided into opposing camps: followers of his methodology have continued to propose symbolic interpretations that are increasingly complex; others have reacted with growing skepticism and even dismay.[24]

What is most unusual about the London double portrait provides a point of departure for a more credible understanding of the picture. The mutual affection of husband and wife in a happy marriage has often been visually expressed in a general way—in ancient funerary monuments (Fig. 2); in medieval effigy tombs (Fig. 3); in the rich seventeenth-century Netherlandish tradition exemplified by Rubens's famous self-portrait with his first wife, Isabella Brant (Fig. 4); and, more recently, in a characteristic wedding photograph of the late nineteenth century (Fig. 5). The Arnolfini double portrait is altogether different from such generalized images of matrimonial attachment because the ceremonial gestures

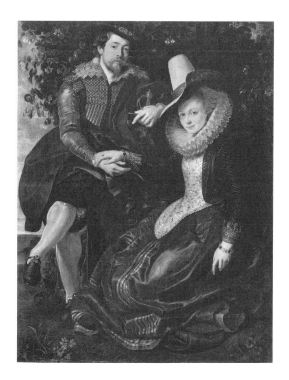

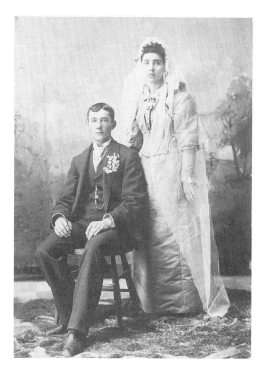

FIGURE 4. Peter Paul Rubens, *Self-Portrait with Isabella Brant,* c. 1609-10. Munich, Alte Pinakothek.

FIGURE 5. Wedding photograph of Mary Melbinger and Ulrich Anderson, c. 1895. Private collection.

of the couple memorialize the circumstances of a particular event.[25] These gestures, problematic even for Panofsky, have subsequently been much discussed, usually in an effort to fit them somehow into the presumed wedding context of the painting.[26] But if allowed to speak again for themselves in the framework of the fifteenth century, they can still fulfill their original function and explain for us what Van Eyck's celebrated and enigmatic couple are actually doing.

ON MARRIAGE LAW AND CEREMONY

The Western conception of matrimony, like so much else in the development of Europe, evolved from a complex intermingling of Roman, Germanic, and Christian elements. As a result, marriage eventually came to be viewed from two perspectives so disparate as to seem almost antithetical to a modern person. On the one hand, based on such texts as Genesis 2:22–24, from which it was inferred that God himself had instituted marriage in the Garden of Eden, or Ephesians 5:31–32, the famous passage that compares the union of husband and wife to the marriage of Christ to the church, a Christian theology of marriage gradually evolved whose capstone was the inclusion of matrimony among the seven sacraments by theologians of the early scholastic period. Concurrently, beginning about 1100, and in marked contrast to the situation that prevailed during the early Middle Ages, the Latin church became the principal legislator on marriage and acquired jurisdiction over most marriage litigation, with the result that ecclesiastical authority in matrimonial matters was not generally challenged prior to the sixteenth century.[1] This fully developed medieval view of marriage as a sacral and ecclesiastical institution was, however, counterbalanced by an older secular and lay tradition that derived partly from barbarian custom but especially from ancient Roman survivals.

For centuries before and after the London double portrait most marriages were arranged, sometimes even before the couple had attained marriageable age, effectively subordinating the interests of the individual to more important social and economic considerations, sup-

plemented in the case of great families by diplomatic and dynastic concerns. For these same reasons, marriages were difficult to arrange and not everyone who wished to could marry, but for all who did the material conditions of adult life were determined in large measure by the terms of the marriage settlement. Only against the background of this development of European marriage as a social institution can both what is and what is not happening in Jan van Eyck's Arnolfini double portrait be understood.

European ideas about marriage were profoundly influenced by ancient Roman precedent. Because intent was the most basic principle of Roman law, the great jurisconsults of the second and third centuries logically held that marriage was concluded by the consent of the parties, and Ulpian's concise expression of this view, "Not cohabitation but consent makes a marriage," came to be included among the legal maxims of the final section of the *Digest* in Justinian's codification of the Roman law.[2] Roman lawyers termed this matrimonial consent *affectio maritalis,* or "conjugal affection," by which they meant, not some momentary expression of assent as part of a marriage rite, but rather a continuing mental state, shared by the partners. From a juridical point of view, this permanent emotive condition constituted the marriage. The *Digest* also envisioned marriage in ideal terms as a lifelong association of husband and wife for the procreation of legitimate children. But if *affectio maritalis* ceased to exist, the requisite legal consent no longer prevailed, and a divorce could easily be arranged.[3]

In a text that was to become a commonplace for later writers, Augustine gave a Christian twist to some of these ideas early in the fifth century when he enumerated the three "good things" about marriage as *proles, fides,* and *sacramentum.* The first, *proles,* or offspring, harmonized completely with Roman law on the purpose of marriage. What Augustine meant by *fides*—the marital fidelity of the spouses to one another—also conformed closely both with the idea of conjugal affection and with what *fides* implied in a legal context: the performance of one's duties as promised by an agreement. As for *sacramentum,* the word had as yet no theological connotations, and Augustine used it simply to refer to the couple's solemn mutual obligation that made their marriage indissoluble; on this matter Augustine's position represents a significant departure from Roman law, epitomizing a major difference between the legal traditions of Rome and the developing Christian view of marriage.[4]

By adopting the principle that marriage was concluded by the consent of the parties, Roman law established a clear legal distinction between concubinage and legitimate marriage. But there were other, less fortunate, consequences of this development, for henceforth no particular religious rites or civil formalities were necessary for contracting a valid

marriage, nor were any specific legal documents required.[5] To minimize possible ambiguity in these circumstances, various precautions were taken in the late Roman Empire to ensure adequate documentation of matrimonial consent, most commonly in the framework of the betrothal, which, as a result, came to displace nuptial rites in importance.

A betrothal in early Roman society was a simple mutual promise of future marriage, exchanged between the two fathers or between the bride's father and her future husband; *sponsalia,* the Latin word for "espousal," derived from the question-and-answer form this reciprocal promise took (the English cognate *respond* still retains something of the original meaning of the Latin root).[6] During the early imperial period, the Roman world adopted two Eastern betrothal practices that remained fundamental to the European conception of marriage long after Van Eyck's time. One of these was the redaction of the betrothal agreement in the presence of witnesses. The other was the custom of confirming the contract of future marriage with an earnest, usually at first a sum of money; to describe this security payment the Latin language appropriated and transmitted to medieval usage a loanword of Semitic origin, *arrha.*[7]

By the fourth century, the written betrothal agreement that created the bride's endowment—comprising both the *dos,* or dowry from her father, and the corresponding *donatio ante nuptias,* or prenuptial gift from her future husband—was often confirmed by ceremonies that in some parts of Europe eventually became part of the marriage ritual: an *osculum,* or kiss, and a ring placed on the fiancée's finger by the bridegroom. By a constitution of Constantine, for example, the betrothal kiss acquired juridical effect: if a man who had kissed his fiancée at the *sponsalia* died before the wedding, one-half of what had been agreed on as his prenuptial gift went to the woman, even though the marriage could not take place.[8] Concurrently, the betrothal ring was conflated with the *arrha* given as a guarantee that the betrothal agreement would be fulfilled, with the result that the bestowal of a ring in the context of a betrothal came to be called the *subarrhatio* of the bride.[9] But the real significance of both ceremonies was that by these actions the two parties to the proposed marriage were themselves directly involved in the *sponsalia,* as distinguished from the relatives or guardians who had arranged the marriage; by giving and receiving the kiss and the ring, the couple expressed publicly, in the presence of witnesses, their own intent to marry.

Although Roman and Germanic attitudes toward marriage differed, the greater importance Roman *sponsalia* assumed in late antiquity harmonized well with the emphasis placed on betrothal in barbarian law. Central to early Germanic marriage was the barbarian con-

cept of *mundium*. Although *mundium* in general was a man's dominion over his unarmed subordinates, this tutelage extended to the reproductive function of women, who were subject to exceptional taboos to protect the purity of the family blood (according to Burgundian law, for example, a woman who compromised a husband's *mundium* by leaving him was to be smothered in dung, and merely to touch a woman's hand was a punishable offense in Salic law).[10] The betrothal established the conditions for the transfer of the *mundium* over a woman to her husband, and the terms of the agreement between father and bridegroom to do this were more rigorously binding than the obligations of Roman *sponsalia.* The marriage ceremony by contrast was seen as no more than a *traditio,* or handing over of the bride to the groom, and the significance of the rite was further eclipsed because the matrimonial bond was juridically created by the subsequent consummation of the marriage. Thus what was most important in constituting a marriage for the Romans—the mutual consent of the spouses—was entirely lacking in barbarian society, where a daughter's *mundium* was for the father to bestow as he would. Conversely, what was of paramount concern to the Germans—the sexual union of the spouses—was of no juridical import to the Romans. Not surprisingly, these differences were to have long-standing consequences for European ideas about marriage.[11]

Another important element of Germanic betrothal was the constitution of the bride's dowry, for it was the dowry that legally distinguished a wife from a woman living in a less formal liaison. In Frankish law, for instance, the legitimacy of children depended on the proper dowering of their mother. Apparently this idea derived from Roman imperial legislation of the fifth century that required a dowry for legitimate marriage. Although that law was abrogated shortly after enactment, the notion that a dowry validated a marriage had meanwhile been adopted by the Germanic population settled within the empire. And the dowry agreement, often committed to writing—again under Roman influence—served to document in a particularly satisfactory way for a semiliterate society that a marriage had been contracted.[12]

When the barbarians appropriated the Latin word *dos* to describe the dowry, the meaning was inverted: whereas in Roman law the *dos* was given by the bride's family, in Germanic practice it became instead a marriage gift from the bridegroom. Payment was usually deferred until after the wedding night, when the husband—satisfied as to the bride's virginity and thus the integrity of her *mundium*—endowed his wife with what was often substantial property in the form of a *Morgengabe,* or "morning gift." Germanic influence on marriage customs was so pervasive that even among the Romanized population of western Europe

during the early Middle Ages, the wife's dowry as a gift from her husband largely replaced ancient Mediterranean practice. The *dos* as constituted by the bride's family did not again become the principal source of the wife's endowment until after the medieval revival of Roman law.[13]

The seventh-century Visigothic king Recceswinth helped to universalize the Germanic idea that a dowry was necessary for valid marriage. In revising an earlier law code, he added to the section on nuptial contracts the title "Let there be no marriage without a dowry." Subsequently this terse expression reappeared in a ninth-century collection of forged capitularies, and still later, the false claim was made that the formula was actually a canon of a church council that met at Arles in 524.[14] Thus provided with an authoritative, if spurious, pedigree, the principle that no marriage was valid without a dowry acquired ecclesiastical approbation and eventually, in the twelfth century, found its way into the mainstream of canon law when Gratian codified the pseudo-canon of Arles in the *Decretum*.[15]

A famous papal letter of 866 in which Nicholas I responded to inquiries from the Bulgarians, whose recently converted king was exploring the advantages of adhering to the Latin rather than the Greek form of his new religion, provides the most detailed early account of a developing Western rite for marriage. As described by the pope, a Roman marriage in the ninth century was contracted in two separate stages that effectively distinguished the secular from the sacred. First came the traditional civil formalities of the *sponsalia,* with the promise of future marriage requiring the consent of the couple as well as their parents. The pledging of the *arrha* followed as the bridegroom placed a ring on the fiancée's finger, and the dowry agreement in written form was presented to the bride before both parties' invited guests, who served as witnesses. The second stage was a religious rite that followed at some suitable later date, when the couple, in the pope's words, were brought "to the nuptial bond" ("ad nuptilia foedera"). This ceremony took place in a church and consisted of a eucharistic liturgy during which the nuptial blessing was bestowed (provided it was a first marriage) as a veil was held over the couple's heads. Following the service, the bride and groom left wearing crowns that were kept in the church especially for this purpose. The pope concludes by remarking that the religious ceremony was not, however, obligatory, for "according to the [Roman] law" only the parties' consent was required.[16]

The religious ceremonies Nicholas I described were further restricted in their application because the church in Rome reserved the nuptial blessing for those who were still *incorrupti* at the time of their wedding, a discipline that in turn explains the crowns, which were

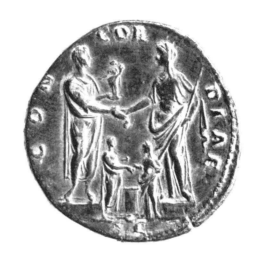

FIGURE 6. *Sestertius* of Antoninus Pius, 138–61. London, British Museum. Photo courtesy of the Trustees of the British Museum.

symbols of virginity, as well as the blessing only of first marriages.[17] The predominantly secular character of marriage customs in ninth-century Rome, as described in the letter to the Bulgarians, is particularly striking, for the essential elements relate not to the ecclesiastical rite, although the pope himself speaks of this as creating the nuptial bond, but to the traditional legal formalities of *sponsalia* in Roman law.

The apparent dichotomy in the pope's views is not difficult to explain. Aside from the church's growing insistence on the indissolubility of a valid marriage, the secular and civil nature of marriage as an institution based on Roman law was already so firmly entrenched by the time of Nicholas I that it survived in modified form in various parts of Italy, including Rome, until the sixteenth century, although elsewhere in Europe quite different and essentially ecclesiastical marriage rites developed in the eleventh and twelfth centuries. These circumstances become directly relevant to the London double portrait on the presumption that the couple depicted by Van Eyck were of Italian descent.

Aside from the mention of the *subarrhatio* of the fiancée with a betrothal ring, the response of Nicholas I to the Bulgarians provides no information about hand gestures that may have accompanied Christian marriage ceremonies in the West prior to the year 1000. But from an early date Christians are presumed to have adopted the characteristic gesture associated with marriage in the ancient Mediterranean world, the symbolic joining of right hands that modern scholarship has called the *dextrarum iunctio,* although this expression is not found in any ancient or medieval text.[18] The Book of Tobit (7:15, according to the Vulgate text), in a passage that greatly influenced the evolution of European marriage rites, refers to a similar gesture when describing how Raguel presided over the marriage of his daughter Sarah to Tobias: "And taking the right hand of his daughter, he put it into the right hand of Tobias."

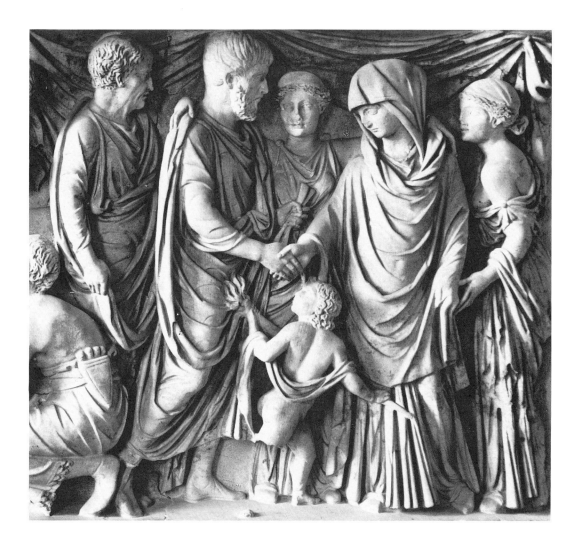

FIGURE 7. Sarcophagus of a Roman general (detail), second half of the second century.
Mantua, Palazzo Ducale. Photo: Alinari/Art Resource, New York.

For pagan society in the Roman empire of the second century the *dextrarum iunctio* is conveniently documented by a *sestertius* of Antoninus Pius (Fig. 6) inscribed "Concordiae" and depicting a minuscule bridal couple joining right hands as they stand before an altar erected in front of colossal statues of the emperor and his wife, clasping hands in the same manner.[19] A closely related motif is found in Roman sarcophagal reliefs of the latter half of the second century and the early third in which a personified Concordia symbolically draws husband and wife together by placing her hands on their shoulders as the couple in turn join right hands (Figs. 7 and 8).[20] Because of the presence of attending allegorical figures, it is generally thought that such images were not intended as representations of actual rites. More likely, they were emblematic depictions of the married state, epitomizing the *concor-*

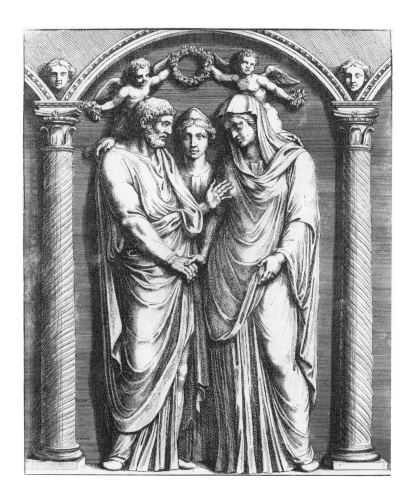

FIGURE 8. Fragment of a Roman sarcophagus, c. 200.
Rome, Palazzo Giustiniani. Pietro Santi Bartoli, *Admiranda
romanarum antiquitatum ac veteris sculpturae vestigia,* Rome,
1693, plate 56. Ann Arbor, Special Collections Library,
University of Michigan.

dia, or harmony, between the spouses characteristic of an ideal marriage, and it is this idealizing element that made the imagery suitable for funerary monuments.[21]

Although a conflation of the Tobit text with the Roman *dextrarum iunctio* may have inspired the Roman mosaic of the fifth century in Santa Maria Maggiore representing the marriage of Moses and Sephora (Fig. 9), the bride's father in the mosaic does not actually bring the couple's hands together. Instead, like the personified Concordia of classical iconography, he uses an embracing gesture to unite the bridal pair. In contrast to the emblematic quality of images like Figures 7 and 8, the Moses and Sephora mosaic appears to have

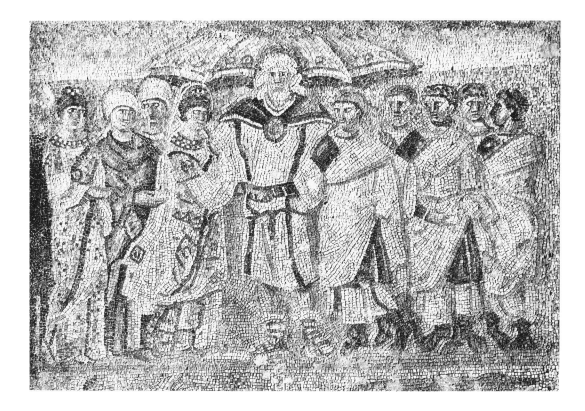

FIGURE 9. *The Marriage of Moses and Sephora.* Nave mosaic, 432–40. Rome, Santa Maria Maggiore. Photo: Alinari/Art Resource, New York.

been intended as the representation of a marriage. The presence of guests supports this interpretation, and their separation by gender, with women accompanying the bride and men the groom, was destined to have a long history in the depiction of European marriage rites (cf. Plate 5). As the earliest Christian monument to depict such a scene, the Santa Maria Maggiore mosaic is thus evidently the prototype for the Christian iconography of this subject.

Astonishingly, there are no comparable images in Western art for many centuries thereafter. A few related Byzantine examples survive, most notably a pair of identical medallions (Fig. 10) on a Syrian gold marriage belt of the late sixth or early seventh century, now at Dumbarton Oaks, depicting the *dextrarum iunctio* of a husband and wife as Christ officiates between them, embracing the couple with his hands on their shoulders. The symbolism of these medallions apparently reflects the development of a popular religious ritual for Christian marriage much earlier in the East than in the West, and although the "Concord" of the Greek inscription implies an element of continuity with the coin type of Antoninus Pius, it is now God who is the source of concord in marriage, as the inscription explicitly

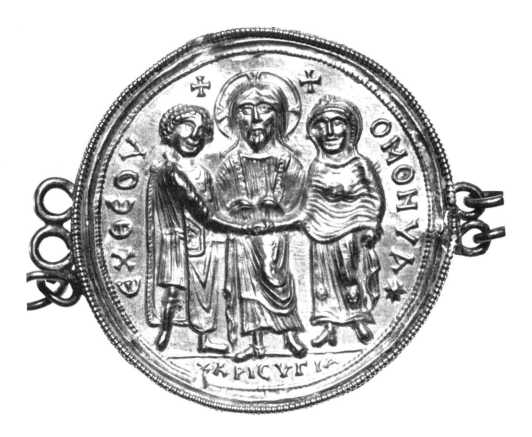

FIGURE 10. Medallion from a Byzantine gold marriage belt, Syria, late sixth or seventh century. Washington, D.C., Dumbarton Oaks Collection. Photo copyright 1992, Byzantine Visual Resources, Dumbarton Oaks, Washington, D.C.

states: "From God, Concord."[22] The disappearance in the West, for the better part of a millennium, of both visual and textual references to a matrimonial joining of right hands strongly suggests that the gesture may have fallen into disuse by late antiquity.[23] A famous spurious text, wrongly ascribed to Augustine, moreover, refers to the marital consent being given "by the heart and mouth," and "not by the clasp of a hand."[24]

In early Frankish Gaul the customary place for blessing a marriage was not a church but the nuptial chamber as the bridal couple prepared to retire on the night of the wedding, and the Roman stricture that only virgins could receive the nuptial blessing was not rigorously applied.[25] Perhaps these different circumstances explain why the earliest attempts in the West to require the blessing of all Christian marriages are found in Frankish lands under Carolingian control, as, for example, in Charlemagne's capitulary of 802.[26] It was, in fact, among the Franks that the basic elements of the new ecclesiastical model for marriage first

appeared during the century that preceded Nicholas I's Bulgarian letter, with its continued emphasis on the older civil model. These developments can be traced in legislation that originated with the Carolingians themselves, as well as in other contemporary documents, including various spurious papal letters in the Pseudo-Isidorian forgeries of the mid-ninth century. The texts involved aimed particularly at prohibiting clandestine marriage, and the most important were later codified in the *Decretum* of Gratian, making them part of the living tradition of Western canon law in the time of Van Eyck.

In addition to the standard betrothal formalities of Roman and barbarian law, legitimate marriages were now also to be marked by public celebration and a priestly blessing. To deal with the vexing problem of impediments to a valid marriage, usually because the couple were too closely related according to ideas about consanguinity that developed during the eighth century, one of these texts prescribes an inquiry into such relationships prior to the betrothal by local people assembled in a church with the priest presiding. Yet another religious element, known as the "nights of Tobias" because it was derived from the biblical account of the marriage of Tobias and Sarah, was introduced into the celebration of marriage during Carolingian times. Newlyweds were counseled, out of respect for the nuptial blessing, to defer the consummation of their marriage for three nights, or at least until after the wedding night, devoting themselves instead to prayer.[27]

In northern France at the turn of the eleventh century these diverse elements coalesced into the earliest form of what was to become the traditional Western marriage rite. In the process a remarkable change occurred, as the civil betrothal formalities associated with contracting a valid marriage according to Roman law since late antiquity were incorporated into a new ecclesiastical rite celebrated at the church door just before the nuptial liturgy of the older Roman tradition (transmitted north of the Alps when the Roman liturgical books were adopted by the Carolingians). And it was this new preliminary rite, rather than the Roman nuptial mass, that eventually came to constitute for both canonists and theologians the essential element of marriage as a sacrament.

According to the Anglo-Norman service books from the first part of the twelfth century that provide the earliest firm evidence for the details of the new ecclesiastical ceremony, the priest met the bridal party and their guests at the door of the church. Following inquiries about possible canonical impediments to their union, the priest verified the couple's consent to be married, and in conformity with the principle taken over from barbarian customary law that there could be no valid marriage without a dowry, either this marriage gift from the groom was paid or the terms of the dowry settlement were read aloud. And what

formerly had been a betrothal ring given as a pledge, or *arrha,* that the promise of future marriage would be fulfilled now became a wedding ring, blessed by the priest and ceremoniously placed on the bride's hand by the groom with the priest's assistance. There is no reference in these rituals to additional hand gestures. The church-door ceremony concluded with the priest's blessing. Then the bride and groom, carrying lighted candles, followed the priest into the church for the nuptial mass of the Roman marriage rite, when further prayers were pronounced over them.[28]

The earliest rubrics for the new rite refer to the site of the ceremony with such phrases as "before the church entrance" or "at the doors of the church." But the preferred expression soon became *in facie ecclesiae,* that is, "in the face of the church," which was interpreted metaphorically, not as a building but as the local Christian community.[29] Thus from the twelfth century onward the church-door wedding rite was thought of as an intrinsically public ceremony, in marked contrast to secret or clandestine marriage.[30] In this sense the new rite helped to realize an ideal embodied in the earliest known Western ecclesiastical legislation that specifically concerned the ritual of Christian marriage, a canon of the Frankish national synod of Verneuil in 755 that enjoined all persons, "noble as well as ignoble," to celebrate their nuptials publicly.[31]

A man and woman in the fifteenth century could indeed contract a valid marriage "in complete solitude," as Panofsky argued, or privately before witnesses, as in his interpretation of the Arnolfini double portrait. But it is not the case that such a marriage was "legitimate," as he and his many followers have also claimed. Marriages contracted secretly rather than in a public rite, which in northern Europe normally entailed the presence of a priest, were in fact considered illicit. Using terminology that is just the opposite of Panofsky's characterization, canon law texts routinely describe clandestine marriage as "non legitimum," and secret marriages were strictly forbidden for centuries prior to the London double portrait.

When compiling the *Decretum* around 1140, Gratian brought together a number of these earlier texts that stressed the public character of legitimate marriage and condemned marriages that were clandestine, including the pseudo-canon of Arles and excerpts from Nicholas I's response to the Bulgarians. Especially important were two letters ascribed to early popes with which the chapter on clandestine marriage begins (both are actually false decretals, but their authenticity was not questioned until long after Van Eyck's time). The first letter catalogues the conditions necessary for legitimate marriage, including *sponsalia,*

a dowry settlement, the blessing of a priest, and the couple's observation of the customary "nights of Tobias"; this anonymous writer goes on to say that clandestine marriages were to be presumed "adultery, concubinage, debauchery, or fornication, rather than *legitima conubia.*" The second letter states categorically: "No Christian of whatsoever condition shall enter into a marriage secretly, but having received the blessing from a priest, he shall marry publicly in the Lord."[32]

Gratian concluded that since clandestine marriage was universally forbidden by his sources, such marriages were "infected," or tainted with moral corruption. Elsewhere in the *Decretum* he drew what remained until after the Council of Trent the standard canonical distinction between a "legitimate" marriage, celebrated according to law and local custom and characterized by public rites such as the constitution of the bride's dowry and the priest's blessing, and a clandestine marriage, which because these formalities had been omitted was "not legitimate." But since the *Decretum* had also codified Nicholas I's opinion that the couple's consent alone created a marriage, Gratian was forced to recognize that a clandestine marriage was nonetheless still a valid one.[33] The importance of Gratian's *Decretum* for understanding the Arnolfini double portrait is that this authoritative textbook of the new canon law firmly established that clandestine marriage was always illicit and at the same time greatly enhanced the priest's blessing as a constituent of legitimate marriage over the secondary role it had had for Nicholas I in the Bulgarian response.

Gratian's *Decretum* is a typical monument of the fervid intellectual activity, particularly in law and theology, that characterizes twelfth-century Europe. Within this framework the classic doctrine of the medieval Latin church on matrimony was hammered out during the latter part of the twelfth century and the first years of the thirteenth, as differing opinions were subjected to discussion and criticism by canonists, theologians, and popes. The central issue was whether the marriage bond was created by the consent of the parties, as in the Roman law, or by the consummation of the marriage, as in the Germanic tradition, a dispute that ended with a definitive victory for the consensualists early in the thirteenth century during the pontificate of Innocent III. There was, however, a significant difference between Roman and canon law with regard to matrimonial consent: whereas the Roman law required the consent of the parents as well as the spouses, in the fully developed medieval canon law parental consent was not necessary.[34] Under the same pope, the church's position on consanguinity as an impediment to marriage was greatly relaxed when the Fourth Lateran Council in 1215 reduced the prohibited degree of relationship from the

seventh to the fourth: thus while formerly persons with a common ancestor as remote as the seventh generation (that is, sixth cousins) could not marry, under the new legislation the prohibition extended only through the fourth generation (or, third cousins).[35]

A further canon of the Fourth Lateran Council contains Innocent III's forceful statement: "Following in the footsteps of our predecessors [the allusion is to the pseudo-papal letters codified in the *Decretum* and cited above], we utterly prohibit clandestine marriages." The canon continues with a series of regulations aimed at preventing clandestine marriage within the prohibited degrees, including the requirement that the bans of marriage be published in the church so as to bring impediments to light, as well as a provision that denies legitimacy to children born of a clandestine marriage where there was an impediment due to consanguinity.[36]

Ecclesiastical objection to clandestine marriage was thus motivated by two considerations. The first concerned unions deemed incestuous, which were often initiated by clandestine marriage: such unions were to be discouraged by the enforcement of the more reasonable consanguinity standards of the Fourth Lateran Council. A second, pastoral, consideration stemmed from the premise that sexual intercourse outside marriage was morally wrong. Because it was frequently uncertain whether persons contracting marriage in secret were really married, from the clerical point of view couples so joined might well live out their entire lives in a continuing state of fornication or—if they later contracted a second marriage when the first was actually binding—adultery.

Although the legislation enacted by the Lateran Council became the public law of the entire Latin church, it marked neither the beginning nor the end of clerical efforts to cope with clandestine marriage. Indeed, from the late twelfth to the early fourteenth century, provincial councils throughout Europe enacted statutes severely penalizing those who entered into marriage secretly; these statutes remained in effect regionally until the same legislative bodies, acting centuries later on a decree of the Council of Trent, invalidated such marriages. Although some penalties were more colorful, the most common was excommunication, the severest punishment the church could inflict.[37] As for the context of the London double portrait, prior to 1559 Bruges and Ghent were part of the diocese of Tournai, a suffragan in turn of the archdiocese of Reims, and the law on clandestine marriage for this ecclesiastical province (which included most of the northern territories of the duke of Burgundy) was established by a provincial council of 1304. The relevant canon provides that "each and every" person of the province who either enters into a clandestine marriage, in any way arranges one, or is merely present at one is to be excommunicated ipso facto and denied the right of Christian burial.[38]

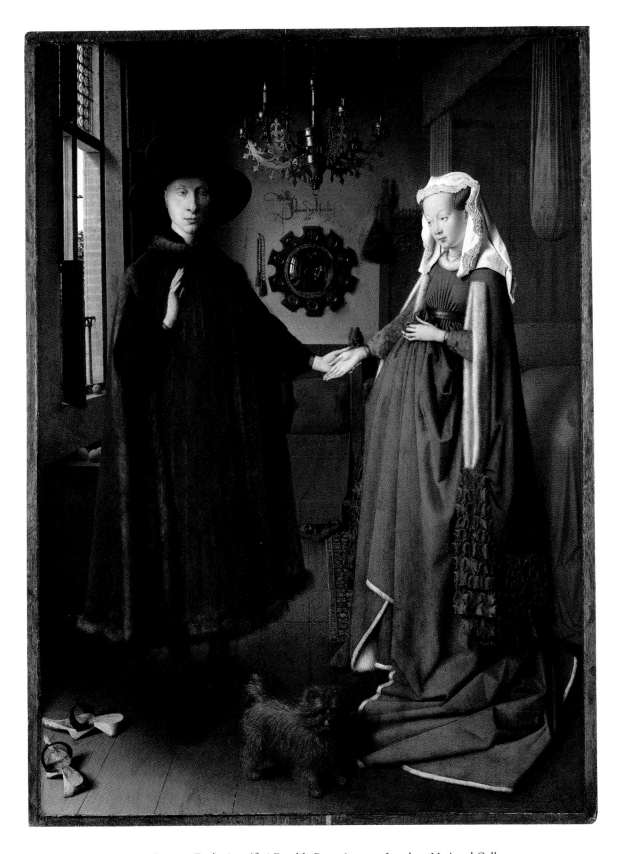

PLATE I. Jan van Eyck, Arnolfini Double Portrait, 1434. London, National Gallery.

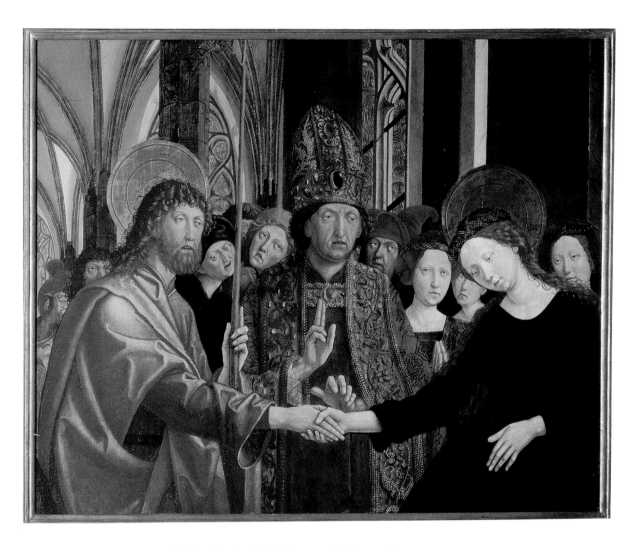

PLATE 2. Michael Pacher, *The Marriage of the Virgin* (fragment), c. 1495–98.
Vienna, Österreichische Galerie.

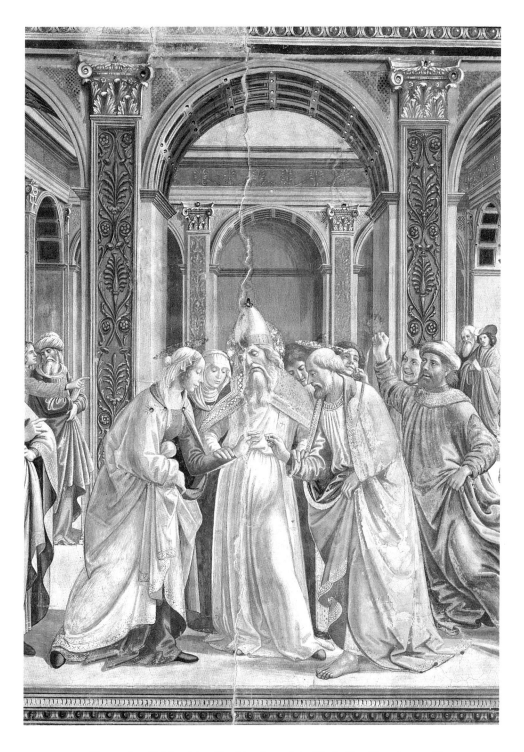

PLATE 3. Domenico Ghirlandaio, *The Marriage of the Virgin* (detail), 1485–90. Florence, Santa Maria Novella. Photo: Scala/Art Resource, New York.

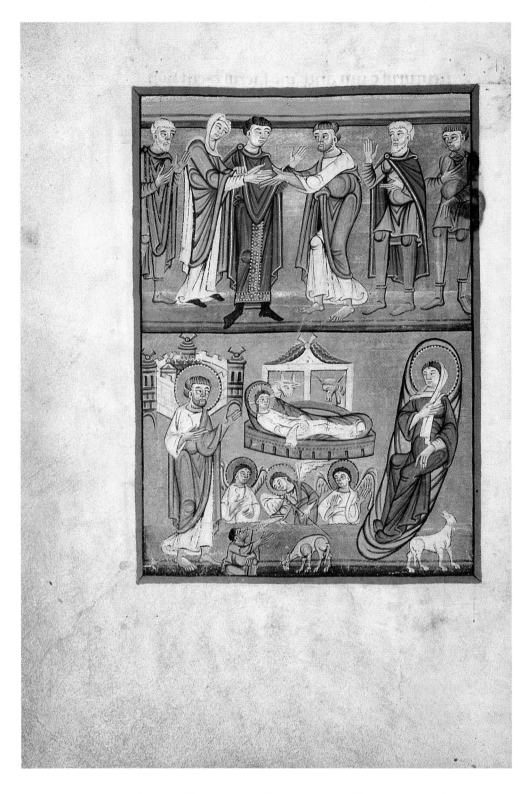

PLATE 4. *The Marriage of the Virgin* and *The Nativity.* Bernulfus Gospels, Reichenau, c. 1040–50. Utrecht, Rijksmuseum Het Catharijneconvent, ABM ms. 3, fol. 7v.

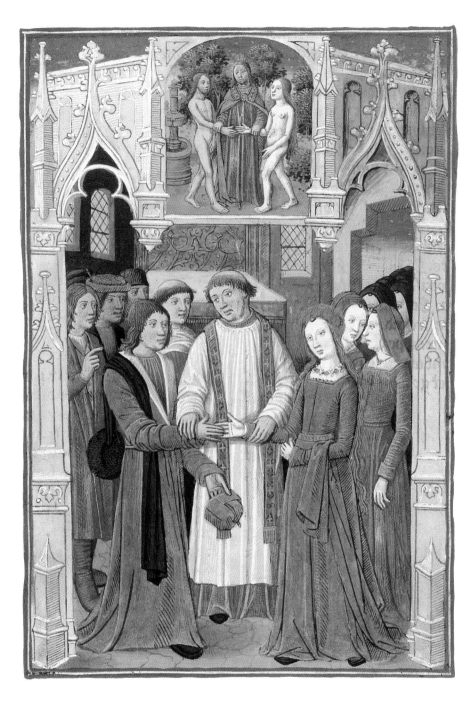

PLATE 5. *The Sacrament of Marriage. L'Art de bien vivre,* Paris, 1492, vellum
exemplar. San Marino, California, The Huntington Library.

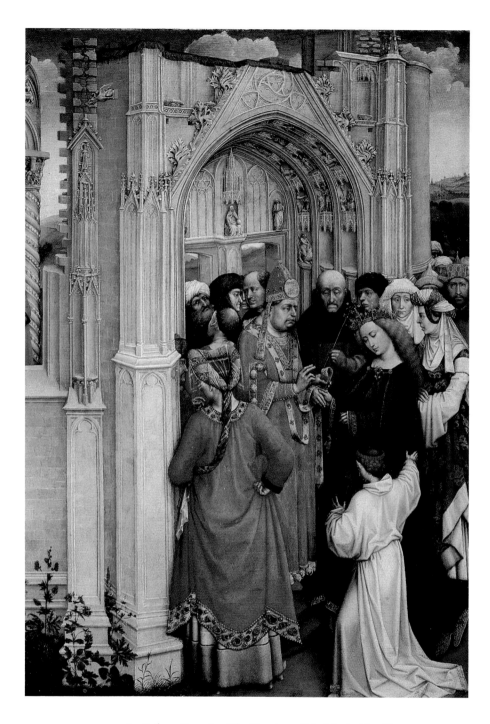

PLATE 6. Robert Campin, *The Marriage of the Virgin* (detail),
c. 1420. Madrid, Prado.

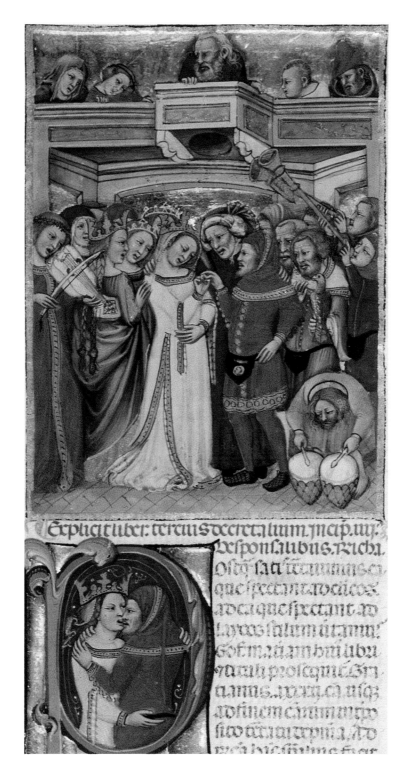

PLATE 7. Nicolò da Bologna, Marriage miniature. Single leaf from
a manuscript of Johannes Andreae, *Novella* on the *Decretales* of
Gregory IX, c. 1350. Washington, D.C., National Gallery
of Art, Rosenwald Collection.

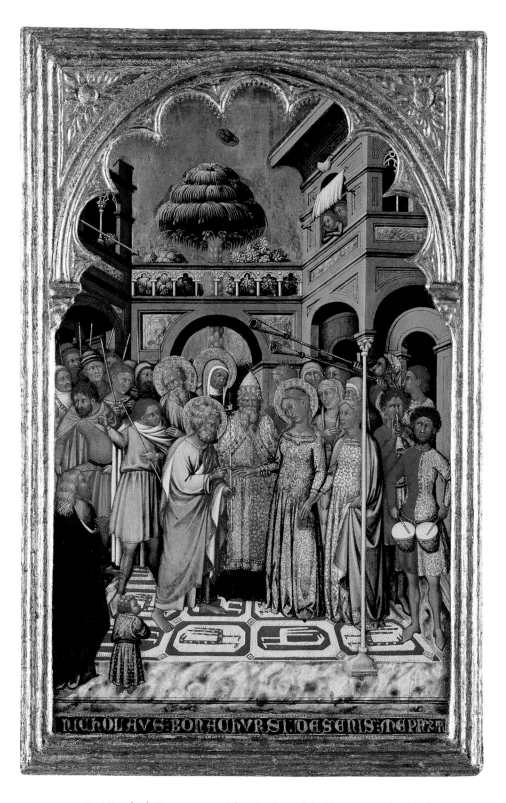

PLATE 8. Niccolò di Buonaccorso, *The Marriage of the Virgin,* second half of the
fourteenth century. London, National Gallery.

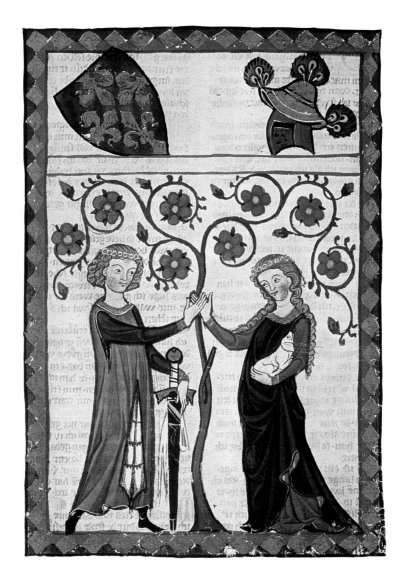

PLATE 9. Bernger von Horheim miniature. Codex Manesse,
early fourteenth century. Heidelberg, Universitätsbibliothek,
ms. Pal. Germ. 848, 178r.

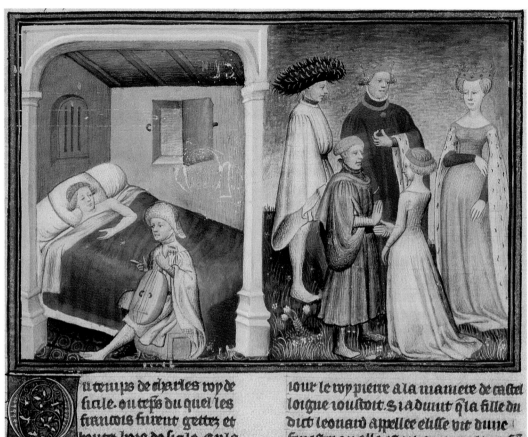

u temps de charles roy de
siale. ou tps du quel les
francois furent gettez et
boutez hors de siale. & en la
cite de palerme demouroit vng niea
toien florentin appelle leonard. jl hom
me tres riche auoit vne seule fille tg
belle et habile a marier: & en cellm ̃
temps pierre roy de arragon et seig̅
de siale failoit a palerme vne moult
belle et g̅ñde feste a ses barons. cellni

iour le roy pierre a la maniere de castel
loigue ioustoit. S̅ i aduint q̅ la fille du
dict leonard appellee elisse vit d'une
fenestre ou elle estoit auec aultres fé
mes le roy courant et ioustãt de vng
plancon a rocher. le roy plaisi tant a
la fille que deslozs elle qui souuant le
regardoit ne pensoit a aultre chose foiz
que a son grant et hault amāt· vne
chose mlt empeschoit lesperãce de la
fille quant elle cõsideroit sa basse con

PLATE 10. Lisa and Perdicone miniature. Boccaccio, *Decameron* (10.7), Paris, early
fourteenth century. Vatican City, Biblioteca Apostolica Vaticana, Pal. lat. 1989, fol. 304r.

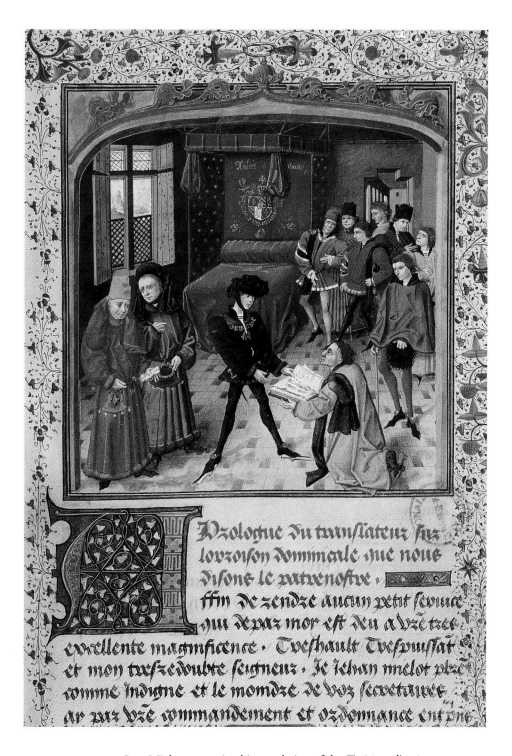

PLATE 11. Jean Miélot presenting his translation of the *Traité sur l'oraison dominicale* to Philip the Good. Flemish, c. 1457. Brussels, Bibliothèque Royale Albert Ier, ms. 9092, fol. 1r.

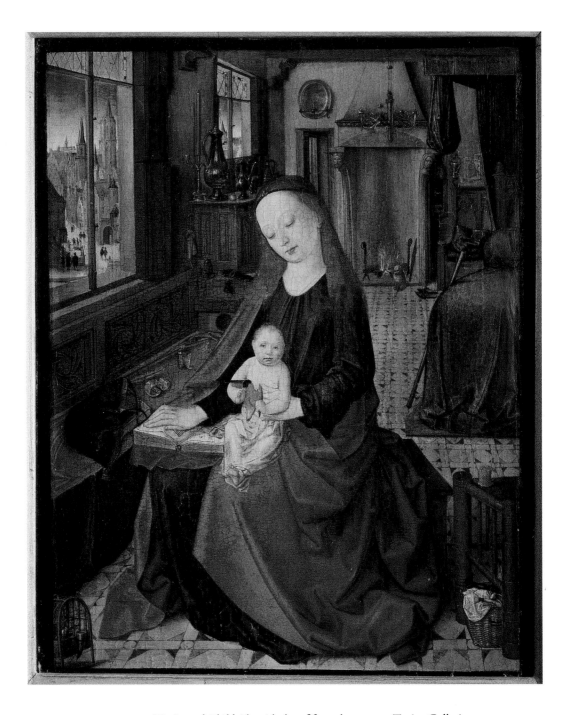

PLATE 12. *Virgin and Child.* Flemish, late fifteenth century. Turin, Galleria
Sabauda. Photo: Archivio Fotografico della Soprintendenza
per i Beni Artistici e Storici.

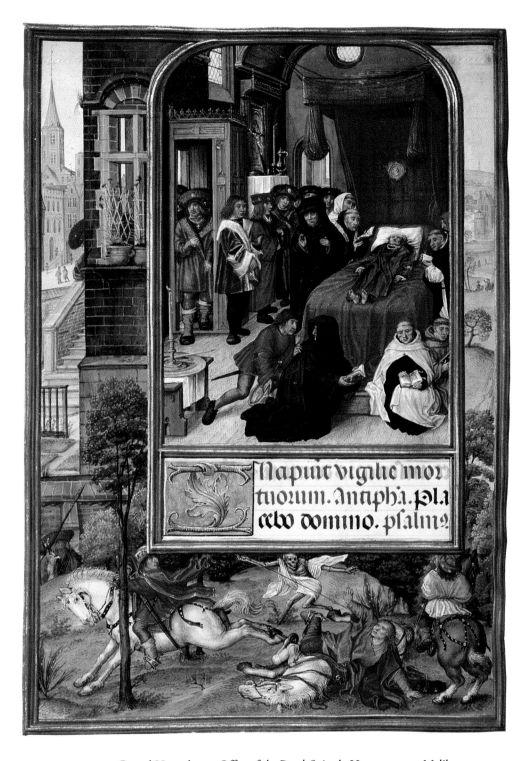

PLATE 13. Gerard Horenbout, *Office of the Dead.* Spinola Hours, c. 1515. Malibu, California, J. Paul Getty Museum, ms. IX. 18, fol. 184v (83.ML.114).

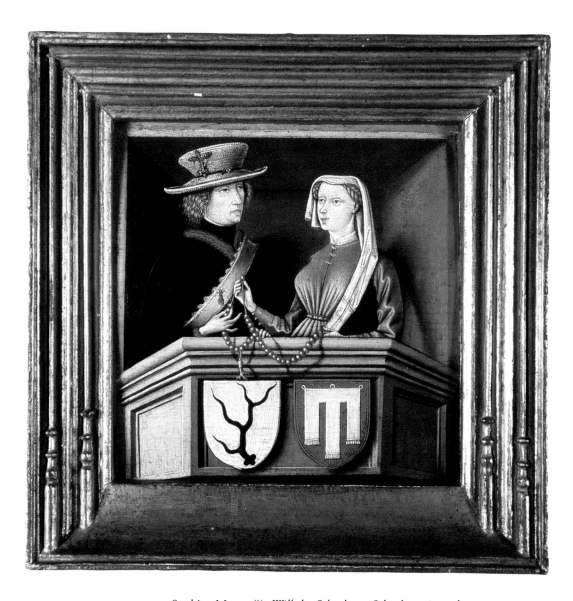

PLATE 14. Swabian Master (?), *Wilhelm Schenk von Schenkenstein and
Agnes von Werdenberg,* c. 1450. Schloss Heiligenberg, Fürstenberg Collection.
Photo: Georg Goerlipp.

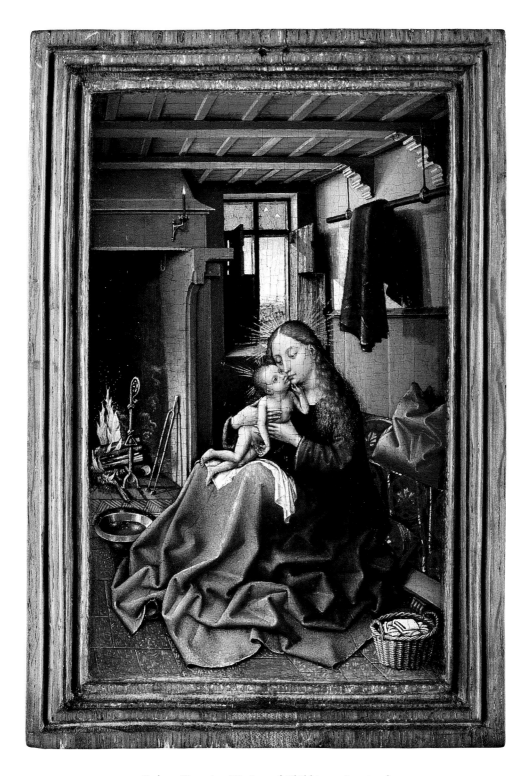

PLATE 15. Robert Campin, *Virgin and Child in an Interior,* first quarter
of the fifteenth century (?). London, National Gallery.

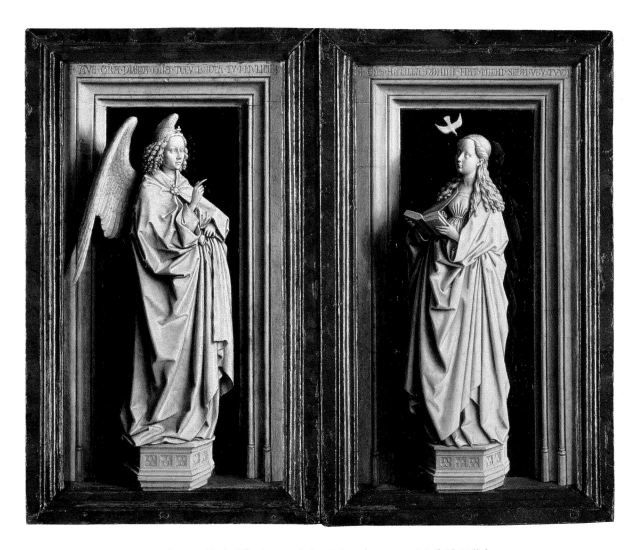

PLATE 16. Jan van Eyck, The Annunciation Diptych, c. 1439. Madrid, Villahermosa Palace, Thyssen-Bornemisza Collection.

Thomas Aquinas sums up the church's doctrine succinctly by saying that if the parties give their consent and there is no impediment to the union, a clandestine marriage is valid but also sinful as well as dishonorable, since often at least one of the parties is guilty of fraud. Similar views are expressed by many later writers, including Van Eyck's contemporary Saint Antoninus of Florence, who observes pointedly that "those who contract marriage clandestinely, sin mortally."[39] And ordinary people evidently held similar views on clandestine marriage: the offspring of such unions were thought likely to be "blind, lame, hunchbacked, and dim-sighted."[40] Lay society in large measure supported the church's new role as arbiter of European marriage law for the simple reason that from the twelfth century on a major concern of both the feudal aristocracy and the rapidly developing middle class was the secure transfer of property and wealth through heredity to legitimate heirs.[41] Because the church now made the rules, only the ecclesiastical establishment could determine which marriages were canonically contracted and consequently which heirs were legitimate. If clandestine marriage is understood within this general framework, the horrendous social and legal disabilities that might follow from such a union are obvious.

Nonetheless, despite the obstacles, men and women continued to marry in secret. It is evident from papal registers of the late fourteenth and the early fifteenth century that some clandestine marriages were intentionally contracted by upper-class couples who were related within the forbidden degrees and for whom a public and ecclesiastically approved wedding was therefore impossible. In such cases papal letters could be subsequently sought to lift the ban of excommunication and to request a dispensation from the impediment. As long as the relationship was not too close, such petitions were usually granted with a specific provision legitimizing all offspring of the union, past as well as future, and—after an appropriate penance had been imposed on the couple—the marriage was publicly solemnized.[42]

Clandestine marriage was sometimes resorted to as the only practical way for children to escape from unsatisfactory marriage alliances arranged by their parents, particularly in the case of girls, who even in great families were sometimes subjected to what today would be considered shocking instances of child abuse to force them into submission. Clandestine marriage also opened the way for the marriage of couples who could never hope for parental approval of their union. The Paston Letters provide a well-known example. In 1469 Margery Paston, a daughter of this famous Norfolk family, made a clandestine marriage with the Pastons' chief bailiff, Richard Calle. Both the family and the bishop of Norwich were appalled by her action, but there was nothing they could do about it, and Margery's mother wrote shortly thereafter to her son that "we have lost of her but a worthless per-

son."[43] Almost exactly contemporaneous with the Arnolfini double portrait was the tragic clandestine marriage of the future Albrecht III, son of Duke Ernst of Bavaria-Munich, to Agnes Bernauer, a barber's daughter and attendant in an Augsburg bathhouse, where Albrecht first met her. Fearing for the future legitimacy of his line, the duke dealt with the situation decisively. Distracting his son's attention with a tournament, he had Agnes seized, tried for witchcraft, and, in October 1435—the year after the completion of the London panel—thrown into the Danube near Straubing, where her tomb may be seen to this day in a chapel the duke endowed in the Carmelite church as expiation for his sin.[44]

Further instructive examples of clandestine marriage are found in Boccaccio's *Decameron*. The most delightful is Pampinea's story for the second day (2.3). A young Florentine merchant named Alessandro, returning to Italy from London, upon leaving Bruges falls in with the retinue of a youthful abbot traveling to Rome. One night Alessandro and the abbot are forced to share the same room, and it turns out that the abbot is really a beautiful young woman in disguise. When the two are alone, the woman reveals her passionate love for Alessandro, who accepts her offer of clandestine marriage before they spend the night together. The following day they continue their journey as if nothing had happened, but when the travelers reach Rome, the "abbot" confesses to the pope both her clandestine marriage to Alessandro and her true identity as a daughter of the king of England, in flight from a marriage her father had arranged with the aged king of Scotland. Amazed that a king's daughter would choose such a husband but realizing "there was no turning back," the pope, in the presence of the cardinals and a large concourse of important persons, "had them go through the marriage ceremony solemnly from the beginning, and after splendid and magnificent nuptials had been celebrated, he dismissed them with his blessing." The passage quoted is particularly important, because it indicates—and canon law texts corroborate—that a clandestine marriage was formalized later by a public ecclesiastical ceremony, for as a gloss to the *Decretales* of Gregory IX explains, "the first marriage has taken effect before God but not before the church."[45]

The reputation of clandestine marriage was further darkened by rakes and profligates who used it as a convenient and seemingly reliable technique for seduction. Just how notorious clandestine marriage had become by the later Middle Ages when used for such ends may be judged from a remark of Aquinas. "According to some," Thomas says, "if in such a case the woman is markedly inferior in social status to the man, he has no further obligation toward her, since it may be presumed as probable that she was not deceived, but merely pretended to be."[46] The use of clandestine marriage as an instrument of seduction,

especially across class lines, was still well understood at the end of the eighteenth century, for the inherent comic possibilities of the situation are skillfully exploited in Mozart's *Don Giovanni,* when the Don proposes such a marriage to Zerlina in attempting to add Masetto's fiancée to the catalogue of his conquests.[47] And it is almost certainly this disreputable aspect of clandestine marriage that accounts for the interpretation of the London double portrait in the Spanish inventory of 1700 as a genre picture representing a couple's mutual deception of one another as they surreptitiously "seem to be getting married at night."

The chance survival of a register of sentences handed down by the officiality, or episcopal court, of the bishop of Cambrai in Brussels between 1448 and 1459 permits a glimpse of the realities of clandestine marriage from a judicial perspective at approximately the same time and place the Arnolfini double portrait was painted. A majority of the 1,590 sentences rendered by the two judges who consecutively presided over this ecclesiastical tribunal during the eleven years covered by the register dealt with matrimonial litigation, and of these, 20 involved instances of clandestine marriage.[48] Before several representative cases are summarized, a few legal technicalities need to be mentioned. A marriage was accounted clandestine in canon law either because it had been contracted secretly—that is, without witnesses or without publication of the bans of matrimony as required by the Fourth Lateran Council—or because it had not been publicly solemnized, a ceremony that in northern Europe normally required the presence of a priest. A betrothal, however, might also be publicly celebrated before a priest; for this and other reasons that will be discussed more fully in the next chapter, canonists and theologians from the twelfth century on distinguished a betrothal from a wedding according to the tense used in expressing the consent to be married: the words of consent in the future tense, or *verba de futuro,* that characterized a betrothal were no more than a promise of future marriage, whereas words of consent in the present tense, or *verba de praesenti,* created the indissoluble marriage bond. Words of future consent followed by sexual union were held to constitute consent in the present tense, and a presumptive marriage was the result.

The documentation in the Brussels *Liber sententiarum* suggests that truly secret marriages were rare, since witnesses were present in all but one case. In another instance the ceremony actually took place in a church before a priest. Celebrated very early on the morning of 15 February 1451 in the parish church of Lier in the presence of a priest who was the precentor of a major church in Malines, the marriage of Elisabeth de Ymersele and Godefroid Vilain was clandestine only because the bans had not been published and the priest acted without proper authorization. Yet when the case came before the Brussels tribunal, in con-

formity with the legislation of the Fourth Lateran Council,[49] the priest was suspended from his priestly functions for three years and ordered to pay various fines, including one for lifting the penalty of the excommunication he had automatically incurred by taking part in the ceremony. Because both bride and groom are described as "nobiles personae," this clandestine marriage, arranged with the complicity of a locally prominent priest, was probably the consequence of strong parental opposition; a clandestine church wedding in such a case presented the family with a fait accompli they had to accept.[50]

Seven of the clandestine marriages documented in the register took place in Reimerswaal on an island of the same name in South Beveland (neither the island, absorbed in the process of land reclamation, nor the town, destroyed by inundation in the sixteenth century, exists today). The journey there from the Brussels region was long and arduous, obliging a couple to travel via Antwerp to Bergen op Zoom in North Brabant (in the diocese of Utrecht, beyond the jurisdiction of the bishop of Cambrai) and thence by water into the Zeeland archipelago. Reimerswaal was thus evidently a favored place for clandestine marriage, with the ceremonies, as mentioned in the register, taking place variously in an inn or a chapel. The case of Elisabeth Winrix and Gilles de Ghesterle is fairly typical. Because the bride's family objected to the marriage, the couple eloped to Reimerswaal to be married clandestinely. When the case was brought before the officiality after they had returned home, all the judge could do was to sentence the couple to solemnize their marriage.[51]

The Brussels register also documents the use of clandestine marriage to circumvent known or perceived canonical impediments to a marriage as well as to escape from an unsatisfactory marriage parents sought to impose. But the reason in fourteen of the twenty instances of clandestine marriage was the couple's hope that by entering into an illicit marriage, they might find a way out of an earlier matrimonial entanglement. Catherine Boene, for example, had at first been publicly betrothed to Gommar Naghel. The bans of marriage were duly published, after which the couple held a wedding celebration, but they failed to solemnize their marriage before the festivities. Subsequently, but in a different locality, Catherine publicly contracted a second betrothal, this time to a certain Hendrik van der Velde. The bans were again published, but the marriage was not solemnized, as the couple eloped instead to Reimerswaal for a clandestine ceremony. When the case came before the bishop's court, the judge dissolved the betrothal of Catherine to Gommar, who was awarded as an indemnity four gold florins and half the money he and Catherine had received on their "wedding" day (the other half had been used to pay for the marriage festivities), while Catherine and Hendrik were directed to solemnize their clandestine mar-

riage and to undertake a pilgrimage to Cologne as a moral recompense for the injury done to the unfortunate Gommar.

A second case is of the same general type. Gerard van der Elst exchanged words of future consent with Gertrude Gheerst, but because sexual intercourse followed the betrothal, a presumptive marriage was the result. After five children had been born of his union with Gertrude, Gerard contracted marriage clandestinely with one Margaret Abs at Reimerswaal, with a child subsequently being born of this second union. At a judicial hearing in Brussels it was decided that Gerard should solemnize his presumptive marriage with Gertrude since that took chronological precedence over the clandestine marriage with Margaret at Reimerswaal. But before the sentence was actually promulgated, Gertrude Gheerst took her revenge by also journeying to Reimerswaal, where she clandestinely exchanged words of present consent with one Baudouin van Vorspoel. In the end the clandestine rites in Reimerswaal proved of no avail to either party, for in his final disposition of the affair the judge merely reiterated his earlier decision that Gerard and Gertrude were to solemnize their long-standing presumptive marriage.[52]

It seems reasonable to conclude from the foregoing discussion that the staid, formidable man of mature age depicted in the London double portrait—presumably the wealthy and aristocratic Lucchese merchant Giovanni Arnolfini—is not a likely candidate for an adventure in clandestine matrimony, a category of human experience completely at variance with the social and psychological mentalities the picture embodies, to say nothing of the legal complications for a family of means that might follow from the doubtful legitimacy of children born of such a union. Nor is it really conceivable that a successful and astute businessman would commission from Van Eyck a picture to commemorate a marriage strictly forbidden by the church and considered mortally sinful by contemporary moralists, a marriage that would have to be formalized later by a public ecclesiastical ceremony, and for which he, his wife, the duke of Burgundy's painter, and the other witness as well would incur ipso facto excommunication and be deprived of their right to Christian burial. And it is surely unlikely that Jan van Eyck would willingly have accepted a commission with such unpleasant liabilities attached.

Thus the historical context argues against the London double portrait as representing a clandestine wedding. Indeed, when the problematic and much discussed hand and arm gestures in the picture are contrasted with what is known of marriage ceremonies in the Burgundian Netherlands of Van Eyck's time, it becomes apparent that the picture cannot depict a wedding in any form, for what the artist has shown bears no resemblance to these rites.

Symbolic matrimonial gestures linking the spouses' hands, evidently unknown in the West in the time of Nicholas I, seem to have developed as part of the new marriage rite *in facie ecclesiae* and within the framework of a new sacramental theology that evolved during the twelfth and thirteenth centuries. Contemporary discussion among canonists and theologians of how the marriage bond was formed also contributed to this development. Once the word *sacramentum,* as used in biblical and patristic texts on marriage, had been dialectically analyzed, matrimony began to be definitively categorized as one of the seven sacraments, especially with the *Sentences* of Peter Lombard, completed in the 1160s.[53] But contrary views continued to be expressed well into the thirteenth century, in part because the financial arrangements associated with marriage smacked to some of simony.[54] Concurrently, as the classic Augustinian definition of a sacrament as "a visible sign of invisible grace" came under the influence of Aristotelian concepts about matter and form, speculation arose as to which "sensible signs" (that is, things that can be experienced or understood through the senses) constituted the form of the various sacraments, and these "sensible signs" were then viewed as the operative instruments by which sacramental grace was conferred.[55]

In the case of matrimony, the speculative phase was especially protracted, as lawyers and theologians offered differing ideas as to the ceremonial significance of nuptial rites. Not surprisingly, some theologians at first emphasized the nuptial blessing of the ancient Roman liturgy because in their view this priestly blessing was the "sensible sign" of the sacrament, a position still supported by William of Auvergne, an early master of theology at Paris and bishop of the city from 1228 until his death in 1249.[56] Other writers, adopting a juridical perspective, argued instead that the *traditio*—whether understood as the handing over of the bride to the groom or as the mutual giving of the spouses to one another—was the central ceremony of the rite because by this action the marriage was constituted.[57] These earlier opinions were gradually displaced as theological and legal opinion crystallized around the Roman law principle that marriage was contracted solely by the consent of the parties, with the result that the words or other "equivalent signs" expressing the mutual consent came to be considered the form of the sacrament of matrimony as well as what created the marriage bond joining the couple for life.[58] Points of disagreement nonetheless remained. According to a rigorist view advanced by Duns Scotus at the beginning of the fourteenth century, for example, and long supported by Scotist theologians, the form of the sacrament of matrimony consisted of "audible words," and thus, although persons such

as deaf-mutes who were unable to exchange words of consent could contract marriage using equivalent signs, they did not, in Scotus's view, receive the sacrament of matrimony.[59]

The development of European rites for marriage reflects these intellectual currents. Beginning in the latter part of the twelfth century, the liturgical documentation for marriage rites gradually becomes more abundant as the number of surviving texts increases and the rubrics for the ceremonies become more explicit. The evidence is nonetheless fragmentary until after the Council of Trent, for service books with a marriage *ordo* are still relatively rare as late as the early sixteenth century. Marriage rites also continued to develop throughout this period and were subject to wide regional variation. Yet despite these differences, local forms of the new ceremony at the church door often evolved from a common prototype, the marriage of Raguel's daughter Sarah to Tobias, according to the Vulgate version: "And taking the right hand of his daughter, he put it ['tradidit'] into the right hand of Tobias saying: The God of Abraham and the God of Isaac and the God of Jacob be with you, and may he himself join you together and bless you abundantly" (Tobit 7:15).

In early rituals for marriage "in the face of the church" the hand gesture remains a *traditio* gesture, precisely as in the Tobit text, as the father, by placing his daughter's hand into the hand of the groom, transfers his tutelage of the woman to her husband. But this gesture was not the ancient *dextrarum iunctio*, because there was no real joining of hands, and the rubrics do not mention that the right hands were used, apparently considering the issue unimportant, despite the specificity of the biblical description of the marriage of Tobias. By the *traditio* the father did no more than "give the bride away," as is sometimes still said in the English-speaking world. Gradually the ceremony was clericalized, with the priest displacing the father and assuming Raguel's role in giving the bride's hand to the groom, although at first there is no mention that right hands were to be used. This definitive hand gesture as part of the consent rite becomes common only in the fourteenth century, when the rubrics in extant service books first refer to the joining of right hands.[60] The hand gesture then also took on new significance, symbolizing the accompanying exchange of the words of consent, which were couched either as questions addressed to the spouses by the priest—"Will you have this woman for your wedded wife?"—or as a formula repeated by the bride and groom after the priest: "I, *N.*, take you, *N.*, to be my wedded husband." With the couple usually still joining their right hands, the priest then concluded what had become the essential part of the sacramental rite with a liturgical formula either patterned directly on Raguel's words or expressed in a more declaratory form, with phrases like "I

marry you in the face of the church" or "What God has joined together, let no man put asunder." In many rituals a blessing of the couple's joined hands followed at this point.[61]

Thus in northern Europe from the fourteenth century on, the joining of the right hands had a composite meaning: not only did it give visual expression to consent in the present tense, but—because the phrasing of the accompanying words of consent involved the idea of a mutual *traditio* of the spouses and because the joining was frequently followed by a sacerdotal blessing independent of the older benediction given during the Roman nuptial mass—it also epitomized in a single gesture the various theories of what constituted the form of the sacrament of matrimony. The ring ceremony sometimes preceded and sometimes followed the exchange of the words of consent accompanied by the joining of hands; in either case its significance for the transalpine ecclesiastical rite of marriage "in the face of the church" was decidedly secondary.

A very different situation prevailed in those parts of Italy where the older traditions described by Nicholas I were not displaced until after the Council of Trent, when the *Rituale romanum* of Paul V made the northern European rite "in the face of the church" normative in the Latin church. Because this archaic Italian marriage ceremony was often presided over by a notary and commonly took place in the house of the bride's father, it might seem at first that this is precisely what the London double portrait depicts, but as will be explained in the next chapter, any apparent similarities are superficial and coincidental. What needs to be stressed here is that when marriage was contracted according to this rite—whether in a domestic or an ecclesiastical setting, whether before a notary or before a priest—there was no joining of the couple's hands but only the giving of a ring by the groom to the bride, without ceremony and without words, after the consent had been verified by the presiding individual.

This regional difference in the characteristic marriage gesture is exemplified by the way artists represented the marriage of the Virgin. A fragment of a Michael Pacher altarpiece in Vienna (Plate 2) depicts the fully developed northern hand-joining rite as Zacharias, in contemporary pontifical vestments, bestows the concluding blessing.[62] In northern works the high priest often assists even more actively in this conventional joining of right hands by actually bringing the hands together, as in Dürer's print in the *Marienleben* cycle or in Van Meckenem's engraving of the same subject (see Fig. 50). Similarly, in Italian works the priest frequently intervenes directly, grasping the wrist or forearm of bride or groom or of both so as to guide the couple's hands together, but his purpose is not, as in northern art, to effect the joining of right hands, but to facilitate the bestowal of the ring. This ceremo-

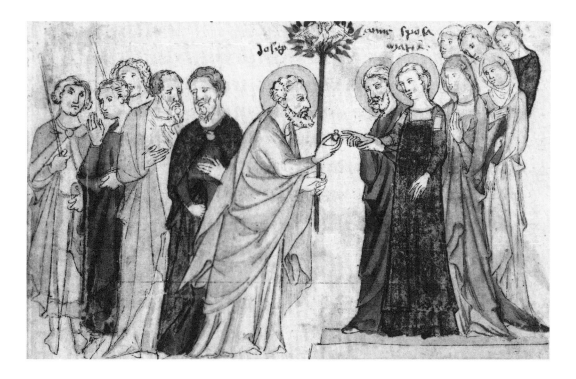

FIGURE 11. *The Marriage of the Virgin.* Italian translation of the *Meditationes vitae Christi,* fourteenth century. Paris, Bibliothèque Nationale, ms. ital. 115, fol. 9r. Photo: Bib. Nat. Paris.

nious intervention of the priest can be seen with particular clarity in a fourteenth-century drawing from the earliest illustrated manuscript of the *Meditationes vitae Christi* (Fig. 11), where the presentation of the Virgin's hand by Zacharias for Joseph's imposition of the ring is still akin to the earlier *traditio* gesture. Although Italian painters commonly show the ring being placed on the Virgin's right hand—as in Giotto's Arena Chapel fresco, Raphael's *Sposalizio,* and Sienese art in general (see Plate 8)—in Florentine works, as exemplified by Fra Angelico's panels in the Prado and the Museo di San Marco or by Ghirlandaio's fresco in the Santa Maria Novella cycle (Plate 3), it is invariably the left hand that receives the ring.[63]

An even more inclusive example of the Italian practice of depicting a ring ceremony rather than the northern hand-joining rite is provided by a richly illustrated Venetian edition of the three-volume corpus of medieval canon law published by Lucantonio Giunta in 1514.[64] Without exception, the thirty-odd woodcuts in this work that illustrate marriage rites center on the bestowal of rings and include such diverse representations as a solemn

FIGURE 12. Clandestine marriage. *Decretales* of Gregory IX, Venice, 1514, fol. 399v.

marriage ceremony before a bishop (see Fig. 25); an illustration of clandestine marriage (Fig. 12) in which a man is about to place a ring on a woman's finger as they stand alone in a room behind a closed and bolted door; and an emblematic image (Fig. 13) intended to illustrate the case of a woman successively married *de praesenti* to two men, each of whom is portrayed in the process of placing a ring on her finger.

The evidence thus indicates that the Western matrimonial joining of right hands was not a survival, or even a revival, of the *dextrarum iunctio* as has generally been assumed since the nineteenth century, for if this ancient matrimonial gesture had survived anywhere, one might reasonably expect to find it in the Italian peninsula. Although it apparently origi-

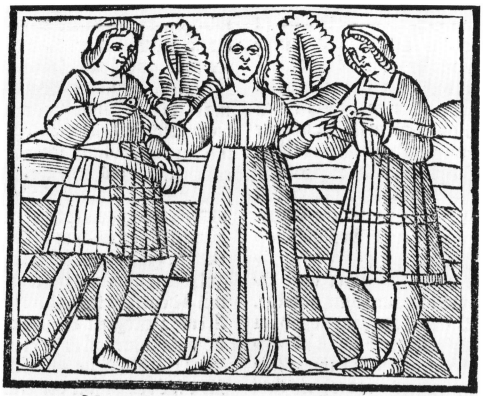

ug. de fide pactionis ꝛ cõ
senfu.

Contrahens succeſſue
per verba de preſenti cũ duo
bus tenetur adhrere dñe.

senfu. Fides autem con
senfus eſt quando non ſtrin
git manum : corde tamen ꝛ
ore conſentit ducere : ꝛ mu/
tuo se concedunt vnus alii

FIGURE 13. Successive marriage to two men. *Decretales* of Gregory IX, Venice, 1514, fol. 400v.

nated in the *traditio,* or transfer of the bride from the guardianship of her father to that of
her husband, the linking of right hands was in fact a new symbolic gesture that arose in
transalpine Europe during the final stage of the development of the marriage ritual "in the
face of the church"; and it signified not so much *concordia* (as the ancient gesture did) as
the mutual consent of the spouses that had become, in scholastic terminology, the essential
form of the sacrament of matrimony.[65]

The iconography of marriage evolved in tandem with the theological and ceremonial
developments outlined above. At the end of the tenth century the subject reappears in
Western art for the first time in many centuries with a representation from the Reichenau

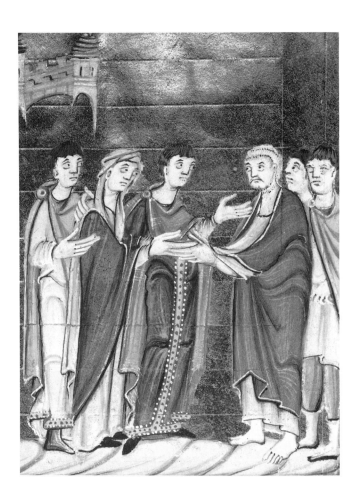

FIGURE 14. *The Marriage of the Virgin.* Gospels of Otto III, Reichenau, c. 1000. Munich, Bayerische Staatsbibliothek, Clm 4453, fol. 28r.

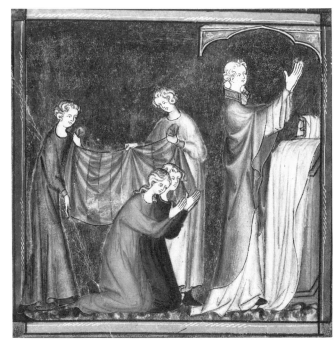

FIGURE 15. Nuptial blessing beneath a veil. Gratian, *Decretum,* French, fourteenth century. Vatican City, Bibliotheca Apostolica Vaticana, ms. lat. 1370, fol. 247v.

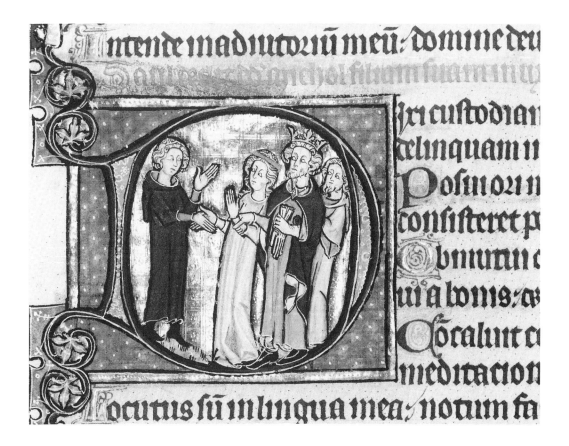

FIGURE 16. *The Marriage of David and Michal.* English Psalter, c. 1310. Munich,
Bayerische Staatsbibliothek, Cod. gall. 16, fol. 35v.

school of the marriage of the Virgin in the Gospels of Otto III (Fig. 14); half a century later
the same composition was repeated in the Bernulfus Gospels, also produced at Reichenau
and now in Utrecht (Plate 4).[66] The officiating priest presides over a *traditio* ceremony in
which Mary is given to Joseph, but the imagery is derived from neither the *dextrarum
iunctio* of antiquity nor the biblical description of the marriage of Tobias. Instead the Vir-
gin's hands, joined palm against palm, are enclosed within Joseph's extended hands, repli-
cating the characteristic medieval *immixtio manuum* gesture with which a feudal lord re-
ceived the fealty of a vassal.[67] Into the fourteenth century, miniatures occasionally depict
the Roman nuptial blessing of the bridal pair beneath a veil (Fig. 15),[68] perhaps reflecting a
continuing currency of the view that this was the essential element in the marriage rite. An
illumination in an English psalter of the early fourteenth century (Fig. 16), however, still
conceptualizes the marriage of David and Michal partly as a *traditio* based on the Tobit text

39

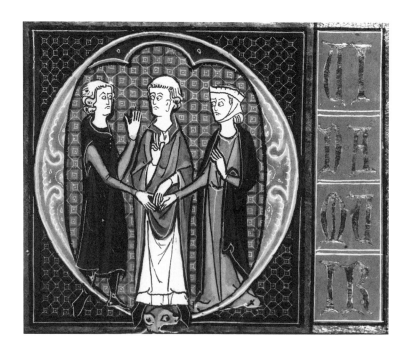

FIGURE 17. Marriage scene. Gratian, *Decretum,* French,
fourteenth century. Vatican City, Bibliotheca Apostolica
Vaticana, ms. lat. 2491, fol. 478r.

(although Saul holds Michal by her left rather than her right hand), but the ritual transfer
of the bride here is subordinate to the more important joining of the couple's right hands
that accompanies the words of consent spoken by David.

Panofsky sought to relate this very miniature to the "Arnolfini Wedding," claiming the
raised left forearm of David exemplified the same gesture as that of the male figure in the
London double portrait.[69] The psalter illumination in fact has its true parallel in similar
French and English miniatures of the early fourteenth century depicting a couple with their
hands joined in the new marriage gesture of consent, usually in the presence of a priest, as
one or both raise their other hand in this way (Fig. 17).[70] The gesture is unrelated to the
London double portrait for it indicates speech and is meant to convey the idea that the
words of consent are being spoken as the hands are joined. Internal evidence in manuscript
psalters helps substantiate this. The miniature in Figure 16 illustrates Vulgate Psalm 38,
whose text has nothing to do with marriage, but just as the descriptive title over the illu-
minated letter, "Saul has given David his daughter Michal as wife" ("Saul dedit David
Michol filiam suam in uxorem"), provides an explanation for the miniature below, so the

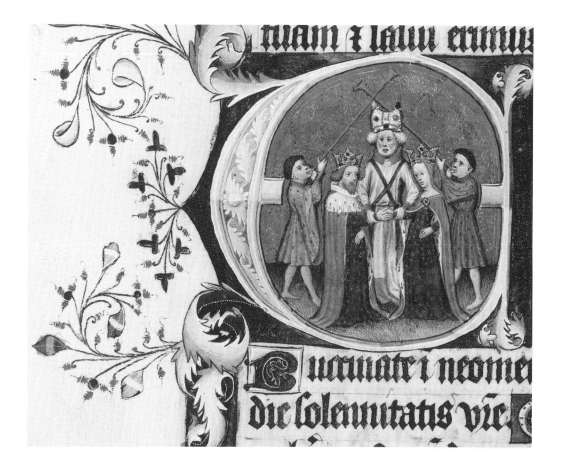

FIGURE 18. *The Marriage of David and Michal.* Psalter and Hours of John, duke of
Bedford, 1420s. London, British Library, Add. ms. 42131, fol. 151v.
Photo by permission of the British Library.

verse directly beneath the historiated initial, "I spoke with my tongue" ("Locutus sum in
lingua mea"), has been exploited as a caption justifying the marriage scene above as an
illustration for this particular psalm.

Reflecting what appears to be a common tradition of psalter illumination, the same ap-
proach is found a century later in another English manuscript that once belonged to the
duke of Bedford. This psalter too is decorated with a cycle of historiated initials depicting
scenes of the psalmist's life, although in this instance the wedding of David and Michal
illustrates Psalm 80 (Fig. 18). Once again the text makes no direct reference or allusion to
marriage, but the verse beneath the initial, "Sound the trumpet on the memorable day of
your solemnity" ("Buccinate . . . tuba in insigni die solemnitatis vestrae"), has been clev-
erly appropriated to warrant the use of subject matter that would otherwise seem irrelevant

41

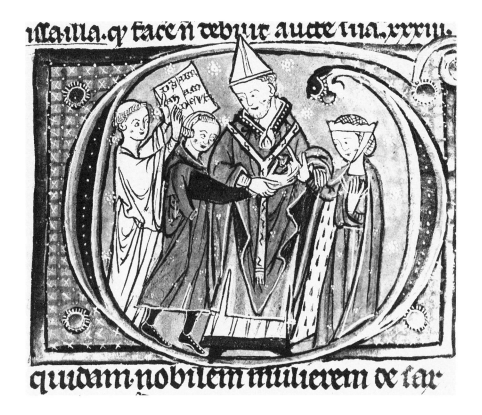

FIGURE 19. Marriage scene. *Decretales* of Gregory IX, English, second
half of the thirteenth century. Hereford, Cathedral Library, ms. O. VII. 7,
fol. 156r. Photo courtesy of the Hereford Mappa Mundi Trust and
the Dean and Chapter of Hereford.

to the psalm text, with the sounding trumpets effectively emphasizing both the solemnity
and the public character of a legitimate wedding.

Relatively rare before about 1300, depictions of marriage ceremonies survive in large
numbers from the fourteenth and especially from the fifteenth century, particularly in the
form of manuscript miniatures illustrating a great variety of religious as well as secular texts.
While representations of other aspects of the rite are occasionally encountered, the over-
whelming majority of those with a transalpine provenance show the bride and groom
standing side by side with their right hands either joined or about to be joined together by
the priest, thus focusing on the central moment of the ceremony, the quintessence of what
had come to be a sacramental rite.

The iconographic tradition is conveniently illustrated by several examples. A depiction
of an aristocratic couple whose hands are joined by a bishop in an English miniature of the
second half of the thirteenth century in the Hereford Cathedral Library *Decretales* (Fig. 19)

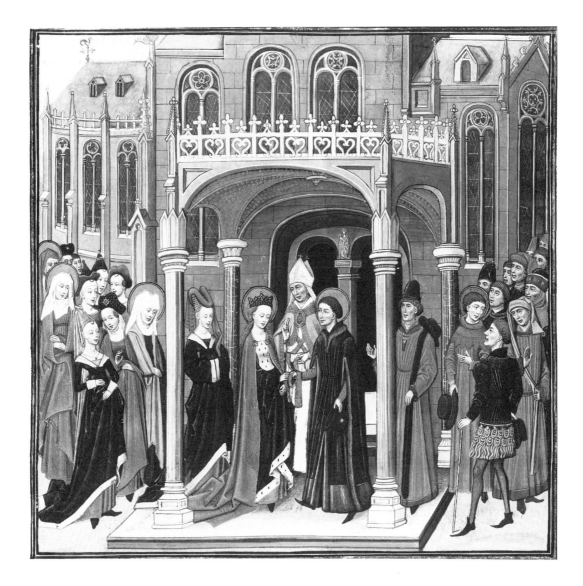

FIGURE 20. *The Marriage of Saint Waudru. Chroniques de Hainaut,* vol. II, Bruges, 1468. Brussels, Bibliothèque Royale Albert I^{er}, ms. 9243, fol. 103r.

is an unusually early instance of this iconographic type.[71] By the first decades of the four-teenth century, however, as exemplified by the French miniature in Figure 17, the type becomes common. The *Marriage of Saint Waudru* miniature from an important fifteenth-century Burgundian manuscript of the *Chroniques de Hainaut* (Fig. 20) vividly depicts a marriage ceremony *in facie ecclesiae* celebrated before a bishop within a church porch and in the presence of numerous guests, still segregated by gender as in the Santa Maria Maggiore mosaic (see Fig. 9). In the *Sacrament of Marriage* woodcut (Plate 5) from a Seven Sacraments cycle with Old Testament antetypes in the Paris 1492 *L'Art de bien vivre,*[72] the

scene of the priest joining the couple's hands in marriage replicates the vignette image above it that depicts the divine institution of marriage in the Garden of Eden, according to a common medieval exegesis of Genesis. The northern European iconography for representing marriage as a sacrament is thus constant in its essentials from the end of the thirteenth to the end of the fifteenth century, the only notable variants being the position of the bride, who may be depicted to the right or left of the groom, and the site of the ceremony, which in some places was moved from the entrance or porch of the church into the interior of the building, as is apparently the case in Plate 5.[73]

Within this larger context of continuity the specific details of marriage rites varied considerably from place to place during the later Middle Ages, but they were generally similar, if not precisely the same, within a given ecclesiastical region. Thus an *ordo* for matrimony in a *rituale* printed shortly after 1500 for use in the archdiocese of Reims, the metropolitan see of the ecclesiastical province in which Bruges and Ghent were then located, comes reasonably close in time and place to the Arnolfini double portrait. The rubrics of the Reims marriage service give an especially symbolic twist to the joining of the right hands, directing the priest to place the end of his stole over the joined hands of the bridal pair as they individually repeat the words of consent.[74] Although this ritual element is not found in the marriage *ordo* of a fourteenth-century missal once used in the cathedral of Tournai,[75] it does appear in a service book issued by the first bishop of Ghent in 1576, as well as in a *Manuale pastorum* published in 1591 for the diocese of Tournai. The Ghent and Tournai rites are virtually identical, and both are noteworthy for the introduction of a subtle but significant variation in the rubrics that accompany the joining of hands. Whereas in the Reims prototype the stole is merely placed over the hands, in the Ghent-Tournai rite the priest, having joined the hands, is directed to wrap the stole around the hands, binding them together in a symbolic way, as seen in Figure 20.[76]

It so happens that the Arnolfini double portrait is both preceded and followed by a famous Netherlandish painting in which this symbolic binding of the hands by the priest's stole is shown: Campin's *Marriage of the Virgin* (Plate 6) in the Prado, most likely painted a few years before the Arnolfini double portrait, and the marriage scene in Rogier's Seven Sacraments Altarpiece (Fig. 21) in Antwerp, completed shortly after the London painting. The currency of the stole-binding rite is thus documented with certainty in the diocese of Tournai during the 1430s, and since Rogier used the joined and bound hands to epitomize the sacramental aspect of marriage, its absence in a marriage picture by Jan van Eyck would be highly unusual and difficult to explain.[77]

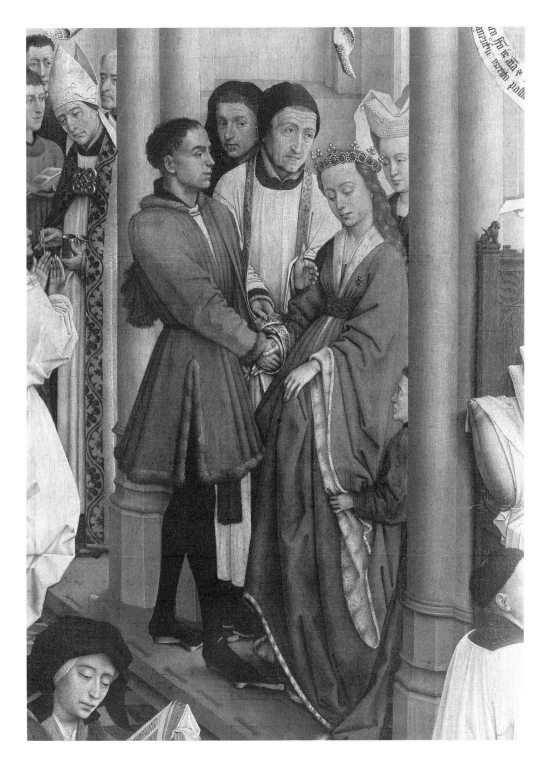

FIGURE 21. Rogier van der Weyden, *The Sacrament of Marriage,* detail of the Seven
Sacraments Altarpiece, c. 1448. Antwerp, Koninklijk Museum voor Schone Kunsten.
Photo copyright A.C.L. Brussels.

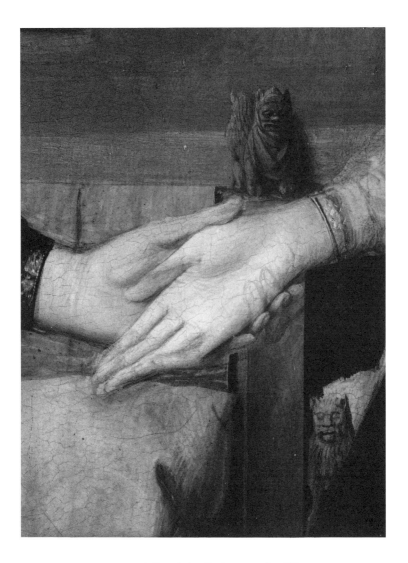

FIGURE 22. Infrared detail photograph of Plate 1.

When the sacramental joining and binding of hands of the contemporary Flemish marriage ritual is compared with what is depicted in the London double portrait, it is evident that the hand gesture in the latter cannot represent the matrimonial joining of right hands for two reasons. In the first place, as has often been noted, it is not the man's right hand but his left that is in contact with the woman's right; all the attempts to explain the anomaly are unsatisfactory. Initially Panofsky himself suggested that the substitution of the man's left hand for the right was merely the result of artistic license, motivated by compositional considerations. Subsequently he cited the "not infrequent" linking of the left and right hands of husband and wife "often found" in English funerary monuments. But the docu-

mentation supporting these statements provides only conventional examples of the joining of right hands (as in Fig. 3).[78] In an addendum to *Early Netherlandish Painting* Panofsky returned to the problem, making reference to an Avignon marriage ritual in which the groom's left hand is indeed joined to the right hand of the bride. But rituals of this type are irrelevant to the Flemish context of the London picture, for they are peculiar to a few localities in the south of France, and the substitution of the groom's left for his right hand was evidently no more than a convenience, since the rubrics require the couple to turn and walk away from the priest with their hands still joined together.[79]

A further anomaly about the hand gesture that compromises the interpretation of the painting as a marriage picture has sometimes been noted in passing but without the obvious conclusion being drawn. Panofsky, for example, with a characteristically clever turn of phrase, remarked that the "husband gingerly holds the lady's right hand." Friedländer referred to the man "reaching out to her with his hand, against which she shyly and reluctantly lays her own," and Weale once wrote of the woman's hand that she "has laid hers in his left, stretched out towards her."[80] And in the 1523/24 inventory of Margaret of Austria's collection, which contains the earliest extant reference to the gesture, the central action of the double portrait is described as "ung homme et une femme estantz desboutz, touchantz la main l'ung de l'aultre," that is, "a man and a woman standing, the one touching the hand of the other."[81] To hold gingerly, or to touch, or to lay one's hand "shyly and reluctantly" on another's is not to join and bind, as the contemporary Flemish marriage rite demands, and thus what ought to be a joining of right hands, were this indeed the representation of a wedding ceremony, is not even a joining of hands. Finally, as revealed by infrared photography, a pentimento in the London double portrait indicates that the subtle nuances of the gesture were important to the painter (Fig. 22). Two fingers of the man's left hand, which initially extended slightly around and over the bottom side of the woman's hand, were deftly reworked as the picture was being painted, as if to strengthen and clarify the meaning of the gesture as a touching or receiving—as opposed to a joining and clasping—of hands.[82]

BETROTHAL CUSTOM AND THE ARNOLFINI *SPONSALIA*

If the interpretation of the Arnolfini double portrait as a wedding is inconsistent with the arm and hand gestures in the painting and if the reading of the picture as a depiction of a clandestine marriage is incompatible with the harsh opprobrium and legal disabilities then associated with that practice, these difficulties disappear once the London panel is recognized for what it in fact portrays: the conclusion and ratification of the arrangements for a future marriage by a formal *sponsalia*, or betrothal ceremony.

The betrothal context of the picture requires an understanding of the relationship between betrothal and marriage in medieval canon law, which is initially somewhat confusing because of changes in the meaning of various words that remain in common use. "Spouse" and "to espouse," both derived from *sponsalia*, the Latin word for "betrothal," illustrate the problem. "To espouse" once meant "to betroth," rather than "to marry," while "spouse" was formerly synonymous with "bride" or "bridegroom" and designated a person promised in marriage, rather than one who was already married. Prior to the fairly recent establishment of a more restrictive modern usage, these and related words were used concurrently with reference to betrothal as well as marriage. Thus the *Oxford English Dictionary* gives, as the primary definition of "espouse," "to contract or betroth," and it also documents the use of "espousal" well into the nineteenth century to mean betrothal, rather than marriage.[1] Analogous shifts in meaning are common to corresponding words in many European languages. For example, *trauen* in German, *trouwen* in Dutch, *sponsare* in Italian, and *épouser*

in French have all come to mean "to marry," whereas formerly they meant "to betroth." Because these changes had begun to manifest themselves well before the fifteenth century, the vocabulary of marriage is sometimes ambiguous in the period covered by this study, especially when taken out of context.

Panofsky touched briefly on these matters, and his remarks, which are not so much incorrect as misleading, provide a convenient point of departure for a more nuanced discussion. According to Panofsky, in Van Eyck's time "the formal procedure of a wedding scarcely differed from that of a betrothal," and both ceremonies "could be called by the same name 'sponsalia' with the only difference that a marriage was called 'sponsalia de praesenti' while a betrothal was called 'sponsalia de futuro.'"[2] Two initial observations are in order. First, although both marriage and betrothal "could be" called *sponsalia,* they in fact rarely were, particularly in northern Europe after about 1200. Second, despite any superficial similarity between the two, the social and legal implications of the *sponsalia de praesenti,* which constituted a true sacramental marriage, were entirely different from those of a betrothal, or *sponsalia de futuro,* which was never more than a promise to marry at some future time.

Because the canon law of the medieval Latin church was a Roman law system, the essential element in the application of marriage law was always intent, as interpreted in light of local custom. Thus the giving of a ring or the joining of the right hands by a priest did not necessarily imply a marriage, since either might be part of some regional betrothal rite. Conversely, the verb *desponsare,* which in classical usage meant unequivocally "to betroth," was commonly used in medieval Latin to refer to marriage as well. What on the surface appears highly confused was usually clarified by the context. When words of the future tense were employed, as in the statement "I will accept you as my husband," the result could only be a betrothal. But if the consent was couched in the present tense, as in the phrase "I take you as my wife," a binding marriage was contracted.[3] In much the same way we have no difficulty distinguishing a proposal of marriage as a future event from the very different implications of the marriage ceremony itself, just as we would never confuse an engagement ring with a wedding ring.

Put another way, the difference between betrothal and marriage for Van Eyck and his contemporaries was of the same order as the modern distinction between the signing of a purchase agreement and the actual sale of a piece of real estate. To an outsider the two transactions might appear confusingly similar, with the same persons and their representatives concerned with the sale of the same property on two separate occasions. But whereas the second transaction transfers ownership of the property to the buyer and is normally

irrevocable, the purchase agreement, like the betrothal, is no more than a mutual promise to do something in the future. As such it can be broken if the terms agreed upon are not fulfilled, although a buyer who otherwise withdraws unilaterally forfeits the earnest deposited to establish "good faith," as we still say, using the concept of *bona fides* appropriated from Roman law.

By about 1100, as the ceremonies and legal conventions originally associated with betrothal in late antiquity were being transformed into a new marriage rite, it became necessary to differentiate clearly between a betrothal and what now constituted a marriage. The scholastic distinction between present and future consent grew out of twelfth-century discussions that sought to resolve this problem. In contrast to the fully developed sacramental theory of the thirteenth century, according to which the marriage bond was created instantaneously as the parties gave their consent, Gratian, writing around 1140, held that the bond was not formed until after the consent had been ratified by physical consummation. This more traditional and sequential view of how a marriage was constituted did not ask whether the consent was expressed in future or present terms; once consent was given in either form, the marriage was said to have been "initiated" ("matrimonium initiatum"), with sexual union completing the process to form a valid and legally binding marriage ("matrimonium ratum"). When the marriage law of the *Decretum* was modernized by the promulgation of the *Decretales* of Gregory IX in 1234, consummation had been virtually eliminated as a significant factor in constituting a marriage, with the full emphasis now placed on consent in the present tense, which in turn was carefully distinguished from the future consent of betrothal.[4]

Since consent in both present and future was also viewed as a contract, beginning in the twelfth century a related distinction was drawn between betrothal and marriage on the basis of *fides* as a pledge to abide by a contractual promise. Thus the giving of *fides* as a promise of future marriage came to be known as *fides pactionis,* whereas *fides* as the matrimonial consent was called *fides consensus.*[5] Both meanings of *fides* have survived into modern English, albeit in largely archaic form. Since "troth" is the English equivalent of *fides,* "to betroth" means to give one's *fides* as an engagement to marry; conversely, if a bride and groom using the traditional wording of the marriage service in the Book of Common Prayer say to one another, "I plight thee my troth," they contract marriage by giving *fides* to each other as the matrimonial consent.

By the thirteenth century both lawyers and theologians were thus able to differentiate precisely between betrothal and marriage on the basis of these distinctions. The *Summa* of Raymond of Peñafort, for instance, written in the mid-thirteenth century and thereafter a

standard work on moral theology, rejects the term *sponsalia de praesenti* as incorrect, indi-
cating that the proper word for marriage is *matrimonium*. Raymond was in this only follow-
ing contemporary usage, for by the thirteenth century *matrimonium* was the common Latin
word for marriage, with its binding obligations and sacramental associations, whereas *spon-
salia,* if used without further qualification, was reserved for betrothal, as in Roman law.
Significantly, at approximately the same time, *De nuptiis* ("On Nuptials"), the old rubric
for the chapters on marriage in the Roman law as codified by Justinian, was dropped in
canon law texts in favor of the dichotomous and more precise *De sponsalibus et matrimoniis*
("On Betrothals and Marriages") found in the *Decretales* of Gregory IX and in all the later
medieval commentaries on canon law. The preferred expressions of careful writers include
sponsalia de futuro for betrothal and *matrimonium de praesenti* for marriage, as well as the
more general, but equally unambiguous, "to contract with words of the future" for the first
and "to contract with words of the present" for the second.[6]

Sponsalia de praesenti nonetheless remained in common usage as a popular designation
for what long survived as the normative form of marriage in some parts of the Italian
peninsula. Where there was continuing political domination by foreigners, as in the south,
the marriage rite "in the face of the church" was eventually adopted in one form or another,
but throughout much of northern and central Italy the old Roman *sponsalia* ceremonies
were accommodated to the new theological and legal ideas about marriage by a modifica-
tion less radical than that in transalpine Europe. In this characteristically Italian rite the
words of consent were accompanied by the giving of a ring, and hence the ceremony was
commonly called *subarrhatio anuli.* As previously noted, that expression originated in the
late Roman betrothal custom—mentioned also by Nicholas I—of presenting the bride
with a betrothal ring as an *arrha,* or pledge that the promise of future marriage would be
fulfilled.

By the beginning of the twelfth century this late Roman *subarrhatio,* or ring-giving cere-
mony, had been transformed into an Italian marriage rite as the result of a development
similar to the concurrent evolution of the church-door marriage rite in northern Europe.
And because this Italian marriage ceremony remained much closer in form to earlier be-
trothal rites, with the words of present consent normally being verified, at least among the
upper classes, by a notary at the bride's house, *sponsalia de praesenti* evidently arose in
popular usage as a convenient descriptive term for the ceremony.[7] But there is no question
that words of consent in the present tense exchanged in this way constituted a perfectly
licit, sacramental marriage as far as ecclesiastical authorities and canon law were concerned,

provided the other conditions requisite for legitimate matrimony were met. Because it is almost certain that members of the Arnolfini and Cenami families residing in Lucca during the fifteenth century would have been married before a notary in such a ceremony—which to us appears more civil than religious—any possible relationship between this archaic form of marriage still common in quattrocento Italy and what is represented in the London double portrait needs to be examined more closely.

The remarkably traditional character of Italian marriage customs is vividly reflected in Marco Antonio Altieri's description of Roman aristocratic marriage at the end of the fifteenth century, which in its main points parallels the short account of Nicholas I written some six centuries earlier. According to Altieri, young women of noble Roman families were so sequestered that few people knew in which houses eligible females lived, obliging parents to engage a go-between, "some venerable priest or good religious," for example, to conduct the initial negotiations. Once a suitable match had been made through the good offices of the intermediary and the financial arrangements for the dowry and prenuptial gift were agreed upon, the betrothal ceremonies were formally concluded in a church, but without the bride. Sometime during the following week, the notary who had drawn up the betrothal instrument came to the house of the bride for the marriage itself. While a relative of the bride held a sword over the couple's heads, the notary verified their consent *de praesenti,* asking the bride and groom three times in turn whether they wished to take one another for legitimate spouses "according to the laws of the church." After they had answered in the affirmative, the groom placed a ring with his family's coat of arms on the bride's left hand as the notary proclaimed, "What God has joined together let no man put asunder." Following the ring giving, the guests congratulated the bridal couple with best wishes for *concordia* in their marriage. The church ceremony, deferred for as much as a year or more while the bride continued to live with her parents, was part of a ritual procession of great antiquity that brought the bride to her husband's house. On the day appointed for the *nozze,* as this rite with its accompanying festivities was called, the bride, wearing her bridal crown and riding a white palfrey (both emblematic of her virginity according to Altieri), was accompanied by the bridal cortège to the entrance of the church. There she was met by the groom, who led her inside for the nuptial liturgy and blessing, followed by a reminder from the priest about the "nights of Tobias." When the service was over, the bride was ceremoniously conducted to her new home.[8]

Italian service books for localities where this ancient form of marriage prevailed have no separate *ordo* for the marriage rite and contain only the orations and blessing of the old

Roman nuptial liturgy.[9] The evolution of the marriage ceremony proper can nonetheless be traced in notarial sources from Tuscany, if not specifically from Lucca. In the eleventh century the main preoccupation remained the *traditio,* or physical transfer of the wife from her father's hand to that of her husband. For example, in a Florentine marriage instrument of 1071 that shows strong barbarian influences superimposed on a Roman substratum, the father takes his daughter, described as his "mundualda"—that is, a woman whose *mundium,* or tutelage, he holds according to Germanic customary law—by the right hand and turns her over ("et sic dedit et tradit eam") to the groom as his legitimate wife. The groom accepts her along with her *mundium* and with his ring takes her to wife ("et cum anulo suo subbarravit eam"). The remainder of the document concerns the two men's reciprocal gifts of fur cloaks, an exchange that completes the transfer of the bride and her property from the father to the groom. There is no reference whatsoever to words of consent, the willingness of the bride being simply presumed, and the ceremony has no religious framework, save for an opening invocation conventional in legal documents of the period.[10]

Elements of both continuity and change are readily apparent when this eleventh-century marriage is compared with the fifteenth-century marriage rite found in a widely used notary's formulary book "according to Florentine style," which brings us reasonably close to what a marriage must have been like in Lucca during the 1430s. This vernacular order of service for the marriage of a fictive couple named Marietta and Lorenzo carries the title "Matrimonium vulgare" and begins with an exordium read by the notary, not unlike that in a traditional service book such as the Book of Common Prayer. Biblical passages relating to marriage are quoted or summarized, and "holy matrimony," as one of the seven sacraments, is declared so sacred that no one may separate husband and wife for any reason: "What God has joined together let no man put asunder." God and the saints are then invoked that the marriage may be a happy one as the couple grow in love, have the consolation of children along with every other good fortune, and, in the end, save their souls after a long life together. The words of consent take the form of affirmative answers to questions from the notary: "Are you, Marietta, satisfied to consent to Lorenzo as your legitimate spouse and husband and to receive from him the matrimonial ring as a sign of legitimate matrimony, according to the precepts of our holy mother the Roman church?" After a similar question addressed to the groom, the marriage rite ends abruptly, with no words or rubrics specified for the actual giving of the ring. Long and short sample forms for a Latin notarial instrument verifying consent in the present tense follow. The short form, entitled "Matrimony and the Giving of the Ring," epitomizes what was deemed

essential by referring in five different ways to the consent of the spouses in the course of the single sentence that constitutes the entire text: "The lady Marietta and Lorenzo have both together and between themselves with mutual consent contracted legitimate matrimony by words of present tense and by reciprocally giving and receiving the ring."[11]

Thus while the ring ceremony remained a constant element between the eleventh and fifteenth centuries, it eventually became the central symbolic action, eclipsing in significance the previously more important *traditio* ritual. The rite also acquired a solemn religious character, based on the idea that matrimony was a sacrament contracted by the consent of the parties and administered, according to orthodox scholastic opinion, not by the officiating notary or priest, but by the spouses themselves to one another. In some places, notably in Florence, the concluding church ceremony described by Altieri and others was often omitted, but this omission is really not as surprising as some modern historians have thought, for it reflects no more than continuity with a tradition that had prevailed in the time of Nicholas I.[12]

In the *Confessionale* of Antoninus, a vernacular handbook for priests with limited formal training, these matters are explained in a way that is easy to understand. Antoninus does not use *sponsalia de praesenti* with reference to marriage, which he calls instead "matrimonio per parole de presenti." He further recognizes that verification of the matrimonial consent by a notary is the normal practice and notes that both *sponsalitio* (by which he means betrothal in the strict sense) and *matrimonio* may be contracted at any time of the year. In the case of first marriages, Antoninus regards the nuptial mass and blessing as an obligatory part of the *nozze,* or ceremonial transfer of the bride to her husband's house, making it sinful for the bride and groom to omit the church ceremony before consummating the marriage. But this rule applies only "where it is the custom to hear such a mass," clearly indicating that in some places, presumably including Antoninus's own diocese of Florence, the religious service was not considered essential. He notes, however, that the *nozze* may not be celebrated during Advent and Lent or immediately following Christmas, Easter, and Pentecost.[13]

A single-leaf Bolognese miniature circa 1350 (Plate 7), originally illustrating the title "On Betrothals and Marriages" from a manuscript of Johannes Andreae's *Novella* on the *Decretales* of Gregory IX, vividly portrays an Italian aristocratic marriage ceremony conducted before a notary.[14] Several figures, apparently members of the household of the bride's family, view the proceedings from a loggia or balcony above what is evidently intended to be an exterior setting, for in practice such a marriage often took place outside the house of the

bride's parents. The outside setting, like the northern church-door rite, was meant to en-hance the public character of the ceremony, which the miniaturist has underscored by the presence of the crowd, including musicians, particularly the trumpeters on the right, who are reminiscent of those in the English miniature (see Fig. 18) previously discussed. It is the most solemn moment of the rite that is depicted as the groom gives, and the bride receives, the ring, symbolic of their mutual consent, while the notary embraces the couple by placing a hand on each one's shoulder, apparently just prior to some concluding formula like "What God has joined together let no man put asunder," as in the account of Marco Altieri. The high social rank of the participants is emphasized by the falcon held by one of the groom's attendants and by the presence of three bridesmaids who, like the bride herself, wear crowns signifying their virginity.[15] Purses are worn by the groom and two members of his retinue, presumably to collect the dowry agreed upon at the betrothal. The historiated initial below depicts the rite of the first kiss, yet another ceremony of late Roman *sponsalia* that had by now become part of the marriage proper.[16]

The notary's embracing gesture is a particularly striking feature of the miniature. Ap-parently a survival from antiquity, it replicates both the ancient "Concordia" gesture (see Figs. 7 and 8) and the early Christian variant of the same iconography, as exemplified by the Santa Maria Maggiore mosaic (see Fig. 9). The juxtaposition of these ancient works with the Bolognese miniature provides additional evidence that the *subarrhatio anuli* sup-planted the *dextrarum iunctio* as the normative matrimonial gesture in the Italian peninsula. A comparison of the miniature and the mosaic further suggests that the notary's assumption of the father's officiating role in the Italian rite paralleled the priest's replacement of the father in the northern church-door ceremony. And because this development seems to have occurred in both Italy and northern Europe as the result of the transformation of a *traditio* ceremony into a sacramental rite, it serves to underscore the equivalency of priest and notary as public witnesses to the couple's matrimonial consent.

Illustrated manuscripts of Gratian's *Decretum* permit us to trace these Italian upper-class marriage customs one step further. When the section "On Penance" opens with a minia-ture depicting a *quadragesimale,* or cycle of daily Lenten sermons delivered by some promi-nent preacher (Fig. 23), a pair of these sequestered young women, now safely married by the ring ceremony, is sometimes seen sitting discreetly in the audience, still wearing their virginal bridal crowns as they piously wait for the end of Lent to conclude their nuptials with the celebration of the *nozze.*

FIGURE 23. *Quadragesimale* miniature. Gratian, *Decretum,* Italian, fourteenth century.
Paris, Bibliothèque Nationale, ms. nouv. acq. lat. 2508, fol. 286r. Photo: Bib. Nat. Paris.

Because images like the marriage miniature of Nicolò da Bologna (Plate 7) appear as normative in canon law manuscripts, it is clearly anachronistic to take the *subarrhatio anuli* ceremony presided over by a notary for a secular or civil marriage, rather than a religious one, as some modern scholars do.[17] Altieri in fact refers to this domestic rite as a "religiosissimo et venerando sacramento,"[18] and the same ring ceremony is also depicted in Italian works between the fourteenth and sixteenth centuries as taking place before a priest, as for example in a fourteenth-century miniature from a manuscript of Gratian's *Decretum* (Fig. 24), or in a woodcut representing such a marriage before a bishop in the 1514 Giunta edition of the *Decretales* of Gregory IX (Fig. 25), which illustrates the same title of the canon law as the Bolognese miniature in Plate 7.

An unusual *Marriage of the Virgin* by Niccolò di Buonaccorso (Plate 8) provides yet another variation of the type. In contrast to the conventional iconography for this subject, which localizes the event within a setting the viewer is meant to associate with the Temple precinct, Buonaccorso has generalized an exterior setting, with a fine Turkish carpet laid out on the pavement before what is evidently the house of the bride's parents, thereby

FIGURE 24. Marriage scene.
Gratian, *Decretum,* Italian,
fourteenth century. Berlin,
Staatsbibliothek Preussischer
Kulturbesitz, ms. lat.
fol. 6, fol. 278r.

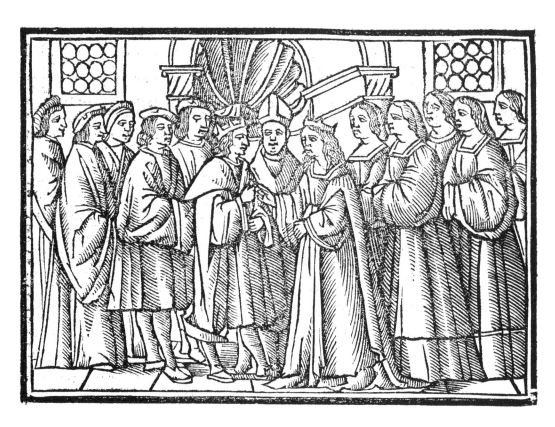

FIGURE 25. Marriage scene. *Decretales* of Gregory IX, Venice, 1514, fol. 389v.

creating a domestic Tuscan ambience for the ceremony. His representation of the biblical narrative thus closely resembles the marriage in the Bolognese miniature, the only major difference being the substitution of the high priest for the notary. And because Buonaccorso's picture, as the central panel of a triptych, was originally flanked by panels with the Virgin's Presentation and Coronation, a fourteenth-century viewer would not have found it secular or wanting in religious sentiment.[19]

The medieval notary was by definition a *persona publica* competent to issue valid public instruments, which he authenticated by his signature and by drawing his distinctive *signum,* or sign, in the lower left margin of the document, as may be seen in the betrothal instrument in Figure 28. A notary acquired this public authority by license from the pope or the emperor, and by the thirteenth century canonists like Hostiensis and Durantis held that documents drawn up by a notary so commissioned were universally valid, even in lands not subject to papal or imperial jurisdiction. To enhance their status, notaries commonly obtained both imperial and papal authorization for their activities, and instances of this double commissioning of notaries are found even in Flanders by the fourteenth century.[20]

In Italy, not surprisingly, the notary—who often would have been commissioned by the pope himself—had long been held equal to the priest as a public witness to a couple's matrimonial consent. Alexander III, the principal papal architect of the new canon law on marriage that developed in the second half of the twelfth century, casually acknowledged this equivalency when he included among the customary solemnities of marriage the exchange of present consent "in the presence of a priest or of a notary, as is done in some places up to the present time."[21] Centuries later, Florentine synodal legislation of 1517 stipulated that no one should contract *sponsalia de praesenti* without first calling "his priest or a notary" to verify the consent.[22] At a time when neither ecclesiastical nor civil authorities kept marriage registers, Italian families of means understandably preferred the notary to the priest, for as a legal practitioner, the notary could also redact a notarial instrument of consent in the present tense, thus verifying that the marriage had actually taken place and completing the dossier of marriage documents he had previously prepared.

Gene Brucker's *Giovanni and Lusanna,* an account of a Florentine mésalliance of the mid-quattrocento, documents the role of the notary from an inverted perspective. When Giovanni della Casa, an upper-class Florentine, sought to continue his liaison with a married woman of artisanal circumstances after her husband's death, the woman's brother insisted on a marriage now that his sister was widowed. Giovanni balked at the presence of a notary at the private ring ceremony, but he did agree to have a friar come from Santa Croce to verify the consent.[23] In this way Giovanni avoided a legal record of the marriage, which

enabled him to claim later, when he wished to marry a woman of his own class, that he had not exchanged words of present consent with Lusanna. This case highlights a major difference between marriage before a notary and marriage before a priest: in fifteenth-century Tuscany the former was inevitably documented by an *instrumentum publicum,* whereas the latter generally was not.[24]

Although it is thus hypothetically conceivable that a couple from Lucca living in Flanders might have been married during the 1430s in a domestic rite before a notary, a comparison of the Italian ceremony depicted in a work like the miniature of Nicolò da Bologna (see Plate 7) with what is shown in the Arnolfini double portrait highlights the intrinsic differences between the two representations. Most important, the quintessential ring ceremony that characterizes the Italian rite in contemporary representations is missing in the London panel, an absence that would be doubly problematic were the painting intended as a marriage picture, for the giving of a ring was also apparently part of the contemporary marriage ritual in Flanders.[25] Moreover, there is no indication of a notary officiating at the ceremony to verify the couple's consent. Van Eyck himself could not have fulfilled this role: his florid signature alone would not have made up for his lack of credentials as a trained and publicly authorized legal professional, nor could it have constituted the painting itself a legal document, since the date under the signature gives only the year of the ceremony. Furthermore, the woman in the double portrait does not wear the bridal crown traditional in first marriages and familiar in contemporary marriage rites both in Italy before a notary (see Plate 7) and in Flanders before a priest (see Plate 6 and Figs. 20 and 21). And in striking contrast to the emphatically public character of both the Bolognese miniature and Buonaccorso panel—underscored by the numerous guests, the exterior setting, and the musical fanfare of drums and trumpets—the couple in the London painting are shown in a private domestic interior, ostensibly attended only by the two individuals reflected in the mirror. This emphasis on a private domestic event in fact inspired and continues to sustain the view that the ceremony represented by Van Eyck was clandestine.

Despite any apparent resemblance between the words and ceremonies associated with betrothal and marriage, and regardless of all that has been written to the contrary about the London double portrait, according to canon law and theological opinion in the fifteenth century, the effects and obligations consequent to the two forms of consent were entirely different. Whether called *matrimonium* or *sponsalia de praesenti,* consent in the present tense constituted the essence of the sacrament of matrimony and created the indissoluble

marriage bond that bound the couple together for life, even if a marriage was never consummated. Betrothal, or *sponsalia de futuro,* in contrast, was only a contractual promise to marry at some future time. Commentators on canon law generally highlight the difference between the two with definitions taken from Roman law. *Sponsalia,* they like to say, is "the promise and counterpromise of a future marriage," whereas matrimony "is a joining together of a man and woman, carrying with it a mode of life in which they are inseparable."[26]

The betrothal represented the finalization of the secular aspects of the future marriage, creating a new kinship between the two families and establishing in large measure the future financial and social position of the bride and groom. And whereas *matrimonium* created a permanent bond that in the eyes of the church could not be broken, *sponsalia de futuro,* according to canon law, could be dissolved for a variety of reasons: by mutual consent, for example, or if one of the parties married someone else or entered religious life; if a second betrothal was contracted with another person and this was followed by sexual intercourse, thus creating a presumptive marriage that took precedence over the earlier betrothal; if the agreed-upon dowry could not be paid, or if the time limit stipulated in the betrothal agreement expired; if one of the parties contracted leprosy, or was paralyzed, or suffered physical disfigurement by losing a nose, an eye, or an ear; or if one of the parties moved away and could not be found; or if one of the parties committed fornication after the betrothal, including the "spiritual fornication" of heresy or disbelief.[27]

Scholastic writers between about 1200 and 1500 commonly recognize four ways to contract *sponsalia.* The least formal was a simple reciprocal promise, such as "I will accept you as wife"/"I will accept you as husband." Hostiensis, whose thirteenth-century *Summa* on the *Decretales* remained an authoritative text long after Van Eyck's time, terms such a betrothal "nuda et simplex"—that is, "simple and without formalities"—in contrast to three other forms he designates "firmata et duplex," or "confirmed and bipartite," because the promise of future marriage was reinforced to make the contract more secure.

One way to reinforce the promise was by pledging *arrha sponsalicia*—usually money or jewels—as an earnest that the marriage would take place as agreed. The *arrha* was forfeited if the party pledging the earnest terminated the engagement, whereas the party receiving the *arrha* became subject to double, sometimes even quadruple, restitution for breaking the contract. By the fifteenth century, betrothal *arrha* sometimes took the form of token gifts from the groom to the bride that, given and received, signified the couple's consent to arrangements often made at least in part by other family members. A fifteenth-century

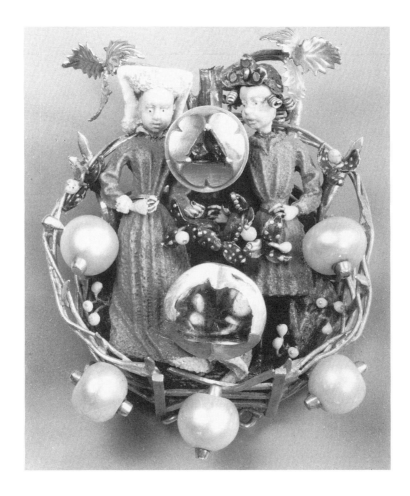

FIGURE 26. Flemish betrothal brooch, c. 1430–40.
Vienna, Kunsthistorisches Museum.

Flemish jeweled and enameled gold brooch in Vienna (Fig. 26) was almost certainly intended for this purpose. As a figurative allusion to betrothal, it depicts a couple generally disposed as in the London double portrait, with the woman extending her left hand to the man as he reciprocates the gesture with his right hand.

Betrothals were also sometimes confirmed with an engagement ring, as in a Nuremberg woodcut of about 1475 by Hans Paur (Fig. 27). In the center field an elegantly attired couple are seated in an open landscape, as the man offers the woman a ring but with no apparent intent of actually placing it on her finger. The twenty-four surrounding compartments, as specified by the inscription, depict some of the possessions the couple will require to set up

FIGURE 27. Hans Paur, German single-leaf betrothal woodcut, c. 1475. Munich,
Staatliche Graphische Sammlung.

housekeeping after the marriage, including a bed and trestle table; tankards, candlesticks,
and other household plate; cooking utensils and agricultural implements; necessities for
personal grooming and hygiene; a horse, saddle, spurs, armor, and weapons for the man;
and spinning and other domestic paraphernalia for the woman.[28]

Although the descriptive expression *subarrhatio anuli* continued to be used for the pre-
sentation of a betrothal ring, theologians and canonists insist on the difference between an
engagement ring, given with words of future consent, and a wedding ring, bestowed with
words of present consent. This same distinction is also commonly expressed iconographi-
cally: the groom is represented placing or about to place a wedding ring on the woman's

finger (see Figs. 11 and 12; Plates 7 and 8), whereas the man merely offers a betrothal ring to the woman (see Figs. 27 and 43), who presumably must take it and place it on her own finger.

In the fourth and most formal type of betrothal, the promise of future marriage was fortified by an oath. Hostiensis equates such a betrothal oath with *fides*, thus using the word with one of its more specific meanings, and in the fifteenth century Antoninus employs the same usage when he says that *fides*, given unilaterally in a betrothal, refers to an oath.[29]

Fides has yet another meaning in the context of a ceremony for public betrothal in the presence of a priest, which provided yet another way to formalize *sponsalia* in northern Europe during the later Middle Ages. First documented in the region around Paris in the second half of the thirteenth century,[30] its use in fifteenth-century Flanders is attested by the register of the bishop of Cambrai's court in Brussels (the reader may recall that Catherine Boene was thus publicly betrothed twice in the course of her matrimonial adventures). Seeking to determine whether either party might already be engaged to someone else, the ceremony sometimes began with the priest asking the spouses individually, "Have you made *fides* with another person?" The betrothal promise, usually specifying that the marriage would take place within forty days, then followed as the couple repeated a set formula after the priest.[31] Although the Ghent *rituale* of 1576 offers a relatively late example, the form these words take in it is nonetheless typical: "I, *N.,* give you, *N.,* whose hand I hold, my *fides* that I will take you as legitimate wife."[32] In an earlier order of service from Amiens the priest concludes the ceremony with the words "Et ainsi se fiancez," meaning literally "And thus you have given *fides* to one another" but conveying as well the modern sense of "And thus you are betrothed."[33] Solemn public betrothal was not, however, thought of as a religious rite, despite the central role played by the priest, since in contrast to any true liturgical ceremony, prayers were normally not used.[34]

It was Marcus van Vaernewyck's 1568 description of the Arnolfini double portrait as the "trauwinghe" of a man and a woman "ghetrauwt" by *fides* that first associated the picture with the concept of *fides*.[35] As suggested above in Chapter 1—where the key passage of the description, to retain something of its ambiguity, was translated "an espousal of a man and a woman espoused by *fides*"—what Van Vaernewyck meant is not entirely clear. For "trauwinghe," like the English "espousal," while still retaining its original meaning of "betrothal," might also refer in the sixteenth century to marriage, just as "ghetrauwt" (like the English "espoused") could mean either "betrothed" or "married."[36] Panofsky's explanation of the central action of the panel was nonetheless based on the assumption that Van

Vaernewyck intended to relate the subject matter of the painting to a marriage, and the confusion was compounded because Panofsky misunderstood the various connotations *fides* then had. Much discussion of the double portrait has now come to be linked with these mistaken ideas. It is true that *fides* can mean an oath, and the man in the London picture is indeed portrayed taking an oath, as Panofsky surmised, but there is nothing in medieval canon law about marriage being "concluded by an oath," *fides manualis* is not referred to in the context of matrimony by any contemporary text, and "fides levata" is no more than an invention of Panofsky's imagination.[37]

The nuanced meanings of *fides* in the framework of fifteenth-century betrothal and marriage have been further obscured by the failure of Panofsky and others to understand the basic scholastic distinction between the *fides* of betrothal (*fides pactionis*) and the *fides* of marriage (*fides consensus*). A standard exposition of the difference between the two in the *Decretales* of Gregory IX begins with a straightforward definition: "*Fides* is spoken of in two ways, for the contract and for the consent"; the definition in turn is explained more fully by the *glossa ordinaria:* "That is to say, one is the *fides* of espousal in the future tense, and the other, the consent in the present tense."[38] By the thirteenth century *fides* was used without further qualification for both the betrothal promise and the matrimonial consent, and a contextual reference is usually needed to separate one usage from the other.[39]

In other respects the basic meaning of *fides* remained unchanged: to "faithfulness," "honesty," and "promise," which are among the primary connotations of the word, Roman law had added the idea of an honest keeping of a promise or the obligations consequent to an agreement—essentially what Augustine meant when he termed *fides* one of three "goods" of Christian marriage. *Fides,* in a somewhat broader medieval usage, meant not only a solemn promise to do something, but—by extension—an oath associated with such a promise or agreement. Thus in a feudal context *fides* can mean either the loyalty of the vassal to the lord or the oath of fealty itself.[40] Similarly, as previously noted, *fides* in scholastic discussions of betrothal can refer variously to the betrothal promise itself or to an oath sworn to confirm the promise of future marriage, in which case the engagement to marry became *firmata et duplex,* as Hostiensis and the canon lawyers would say.

Whether in a particular instance *fides* was the betrothal promise or an oath fortifying that promise, the question remains, if a painter of the fifteenth century wished to represent a betrothal rather than a marriage, what gestures would have been appropriate to signify the giving of *fides?* Actual betrothal instruments survive in substantial numbers from the fifteenth century, but they provide little information about what actually took place at a

FIGURE 28. Betrothal contract of Jehan d'Argenteau and Marie de Spontin, 18 December 1463. Washington, D.C., Library of Congress, Mercy-Argenteau Collection.

sponsalia. A notarial Flemish betrothal contract of 1463 (Fig. 28), for example, is largely concerned with specifying the dowry arrangements for the future marriage of Jehan d'Argenteau, lord of Ascenoy, to Marie de Spontin. What is of interest beyond these legal details is that the document was drawn up by Jacques de Celles, a priest as well as a notary, that the instrument was signed on a road, which is to say in a public place, and that the agreement was made between the groom and the bride's father, Gielle, the lord of Pousseur; Marie herself was not present.[41] Late medieval rituals with an order of service for the newer rite of public betrothal before a priest yield nothing of significance about more traditional ceremonies either, for while they routinely use formulas that equate the giving of *fides* with the betrothal promise, when an accompanying gesture is indicated by the rubrics, it is invariably the joining of right hands, usually by the priest and in obvious imitation of the marriage rite "in the face of the church."[42] Fortunately other sources, both written and visual, preserve the memory of older betrothal gestures associated with the giving of *fides* as a promise of future marriage.

Because betrothal ceremonies are less richly documented than marriage rites, what actually happened at a fifteenth-century betrothal is relatively difficult to determine. The detailed account in a *consilium* of the important Italian jurist Bartholomaeus Caepolla, who was active in the Verona-Padua region in mid-century and died about 1477, is thus of considerable interest. Caepolla's summary begins with a priest standing in a church, before the altar "in the face of the people," and explaining to those present that they have been called together "in this sacred place" to be informed about the dowry arrangements recently concluded between Sempronius and his relatives on the one hand and Titius on the other, according to which Sempronius promises to give his sister Maria in marriage to Titius, who agrees in turn to accept her. The priest asks the two men if this is indeed so, and when they reply in the affirmative, he tells them, "Touch your hands" ("tangatis vobis manum"). After the two men have touched hands, the short ceremony ends, and the guests go to the house of Sempronius for a celebration, in the course of which Maria is introduced for the first time. In the presence of the guests, and holding a cup filled with wine, Titius asks Maria if she is pleased with what her brother and relatives have done. When Maria replies that she is, he offers her the cup, from which she drinks, returning it then to Titius who drinks from the same vessel. Apparently the priest and the ecclesiastical setting serve only to lend greater public authority to the ratification of the contract, for the *sponsalia* is actually effected by the two men's touching hands, with the woman's consent playing a decidedly

secondary role, when—following a time-honored Lombard practice for confirming contracts, as Caepolla notes—she drinks from the same vessel as her husband-to-be.[43]

Altieri also mentions that the groom and the bride's father confirm the betrothal arrangements in a church by a touching of hands, with the bride again absent. Other Italian sources refer variously to similar gestures in the context of betrothal arrangements as *impalmamento* and *toccamano,* and Italian lexicographers note an archaic usage of *toccamano* to mean the "touching of the bride's hand by the bridegroom."[44] Sometimes in this usage the force of "touching" is rather different from that in modern English, for the romance cognates *toccare* and *toucher* can also imply a striking action, as in sounding a bell with a clapper.[45] The gesture stems from a traditional way of ratifying a pact or agreement, a practice to which Accursius, the most important of the medieval glossators on the Roman law, alludes in his apparatus to the *Digest* when suggesting that the word "pactum" derives from a *percussio palmarum,* or "striking of palms."[46] And since by the early thirteenth century, when Accursius wrote this gloss, *fides pactionis* was a conventional Latin expression for the betrothal promise, it would not be surprising if a "striking of palms" constituted one way to confirm the promise of future marriage.

Such a gesture in the context of betrothal was still familiar to Shakespeare and his contemporaries. In the famous scene between Katherine and Henry in *Henry V* (act 5, scene 2) the English king asks the French princess to literally "strike a bargain" as he concludes his proposal of marriage with: "Give me your answer; i' faith, do; and so clap hands and a bargain: how say you lady?" A similar gesture in the context of betrothal is mentioned in Pierre de Larivey's late sixteenth-century comedy *La Constance.* The heroine, angry at not having been consulted and threatening to become a nun, explains to a confidante that financial expediency brought about her sudden engagement to a man other than her beloved. On returning home after concluding the betrothal contract with the groom, the young woman's father informed her in the most forthright manner of what had transpired: "Constance," he said, "I've married you off. See to it that you and your mother have the house in order, and get yourself ready, for this evening our Leonard is coming to see you and to touch your hand" ("te viendra veoir et toucher en main").[47] In French usage of the time "toucher en main" was thus clearly an idiomatic expression that referred to the bride-to-be's formal consent, given by a hand-touching gesture, to a betrothal agreement negotiated between her father and future husband.

What makes these instances of betrothal hand touching particularly interesting is that "touching the hand of one another" is how the inventory of 1523/24 describes what is

happening in the Arnolfini double portrait. Since Larivey's language documents hand touching as a betrothal gesture in colloquial French at the end of the sixteenth century, the odds are that the redactor of the inventory entry still understood what the painting represented and by writing "touchantz la main l'ung de l'aultre"—which is the earliest extant interpretation of what the couple are doing—intended to characterize that the panel portrayed a betrothal.

Visual evidence that touching or striking hands was one way to confirm a betrothal agreement during the late Middle Ages is provided by an illumination in the Codex Manesse, where a young couple contract their own betrothal with such a gesture (Plate 9). The early fourteenth-century miniature illustrates a poem of Bernger von Horheim, in which the poet, about to depart on an expedition to Apulia led by the German emperor Henry IV, takes leave of his beloved by pledging his everlasting love. The short lyric makes no specific mention of betrothal, but that is evidently how the miniaturist read the situation in creating this engaging composition of young lovers exchanging the hand-touching gesture under a stylized tree.[48] Although manuscript painters were not always adept at rendering hands, so that there is considerable ambiguity at times about what an artist intended, such is not the case with the Von Horheim miniature, which is the work of an accomplished artist, the "Maler des Grundstocks," who was the principal illuminator of the Codex Manesse. And since elsewhere in the manuscript the same master has skillfully depicted half a dozen hand-clasping gestures that are unequivocal in meaning, it is reasonable to conclude that what is portrayed in this miniature was meant as a touching or striking of hands, rather than a handfasting or handshaking gesture.[49]

The casual attitude toward the woman's consent in several of these examples is by no means exceptional. Scholastic authors sometimes take up the question of a woman who is too embarrassed or timid to speak up in the course of negotiations concerning her betrothal and eventual marriage. The issue is discussed in a gloss to the *Summa* of Raymond of Peñafort that provides further information about the gestures appropriate to betrothal. "What if a man," asks the glossator, "laying or fastening his hand on the hand of the woman, says, 'I give you *fides* that I will accept you to be my wife,' and she says nothing— are *sponsalia* contracted?" His answer is that the woman's consent may be presumed if she acquiesced or did not disagree when the marriage arrangements were being discussed before the *fides* was given, "especially," he adds, "if she will have freely given her hand, as required for the receiving of *fides*."[50] In discussing the same problem in the fifteenth century, Antoninus hedges at first, thinking that if the woman does not audibly respond to the groom's

words of betrothal, there is no *sponsalia,* but in the end he repeats almost verbatim the passage just quoted from the Peñafort gloss, although without acknowledging his source, which might well be yet another author.[51] According to Ferraris's *Prompta bibliotheca* the same gesture as a sign of betrothal consent was still current in the eighteenth century, for the article on *sponsalia* in this popular clerical encyclopedia notes that a couple "may be presumed to have contracted a betrothal when the stretching out of the hand of one party is accepted without contradiction or resistance by the other party."[52] No reference is made anywhere in these texts to which hands were to be used, suggesting this was of no particular significance when contracting *sponsalia.*

The evidence presented above establishes a framework for understanding what Van Eyck intended to represent in the Arnolfini double portrait. The giving of *fides* in the context of *sponsalia* was synonymous with the betrothal promise, regardless of whether the *sponsi* themselves acted or others, such as parents or guardians, acted on their behalf. The function of any gesture accompanying the giving of *fides* was to indicate the consent of both parties to what was being done. And although this could be effected in various ways, including a joining of right hands in imitation of the marriage rite—as in the new form of public betrothal before a priest that had developed by the late thirteenth century—a more tradi-tional gesture, carried out either in private or more publicly before witnesses, involved extending one's arm toward the extended arm of the other person in order to touch or strike hands or to lay one hand against another. The Flemish betrothal brooch in Vienna (see Fig. 26) apparently depicts a gesture of this sort.

Iconographic corroboration for the use of related betrothal gestures is provided by two important Franco-Flemish manuscripts of Boccaccio's *Decameron* in the French translation prepared by Laurent de Premierfait in 1414 for the duke of Berry. The earlier of the two manuscripts (Pal. lat. 1989 of the Vatican Library) was illuminated by the Cité des Dames Master for John the Fearless of Burgundy shortly before the duke's death in 1419, whence it passed to his son and successor, Philip the Good. The illustrations of the second Boccac-cio manuscript, Bibliothèque de l'Arsenal ms. 5070, are attributed to the anonymous min-iaturists known as the Mansel Master and the Master of Guillebert de Mets working from about 1430 to the 1440s; although the original provenance of the codex is unknown, at an early date it also passed into the famous library of Philip the Good. The two manuscripts, illustrating each of the hundred *novelle* of Boccaccio's masterpiece with a double vignette, are closely related since the Vatican Palatinus served as the model for the decoration of the Arsenal *Decameron,* but occasional differences between them indicate the independence of the Arsenal illuminators with respect to the Vatican prototype.[53] These circumstances, cou-

pled with the miniaturists' accommodation of the French version of the Italian text to a Franco-Flemish setting by repeatedly introducing northern forms of betrothal into their reinterpretations of Boccaccio's stories, bring us close in time, place, and subject matter to the Arnolfini double portrait of 1434.

The miniatures of both manuscripts depict three different but closely related gestures for betrothal, but only by inverting Boccaccio's original intentions. To explain briefly, Boccaccio uses *sposare* loosely with the popular Italian meaning of "betrothal in the present tense," by which he means a true and binding marriage contracted in the characteristic Italian way, by the giving and receiving of a ring. *Nozze,* in contrast, refers in his usage to the subsequent festivities accompanying the *deductio* of the bride to her husband's house; religious rites (with the one exception, in *novella* 2.3, noted below) are not mentioned as part of the *nozze* celebrations in the *Decameron* stories. Although Premierfait's French translation faithfully follows the original text, using *épouser* and *noces* to render their Italian counterparts, the miniaturists routinely take *épouser* to mean a betrothal rather than a marriage. The giving of rings, if mentioned, is suppressed in favor of betrothal gestures, and if a *noce* needs to be illustrated, the artist portrays a conventional northern ecclesiastical wedding ceremony, with a cleric presiding over the joining of right hands, as in the Arsenal Boccaccio illustration of Pampinea's *novella* (2.3), depicting the pope in the process of formalizing Alessandro's and the "abbot's" earlier clandestine marriage (Fig. 29).[54]

The betrothal gestures in the Arsenal Boccaccio (which closely follow those in the corresponding miniatures in the Vatican manuscript) can be categorized according to an ascending order of formality. The least formal type is illustrated by a miniature (Fig. 30) for Elisa's story of the fifth day (5.3), which concerns a young Roman of illustrious family named Pietro Boccamazza, who falls in love with and wishes to marry a young woman of humble origin named Agnolella. When his family objects to the match as a mésalliance and attempts to intimidate Agnolella's father, the lovers flee the city. Soon they are attacked by brigands, separated, and lost in a vast forest, where each has harrowing adventures before they separately find their way to a castle belonging to the Orsini and are reunited. Although at first reluctant, the lady of the castle, on reflection, agrees to help, and Pietro and Agnolella are "espoused" on the spot. The *nozze* are arranged and paid for by the lady's husband, after which she accompanies the couple back to Rome and succeeds in restoring Pietro to the good graces of his family.

Although the text envisions an impromptu marriage *de praesenti* with the lady assisting, the Arsenal miniaturist portrays a betrothal, depicting Pietro and Agnolella outside the castle and without witnesses, executing with their right hands a simple touching gesture

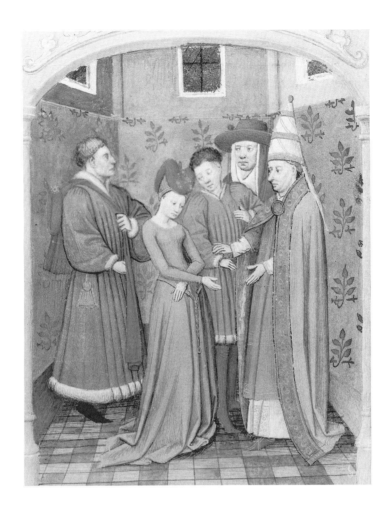

FIGURE 29. Boccaccio, *Decameron* (2.3), c. 1440.
Paris, Bibliothèque de l'Arsenal, ms. 5070, fol. 47r.
Photo: Bib. Nat. Paris.

similar to that in the Manesse miniature (see Plate 9). The circumstances seem to dictate that their betrothal take the form of a simple promise, the *nuda et simplex* betrothal of Hostiensis and the canonists, and this is evidently what the artist has represented. Because their families were not involved, there surely was no marriage settlement at this point and thus no need or desire on the part of the lovers to formalize the betrothal in a more binding manner. Their love was clearly sufficient, and presumably they expected that the marriage would follow shortly through the good offices of the lady.

A second betrothal gesture illustrates Lauretta's story for the fifth day (5.7), which may be summarized briefly as follows. Messer Amerigo Abate, a Sicilian nobleman, purchased as

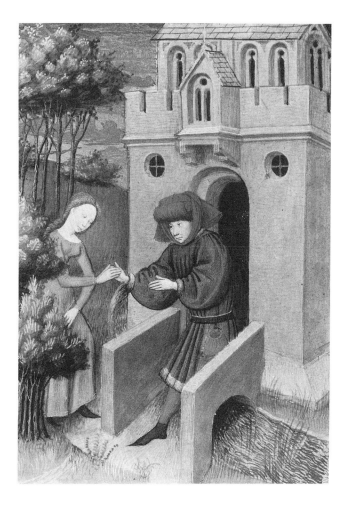

FIGURE 30. Arsenal Boccaccio (5.3), fol. 191r.
Photo: Bib. Nat. Paris.

slaves some children captured by Genoese pirates along the Armenian coast, believing them to be Turks. One of them, a boy named Teodoro, he had baptized as Pietro and raised with his own children. Eventually Pietro fell in love with Messer Amerigo's daughter Violante, who, following a short affair, found herself pregnant. When her father, by accident, discovered her giving birth to the child, he ordered the baby killed and Pietro executed, while Violante was given a choice between two methods of suicide. The tale has, of course, a happy resolution. When Pietro's father, Fineo, who is really an Armenian Christian, appears in town on an embassy to the pope, he chances to recognize his son being taken to his execution, saves him from death, and arranges with Messer Amerigo for the marriage of

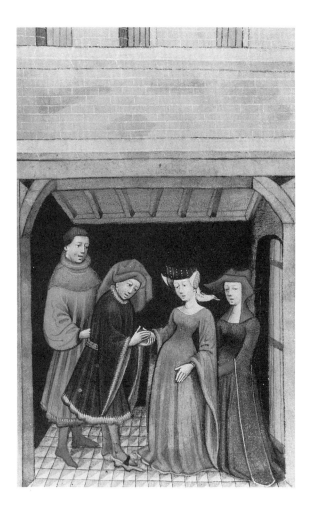

FIGURE 31. Arsenal Boccaccio (5.7), fol. 204r.
Photo: Bib. Nat. Paris.

the lovers. Pietro resumes his former name, Teodoro, and he and Violante, agreeing to what their fathers have arranged, are "espoused." The *nozze* follow later, after Violante recovers her strength and Fineo returns from his mission to Rome.

In the "espousal" miniature of the Arsenal manuscript (Fig. 31), reinterpreted as a betrothal in the strict sense, each of the two lovers is accompanied by an individual of the same sex. These figures cannot readily be identified, although the artist apparently intended the man behind Teodoro to represent Fineo, who appears similarly attired at one of the central windows in the first scene of the double miniature. The gesture depicted is one in which Teodoro gently takes Violante's right hand in his left as they touch right hands. The two witnesses lend the episode a note of formality, but as in the case of the betrothal of

Pietro and Agnolella, the reader would scarcely expect elaborate precautions to ensure that the promised marriage would eventually take place. Even if the fathers later agreed on a substantial marriage settlement, as they would be likely to do given their economic circumstances, the couple were clearly lucky to have escaped with their lives. Besides, they already had a child who would immediately be legitimized, according to canon law, as a consequence of the *matrimonium* of the parents, thus providing an additional reason (from a northern European perspective) for the marriage to take place shortly after the betrothal.

A third miniature of the Arsenal manuscript (Fig. 32) illustrates Pampinea's *novella* for the tenth day (10.7) with a gesture that parallels what is seen in the Arnolfini double portrait. The heroine of the tale is Lisa, the daughter of Bernardo Puccini, a rich Florentine apothecary living in Palermo. Lisa falls in love with King Pietro of Aragon when she sees him fight in a tournament. Realizing the hopelessness of her situation, she sickens and resolves to die, but not before contriving to inform the king of her love. She asks her parents to summon a minstrel with court connections, Minuccio d'Arezzo; he becomes her confidant and conveys her secret to the king. On the very day he learns of Lisa's infatuation, the king rides to Bernardo's house to visit Lisa and inquire whether she is married. As a result, Lisa makes a speedy recovery. Sometime later, having discussed what could be done for Lisa, the king and queen, escorted by a large retinue of barons and ladies, ride to the garden of Bernardo's house. The girl is summoned, and the king explains that he and the queen wish to reward her by providing a husband. When Lisa accepts and her parents approve, the young man, who is "gentile uomo ma povero" and named Perdicone, is sent for and proceeds to "espouse" the girl, with the king presenting Perdicone with the lordships of Cefalù and Calatabellotta as Lisa's dowry. Subsequently, Lisa's parents and the young couple joyfully celebrate the *nozze,* while the king for the remainder of his life considers himself Lisa's loyal knight. For Boccaccio, the garden episode is meant to be a public marriage of the *sponsalia de praesenti* type, celebrated in the presence of the large royal retinue as Perdicone gives Lisa the ring characteristic of the Italian marriage rite, which the king provides at the appropriate moment. The two lordships of "bonissime terre e di gran frutto" that constitute the dowry are not simply promised but really presented, as the circumstances of an actual marriage require.

Laurent de Premierfait's French rendering of this passage closely follows the original Italian,[55] but the Arsenal Boccaccio miniaturist has disregarded the specifics of the text in adapting the scene to a more familiar northern context. Suppressing the ring ceremony entirely, he depicts instead the betrothal of Lisa and Perdicone, who, following a convention

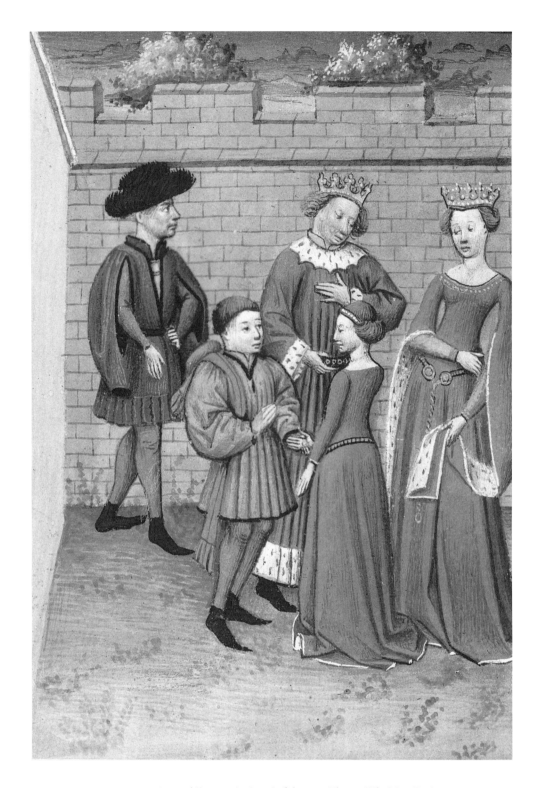

FIGURE 32. Arsenal Boccaccio (10.7), fol. 368r. Photo: Bib. Nat. Paris.

used throughout the manuscript, are represented by their diminutive size as adolescents, with the boy giving *fides* unilaterally in the form of an oath, thereby formalizing and solemnizing this unusual betrothal arranged and presided over by a king and queen.

As visual documentation for the subject matter of Van Eyck's double portrait, the Boccaccio miniatures conveniently bracket the London panel in time, the Vatican manuscript being a decade and a half earlier and the Arsenal codex slightly later. The miniatures are also uncommonly secure in the contextual information they provide, since as a group they can only be taken to represent various betrothal gestures.[56] Although the Vatican prototypes are similar to the Arsenal betrothal miniatures in all essential respects, there is one minor but notable difference. Uniquely, for there is no other instance of this in either manuscript, the king in the Palatinus miniature illustrating the betrothal of Lisa and Perdicone (Plate 10) does actually hold the ring mentioned in the text, but it serves no evident purpose and is not used, as even the French version of the story requires. The suppression of the ring as a superfluous detail underscores the Arsenal miniaturist's independence of the earlier Parisian model, thereby enhancing the validity of the Arsenal illumination as an authentic representation of gestures accompanying a sworn betrothal in a Netherlandish milieu about the time the London double portrait was painted.

The artists of both manuscripts have also followed a northern European tradition in depicting an oath sworn with the right hand raised. Since this swearing gesture requires the use of the right hand, Perdicone must accomplish with his left hand the characteristic betrothal gesture of touching or taking the extended right hand of his *sponsa,* who in giving it to him acknowledges her acceptance of the *fides* as a promise of future marriage.[57] It is in this way, with the same disposition of the hands and arms, that Van Eyck has portrayed the couple in the London double portrait, as their betrothal is fortified with a solemn oath. And just as Van Eyck and the second man reflected in the mirror witness the *sponsalia* of the Arnolfini, so in the Vatican and Arsenal miniatures the witnesses are the king and queen as well as a third individual, who can be identified on the basis of the pendant scene in both manuscripts as the minstrel Minuccio d'Arezzo, whose services made the happy denouement of the *novella* possible.

A miniature in a Froissart manuscript illuminated in Bruges circa 1470 provides a further example of the sworn betrothal gestures of the London double portrait: apparently it was meant to depict Richard II's betrothal to Isabelle of France (Fig. 33).[58] This marriage alliance between the kings of England and France was concluded at Paris in March 1396, when Richard's nephew and trusted confidant, the earl of Nottingham, acting as proxy for his uncle, betrothed the young daughter of Charles VI. The following October the two kings

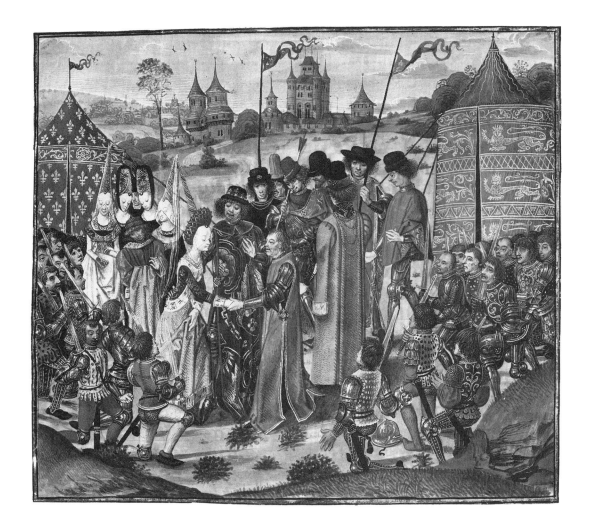

FIGURE 33. "Comment l'ordonnance des nopces du roy d'Angleterre et d'Ysabel fille de France se fist." Froissart, *Chroniques,* vol. IV, Bruges, c. 1470. Paris, Bibliothèque Nationale, ms. fr. 2646, fol. 245v. Photo: Bib. Nat. Paris.

met at a ceremonious encampment in Normandy, on which occasion, according to Froissart, Isabelle was delivered over to Richard by her father and taken to Calais. Several days later, on 1 November, just prior to her seventh birthday, the French princess married the English king in St. Nicholas church in Calais with the archbishop of Canterbury presiding.[59]

The Froissart miniaturist has conflated the events of the two-day encampment into a single composite image, whose historical inaccuracy is readily apparent from the artist's depiction of the seven-year-old princess as a mature woman. Froissart does not mention whether the proxy betrothal, described at length in the preceding chapter of the chronicle,

was repeated at the encampment with Richard acting in his own stead. But the possibility that it might have been is suggested by similar circumstances attending the marriage of Philip the Good to his third wife, Isabel of Portugal, in 1429.[60] In that instance, the duke's proxy, Jehan de Roubaix, actually married the Portuguese infanta "par parolle de present" on 25 July in the royal palace in Lisbon. The following January, shortly after the bride's arrival in Sluis, a second, private, rite was held at six in the morning in the infanta's lodgings, when the "words of the present" previously exchanged by the bride and the duke's proxy were ratified in the presence of the bishop of Tournai, who then celebrated mass. In describing the two ceremonies, the same writer notes that the proxy marriage in Lisbon took place in the presence of "a great number of persons of all estates," whereas "only a small number [were] invited" to the Sluis rite.[61] The betrothal scene the miniaturist portrayed—with the French king turning his daughter over to Richard II, who takes the right hand of the princess with his left as he raises his own right hand (seen in profile beneath the left hand of the king of France) to swear the promissory oath—was thus apparently a plausible illustration for a chapter entitled "How the arrangement for the marriage of the king of England and Isabelle of France was made" ("Comment l'ordonnance des nopces . . . se fist").

In a generic sense, the oath sworn by the man in the Arnolfini double portrait is a promissory oath. In such an oath, God is called on to witness that whatever is promised will be carried out. Scholastic commentators further classify oaths in an ascending hierarchy of formality, based on the manner in which the oath was sworn. The oath of the London picture falls into the highest category and is technically termed a solemn, real oath. A real oath, as distinguished from a verbal oath, was effected solely by some appropriate action or gesture and thus required no spoken words, and because the gesture also served to introduce a ceremonial element into the swearing, the oath became, by definition, solemn as well.[62]

Two different gestures were used when swearing a solemn, real oath in the fifteenth century. More common was the *iuramentum corporale,* or corporal oath, which was sworn by touching the hand to some sacred object—the Gospels, for example, a cross, or the relics of saints—the idea being that from such things "the divine truth shines forth in vestigial form," as one scholastic writer put it.[63] As this was the standard form of the solemn oath in southern Europe, betrothal agreements among upper-class Italian families were customarily confirmed by the bride's father and the groom, each swearing an oath "ad sancti Dei evangelia corporaliter" in the presence of a notary and other witnesses.[64] Since canon law required its use in ecclesiastical courts, the *iuramentum corporale* sworn on the Gospels was familiar in every part of Europe under the influence of the Latin church.[65] But

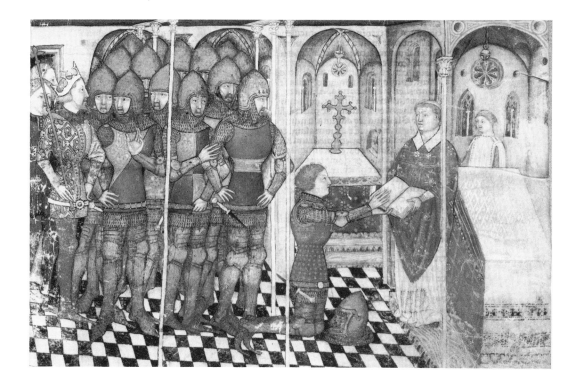

FIGURE 34. Galahad swearing to join the quest for the Grail. *La Geste du Graal,* early fifteenth century. Paris, Bibliothèque Nationale, ms. fr. 343, fol. 7r. Photo: Bib. Nat. Paris.

in the north it was more particularly associated with ecclesiastical affairs, although the laity there sometimes swore promissory oaths in this fashion: a miniature (Fig. 34) in an early fifteenth-century manuscript of the *Geste du Graal,* for example, depicts Galahad swearing on the Gospels, held by a priest, to undertake the quest for the Holy Grail, and a window of about 1500 in the cathedral of Tournai represents a municipal magistrate taking his oath of office the same way, in a church and before a bishop.[66]

A second gesture for the solemn, real oath was peculiar to northern Europe and deemed suitable only for the laity. In this form the oath was sworn by raising the right hand and arm heavenward in imitation of the angel of Apocalypse 10:5–6, who "lifted up his hand to heaven and swore by him that liveth forever and ever."[67] The unusual modern American form of the solemn oath (beginning in the case of inaugural oaths of office with the rubric "Raise your right hand," followed by "I, *N.,* do *solemnly* swear . . .") is a survival of a medieval English usage that combined the tradition of the raised right hand with that of

FIGURE 35. Gerard ter Borch, *Ratification of the Treaty of Münster,* 1648.
London, National Gallery.

the corporal oath. A more typically European distinction between the two forms of the
solemn oath, coupled with a geographic differentiation in use, is conveniently docu-
mented by Ter Borch's *Ratification of the Treaty of Münster* (Fig. 35), where the Spaniards
use the corporal oath (they touch the Gospels) while the Dutch envoys swear by raising the
right hand.[68]

Two images of the swearing Apocalypse angel illustrate regional variants in the position
of the right hand in the northern form of the solemn oath. In a miniature from the Cloisters
Apocalypse (Fig. 36), a fourteenth-century Norman manuscript, all digits of the raised right
hand are fully extended, as is also the case in the Vatican and Arsenal *Decameron* miniatures
(see Plate 10 and Fig. 32), the London double portrait, and modern American practice.[69]
Presumably that was the original disposition of the hand for an oath of this type, since it is
found as early as the Trier Apocalypse of the ninth century. Dürer's *Apocalypse* of 1498
(Fig. 37) documents the development of a variant form used by the late Middle Ages in

FIGURE 36. *Angel with the Book.*
Cloisters Apocalypse, fol. 16r (detail),
Norman, c. 1320. New York,
The Metropolitan Museum of Art,
The Cloisters Collection (68.174).

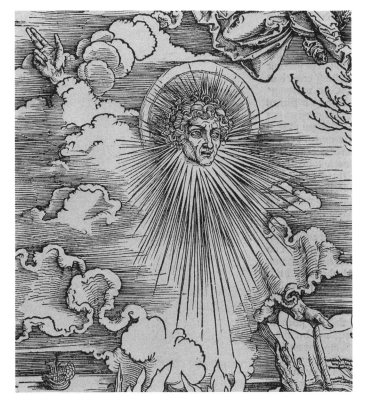

FIGURE 37. *Angel with the Book*
(detail). Albrecht Dürer, *Apocalypse,*
1498. Saint Louis, Missouri,
The Saint Louis Art Museum.

some places when swearing an oath—apparently in imitation of the gesture for sacerdotal benediction (see Plate 2) and perhaps with the intent of Trinitarian symbolism—in which the last two fingers are folded down against the palm and the others extended, as in Ter Borch's picture.[70] This alternative gesture of the raised right hand has survived into the twentieth century in Germany and Holland and was used by Queen Beatrix of the Netherlands when she took her inaugural oath in 1980.

When Van Eyck's double portrait is restored to its proper legal and historical context, the meaning of the picture becomes readily apparent. What the artist has depicted is not a clandestine and illegal marriage but rather a solemn *sponsalia* or betrothal, sworn to by the groom in the presence of two witnesses. The couple touch or lay their hands together in what was then a characteristic betrothal gesture used to express the requisite mutual consent of the couple to the promise of future marriage. When understood in the framework of the contemporary usage of *toucher* in a betrothal context, the couple's action conforms as closely as one could wish with the inventory description of 1523/24: "touchantz la main l'ung de l'aultre." The man uses his left hand to touch the woman's extended right hand because at the same moment he needs his right arm and hand to swear the solemn, real oath that fortifies the *sponsalia* promise and requires from him no verbal formula. An air of solemnity pervades the picture because by his gesture in swearing the oath the groom calls God to witness that the marriage will take place as promised. And because, as previously noted, Antoninus indicates that *fides* was synonymous with a unilateral oath sworn in connection with a *sponsalia,* even Van Vaernewyck's problematic description of the picture makes sense if what he says is understood to mean "a betrothal [*trauwinghe*] of a man and a woman who are betrothed [*ghetrauwt*] by *fides* [i.e. with an oath]."[71]

Referred to in the inventory of 1516 without further qualification as a "chambre," the room in the painting cannot be taken for a nuptial chamber, as has often been argued, since there has been as yet no marriage, nor is this interior intended as a bedroom, as critics have frequently presumed.[72] In fact, the hung bed with its canopy as well as the high-backed chair alongside it in the Arnolfini double portrait are prototypical examples of what furniture historians call furniture of estate. Originating in royal courts of the thirteenth century as a means of expressing in visual terms the owner's "degree of estate," hung beds in particular were so important as status symbols that they came to be displayed in reception chambers as ceremonial objects, not intended for ordinary use. Beds are depicted as an indication of high estate in many presentation miniatures of Franco-Flemish manuscripts with a royal or ducal provenance (Plate 11, Fig. 38), and a hung bed of this type is specifically

FIGURE 38. The author presenting his *Histoire de la conquête de la toison d'or* to the duke of
Burgundy. Flemish, c. 1470. Paris, Bibliothèque Nationale, ms. fr. 331, fol. 1r.
Photo: Bib. Nat. Paris.

described by Aliénor de Poitiers in her account of Burgundian court ceremonies at the time
of the birth of Margaret of Austria's mother in 1456 as "a bed where no one sleeps" ("un
lict où nully ne couche").[73]

By the fifteenth century, the wealthy middle class, particularly in England and the Neth-
erlands, imitated noble courts by adopting furniture of estate. They could do this because
degree of estate was determined not by rank, which was fixed, but by precedence, which
varied with the occasion according to the rank of other persons who were present. The
furniture that was exclusively the privilege of a king or a great lord in his court thus became
the prerogative of a lesser man in the humbler circumstances of his own house and in the

FIGURE 39. Jean Miélot in his study. *Le Miroir de la salvation
humaine,* Flemish, late fifteenth century. Paris, Bibliothèque
Nationale, ms. fr. 6275, fol. 96v. Photo: Bib. Nat. Paris.

presence of his wife and children. Aliénor de Poitiers also mentions the high-backed chair placed beside the bed—just as in the London panel—"like the great chairs of earlier times," suggesting something of the archaic quality a chair like this had acquired by the mid-fifteenth century. According to these same conventions of status and precedence, authors and scribes are sometimes portrayed in frontispiece miniatures of Flemish manuscripts at work in the seclusion of their studies, sitting in an impressive canopied chair of estate (Fig. 39). And indeed, all the hung beds, cloths of honor, canopied seats, and buffets set with plate that are so commonly seen in early Flemish painting would have been immediately recognized as furnishings of estate by a fifteenth-century viewer.[74]

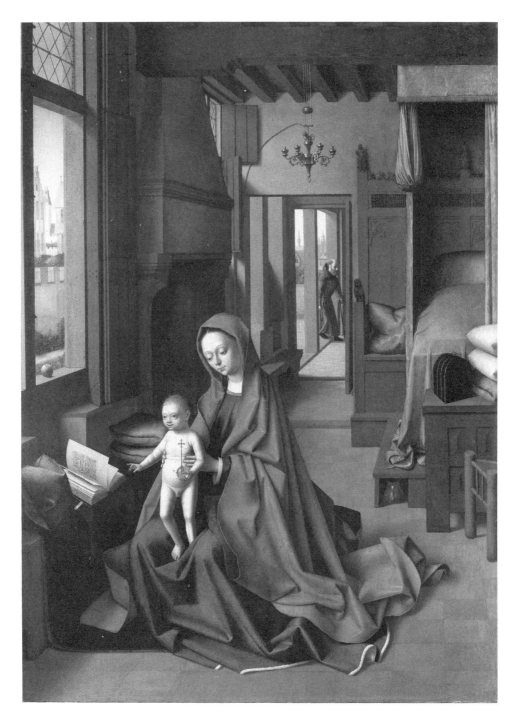

FIGURE 40. Petrus Christus, *The Holy Family in a Domestic Interior,* c. 1460. Kansas City, Missouri, The Nelson-Atkins Museum of Art, Nelson Fund (56-51).

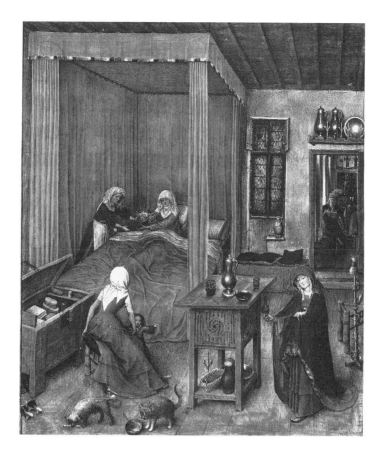

FIGURE 41. Jan van Eyck, *The Birth of John the Baptist.* Turin-Milan Hours, c. 1423–25, fol. 93v. Turin, Museo Civico.

As an important indicator of the owner's status, the hung bed, in a middle-class setting, was normally placed in the principal room of the house. Many examples of this practice can be found in early Netherlandish painting, as in the Kansas City *Holy Family in a Domestic Interior* by Petrus Christus (Fig. 40) and an anonymous Flemish primitive *Virgin and Child* in Turin (Plate 12);[75] in both cases the hung bed is the principal furnishing in what is clearly the main room, with direct access to the exterior of the house by way of the front entrance (see also Plate 13 and Fig. 38).[76] When Flemish works of the fifteenth century depict hung beds in actual use, the context is usually a birth, as in the *Birth of John the Baptist* miniature in the Turin-Milan Hours (Fig. 41), or a death, as in the *Office of the Dead* miniature in the Spinola Hours (Plate 13). On these important social occasions visitors were received in the principal chamber of the house to greet the new mother following her confinement, to assist the dying, or to pay their last respects to the deceased lying in state on a hung bed.

FIGURE 42. Claes Jansz. Visscher, *Prayer before a Meal*, 1609. Amsterdam, Rijksmuseum.

Because, in the words of an authority on furniture of estate, "the canopied bed became inseparably associated with prestige, honour, power, wealth and privilege,"[77] it stands to reason that for rich burghers the hung bed, taken over in emulation of the nobility, continued to have the same social connotations that had led them to adopt it in the first place. This tradition was still very much intact in upper-class Netherlandish households at the beginning of the seventeenth century, as can be seen in an engraving by Claes Jansz. Visscher of 1609 (Fig. 42) that depicts an affluent family at table in a room of patrician proportions with direct access to the exterior that was furnished with an imposing canopied bed (partially visible on the left). Thus as the principal furniture of estate in what is presumably the house of the bride's father, the bed in the London panel provided what must have seemed to a contemporary the most obvious background for a commemorative portrait of the couple's betrothal.

The young woman is apparently at home, while the man appears to be visiting, as suggested by the clogs he has removed on entering. One of the two men whose images are

reflected in the mirror and who by their presence as witnesses further solemnize the engagement is identified with certainty as the painter by the famous inscription on the rear wall. It is impossible to say whether Van Eyck based the painting on his own recollections of the ceremony or worked from a preparatory sketch made at the site, as the silverpoint drawing of the so-called Cardinal Albergati in Dresden might seem to suggest. But when he had finished the painting, he signed it above the mirror with a calligraphic flourish to tell us, "Jan van Eyck was here." There is no way to know exactly what his function may have been beyond that of a simple witness to the ceremony, but the purpose behind the picture clearly involved a studied and conscious commemoration of this betrothal ceremony in a permanent pictorial form.

One can only speculate why the picture was painted, but the improbability of earlier scholarly theories merits passing comment. The double portrait could not have replaced either of the two notarial documents commonly associated with contracting a marriage in the fifteenth century. The inscription records only the year of the adjacent signature, so that the panel is inadequately dated by contemporary standards to serve as a legal instrument. Because there is as yet no marriage but only a betrothal, the painting cannot be a substitute "marriage certificate," replacing the notarial instrument documenting consent in the present tense that was common in Italy. And because it is inconceivable that persons of considerable wealth would agree to a proposed future marriage without a public instrument of the type illustrated in Figure 28, the double portrait just as certainly could not take the place of a legal document of this sort. What the painting does is to record visually the consent of the bride and groom to the betrothal agreement as well as the groom's ratification of the contract by a solemn oath. But that this visual record might have had any legal significance for the two families is no more likely than that the parties to an important modern financial transaction would substitute a photograph of the participants for the customary legal documents.

A further observation about the double portrait is in order. If the Netherlandish ambience of the picture—both clothing and decor—is unmistakable to even a casual observer, the thoroughly northern character of the betrothal itself, including the active participation of the bride and the manner in which the solemn oath is sworn with the raised right hand and arm, is less readily apparent. By contrast, an Italian *sponsalia* was concluded between men in the presence of other male family members; women in general and the bride in particular were not in attendance, at least not among the upper classes. And although the confirmation of betrothal agreements by oaths was so customary in Florence as to give rise

to *giure* or *giuramento* as common names for a betrothal, both parties, not just the groom, swore to abide by the *sponsalia* instrument, and they did so with corporal oaths, as the documents sometimes note.[78] And finally, even though by convention the marriage itself frequently took place at the house of the bride's family and in the presence of a notary, the betrothal was often concluded in a church, sometimes even in the presence of a priest, so as to further fortify the financial agreements that were involved. Italian practice was thus a veritable inversion of what constituted the norm in transalpine Europe and what is seen in the double portrait. If the couple in the London panel are indeed Italians originally from Lucca, everything about the picture attests to individuals whose families, by long residence in Franco-Flemish lands, had become completely attuned to northern ways.

This interpretation conforms closely with what is known of the Cenami in particular. While Paris was the principal center of the family's commercial activities, the grandfather of Arnolfini's wife first established a branch of the family firm in Bruges and in 1381 also acquired a house there. His son, Guglielmo, the father of Giovanna and her five siblings, was registered as a merchant in Bruges as early as 1396. The period from the late fourteenth to the early fifteenth century was a flourishing one for these Parisian mercantile families from Lucca. But as a consequence of the assassination of Louis d'Orléans in 1407, conditions for their activities in Paris became unfavorable for decades, and many appear to have consolidated their operations in Bruges. The Cenami were an exception, most likely because the property they owned in Paris was of great value, and Guglielmo Cenami remained active in the French capital throughout these troubled years. Nonetheless, given the important position of Bruges in the years just prior to the London double portrait and the serious collapse of the Paris market, there can be little doubt that Cenami's affairs often required him to journey to Bruges, thus providing ample opportunity for marriage negotiations between the two families. Not surprisingly, since it was customary for foreigners to live near their compatriots, the Cenami residence in Bruges was in the same quarter of the city as the house of Giovanni Arnolfini, and although no supporting documentation survives, it is reasonable to assume that Guglielmo resided there on occasion with his family.[79]

Besides being solemn promises of future marriage, betrothal agreements were intended to accomplish two further ends. First, they specified in detail the various gifts—principally the dowry from the bride's family and the counterdower from the groom—that created an endowment to support the bride both in marriage and in widowhood, including provision for the inheritance of such property after her death. The notarial instrument that formalized the financial arrangements for Philip's marriage to Isabel of Portugal was, aside from its grand scale, fairly typical. The dowry, or *dos,* from the bride's father was double the dower,

or *dotalium,* provided by the duke himself. Two-thirds of the enormous dowry of 154,000 Tournai gold crowns was payable at the time of the marriage, with the remainder due within twelve months. The dower, in contrast, was to be made available to the future duchess only after her husband's death; meanwhile it was guaranteed by assigning Isabel Malines and two other Flemish towns, which were deemed sufficient to yield an annual income equivalent to 8 percent of the dowry. By further clauses the bride renounced any additional claim on the duke's territories or his personal possessions, while the king of Portugal agreed to provide his daughter with jewels suitable to her status and pay the expenses—which must have been considerable—of her voyage from Portugal to Flanders.[80]

Second, *sponsalia* instruments formalized the new alliance between two families, which frequently was the real purpose behind the marriage, the bride being often a mere pawn in some larger political or economic context. The marriage of Richard II to a seven-year-old French princess, negotiated with the hope of ending the Hundred Years' War, is no more than an extreme instance of this. Thus when a betrothal rather than a wedding was depicted (the Froissart miniature in Figure 33 is a case in point), it seems clear that these financial and secular aspects of a marriage alliance were being commemorated.

The surviving northern works of the fifteenth century that come closest in intent to the London panel are a Nuremberg betrothal portrait of 1475, now in Dessau (Fig. 43), and the small double portrait of Wilhelm Schenk von Schenkenstein and Agnes von Werdenberg in the Fürstenberg collection (Plate 14).[81] In contrast to Flemish and particularly Italian custom, in Germany a ring was associated more with betrothal than with marriage. Indeed, most early German service books do not even mention a wedding ring; the few that do include a blessing of the ring but are silent on what is to be done with it.[82] Evidently the modern German practice of using the engagement ring also for the wedding ring and distinguishing between the two on the basis of whether the ring is on the left or the right hand was already well established by the fifteenth century. When an early German wedding service contains a ring blessing, the priest must have performed this rite as the ring was moved from the left to the right hand. Like the Hans Paur woodcut of approximately the same date (see Fig. 27), the Dessau panel memorializes the couple's betrothal by depicting the offering of a ring—which the woman must take and place on her hand to indicate her consent.[83] Like the London panel, the Dessau double portrait records only the year, underscoring the commemorative—as opposed to any possible legal—character of the picture.

As for the Fürstenberg double portrait, the man's fur-edged outer garment and straw hat closely resemble what the male figure in the London panel wears, while both women have their hair similarly dressed and loosely covered with a veil instead of wearing the traditional

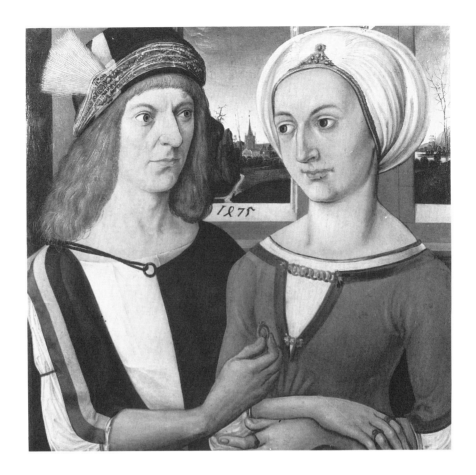

FIGURE 43. Master of the Landauer Altar, Double Portrait, Nuremberg, 1475.
Dessau, Anhaltische Gemäldegalerie.

bridal crown so often seen in contemporary depictions of a marriage (see Figs. 20 and 21; Plates 6 and 7). The Fürstenberg panel also emphasizes the new familial alliance by the armorial bearings prominently displayed beneath the two figures, and the coral rosary being given to the *sponsa* is most likely intended as a betrothal *arrha*.

To an even greater degree than in northern Europe, betrothal customs in Italy stressed the formation of a bond between the contracting families, and that is why as many male relatives as possible from both families were present at the *sponsalia*. They came to witness the creation of a new *parentado,* or kinship group, that bound them together; in Rome this familial tie was publicly acknowledged by the custom of the *baso de bocco,* as the bride's

father and the groom symbolically exchanged a ceremonial kiss on the mouth.[84] In its presumed Italian context, the London double portrait's emphasis on the betrothal stems from a long tradition among Italian mercantile families, richly documented in the social history of the fourteenth and fifteenth centuries, of marriage as a means of upward mobility and calculated improvement of a family's resources and social status from one generation to the next.[85]

Besides scattered references from the fourteenth century, little is known of Arnolfini commercial operations in northern Europe before the first quarter of the fifteenth century, when members of the family were active in both Paris and Bruges. The earliest known documents that mention Giovanni di Arrigo Arnolfini date from the early 1420s and indicate that by that time his activities in Bruges as a moneylender and purveyor of luxury goods to the duke of Burgundy were substantial.[86] Thus he was probably born sometime during the last decade of the fourteenth century, suggesting that he would have been in his mid- to late thirties in 1434, the year of the double portrait. The painting confirms this approximate age, for the man appears many years older than the woman, who is still in the full bloom of her youth. Like other contemporaries of similar circumstances, Giovanni Arnolfini seemingly had some difficulties in arranging a suitable marriage. An alliance with the Cenami would doubtless have brought him the financial advantages he might be expected to require, for in addition to whatever dowry Guglielmo provided for his daughter, the Cenami connections in Paris presumably would be useful to Arnolfini in the conduct of his own business affairs. If it is indeed true, as the tradition mentioned earlier relates, that Giovanna was born "ex corona Franciae," she would have been particularly desirable as a prospective bride for reasons of social status and the prestige this could bestow on the Arnolfini name. Quite possibly Arnolfini's own subsequent financial relations with the French king stemmed in part from his marriage to Giovanna. The terms of the marriage settlement are not known, but the circumstances suggest that the parties to this agreement, especially the bridegroom if he really is Giovanni Arnolfini, may have wished to make the promise of future marriage as solemn and formal as possible.

Ambitious Italian men often delayed marrying until they were in their mid-thirties as they continued to seek the most advantageous match; there was also a marked tendency for men to marry up and for women to marry down.[87] Since the Cenami seem to have been considerably more prominent at the time of the betrothal than the Arnolfini, this may well have been the case for the individuals presumed to be depicted in the double portrait,

providing more than adequate reason why Giovanni Arnolfini might have commissioned the painting.

What Van Eyck's double portrait really celebrates is not the sacrament of marriage, as Panofsky and his followers would have it, but rather an alliance between two rich and important Italian mercantile families with all the financial and social benefits that might be expected to accrue therefrom, and what cemented the alliance was not the sacramental rite of the church but this highly formalized, even ceremonious, *sponsalia*. And it was this, rather than the couple's eventual marriage, that the parties especially wished to remember.

PROBLEMS OF
SYMBOLIC INTERPRETATION

Because Panofsky's interpretation of the Arnolfini double portrait provided the framework for the original presentation of the theory of disguised symbolism, it has had consequences far beyond the analysis of a single picture.[1] A few of these will be addressed in this concluding chapter.

The idea that symbols in early Netherlandish painting might be hidden in a sacramental context actually seems to have originated with Max Friedländer, who suggested as early as 1924 that there is "a mood of sacramental symbolism" about the London panel and that thus "even the most humble thing . . . is endowed with the meaning and importance of a ritual object."[2] From this interpretation it was but a short step to Panofsky's assertion that the painting "impresses the beholder with a kind of mystery and makes him inclined to suspect a hidden significance in all and every object, even when they are not immediately connected with the sacramental performance."[3] Initially Panofsky's approach to what he termed "*transfigured reality*" remained tentative and cautious: "I would not dare to assert," he wrote in the 1934 article, "that the observer is expected to realize such notions consciously."[4] But by the time *Early Netherlandish Painting* was written, that is just what he did. Earlier qualification was dropped as the theory became a "principle" that could be applied categorically to the double portrait: "All the objects therein bear a symbolic significance" because the "nuptial chamber" is "hallowed by sacramental associations." And with a rhetorical flourish "disguised symbolism" was ensconced in Van Eyck's world, where, it

was said, "no residue remained of either objectivity without significance or significance without disguise."[5]

Because Van Eyck was further credited with having first "systematized the principle of 'disguised symbolism,'" it followed that such symbols might also be found in other Netherlandish masters. But at this point Panofsky retreated from his universalizing approach, at least with reference to painters besides Van Eyck. Writing about the lilies in the Mérode Altarpiece (see Fig. 47), he noted that if we did not know from hundreds of other Annunciations that the lily was a symbol, "we could not possibly infer from this one picture that it is more than a nice still-life feature." And to deal with such potential ambiguities, Panofsky proposed "the use of historical methods tempered, if possible, by common sense" to ascertain whether a particular object was imbued with symbolic meaning.[6]

In the end Panofsky succeeded in mystifying a whole school of early northern painting, and his views about disguised symbolism have exerted a profound influence on iconographic scholarship for more than half a century. In what follows my purpose is not to engage in a systematic critique of the various symbolic interpretations he proposed, some of which have already been questioned by others. Instead, I take several of these now classic examples of presumed symbolism in the double portrait as a point of departure for further discussion, using them as illustrations of methodologically unsound iconographic interpretation, with the aim of placing the picture in a comparative historical context that offers a better understanding of fifteenth-century mentalities.

It seems appropriate to begin by asking what can be known with reasonable certainty about the relationship between reality and symbol in Van Eyck's work. In contrast to the widely held view that his pictures are replete with hidden meaning, the unequivocally symbolic elements in the painter's work are strikingly commonplace. In the *Adoration of the Lamb* panel of the Ghent Altarpiece, for instance, the individualized saints are identified by a conventional use of traditional attributes: Barbara with her tower, Agnes holding a lamb, the Magdalene carrying an ointment jar, Christopher endowed with gigantic stature, or Stephen using his dalmatic as an improvised container for the stones emblematic of his martyrdom. More unusual but no less certain, the tongue held in a pair of forceps by one of the bishop martyrs standing next to Stephen (Fig. 44) establishes that this figure is intended as Livinus of Ghent, the apostle of Flanders. And although no one could misconstrue the identity of the imposing figures of Adam and Eve in the upper register of the polyptych, the obvious has been confirmed by the illusionistic epigraphic inscriptions "Adam" and "Eva" painted over their heads.

FIGURE 44. Jan van Eyck, Bishop martyrs, detail of the *Adoration
of the Lamb* panel of the Ghent Altarpiece, completed 1432.
Ghent, St. Bavon. Photo copyright A.C.L. Brussels.

In a work like the *Madonna of Canon van der Paele* (Fig. 45) remarkable verisimilitude
creates a disturbing tension for the modern viewer: because the donor, who is depicted as
living and mortal, shares a temporally ambiguous space with the sacred figures, the picture
is mystified for us and seems to demand some symbolic reading. But here too the basic
iconographic conception, found as early as the ninth century in the famous narthex mosaic
of the Hagia Sophia depicting Leo VI prostrate before the throne of Christ (Fig. 46), is
entirely traditional. The figures flanking the Virgin are securely identified as George and

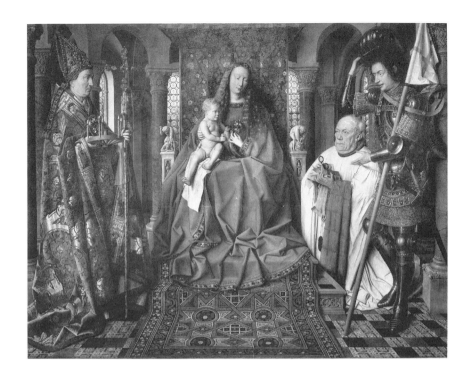

FIGURE 45. Jan van Eyck, *Madonna of Canon van der Paele,* 1436. Bruges, Groeningemuseum. Photo copyright A.C.L. Brussels.

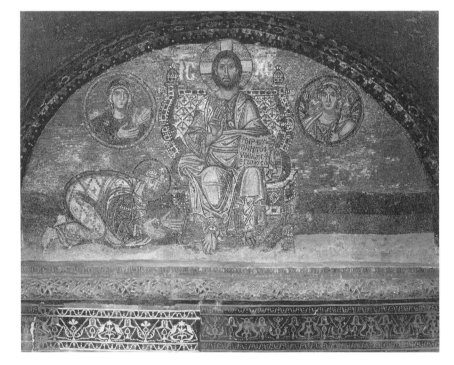

FIGURE 46. Leo VI prostrate before the throne of Christ. Narthex mosaic, late ninth century. Constantinople, Hagia Sophia. Photo copyright 1992, Byzantine Visual Resources, Dumbarton Oaks, Washington, D.C.

Donatian by conventional attributes, including the latter's spectacular wagon wheel embla-zoned with five lighted candles. Still not satisfied, the painter added didactic inscriptions along the left and right sides of the frame, describing Donatian as the first archbishop of Reims and George as the Cappadocian who vanquished the dragon, information that would make these saints recognizable even without their attributes. And as if these inscrip-tions were still not enough, on the frame directly beneath these figures Van Eyck has care-fully inscribed their names: "Saint Donatian Archbishop" and "Saint George Soldier of Christ." Since inscriptions of this type, used in conjunction with otherwise readily identi-fiable saints, pervade the Eyckian corpus from early works like the Ghent Altarpiece to late compositions such as the Dresden Triptych, a fundamental question about Eyckian sym-bolism is simple enough to formulate: Is the painter's mentality, as manifested in these di-dactic inscriptions, which are not far removed in either form or purpose from those in works of art as early as the twelfth century,[7] really compatible with the complex meanings modern critics claim to find in the ordinary household objects depicted in Van Eyck's works?

The problem can be illustrated with reference to a widely accepted example of symbolism in early Netherlandish painting. The laver and basin in the Ghent Altarpiece and Mérode Annunciations (Fig. 47) were interpreted by Panofsky as "an indoors substitute" for the "fountain of gardens" and "well of living waters" that medieval authors took over from the Song of Songs and applied figuratively to the Virgin's purity.[8] In repeating this interpreta-tion, followers of Panofsky have added the towel nearby as a further symbol of Marian purity or virginity.[9] But from the vantage point of Van Eyck's time we can be certain that lavabos and towels were in common daily use for purposes of personal hygiene. Accord-ingly, a lavabo and a towel are depicted side by side—closely replicating the imagery of the Mérode panel—in the border of Hans Paur's betrothal woodcut (see Fig. 27), where they are accounted requisite necessities for any new household. The question thus arises: Is such a lavabo, used to wash what is soiled or unclean, any more likely to have been a symbol of purity or virginity for Van Eyck's contemporaries than a bathtub or washbowl would be for us? Further, since in Panofsky's view we recognize the symbolic character of the lilies in the Mérode Altarpiece only because we infer it from hundreds of other Annunciations, is it really plausible to imagine that a man or woman living in fifteenth-century Flanders, look-ing at the same painting, would have seen in the equivalent of a washbasin something so transcendent as a symbol for the Virgin's purity?

The disparity between the lily and the lavabo as possible vehicles of symbolic meaning is supported by a remark of Joannes Molanus, the earliest Flemish writer to be concerned

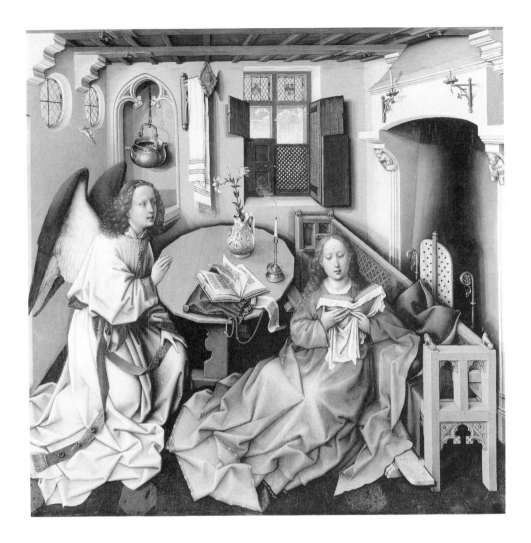

FIGURE 47. Robert Campin, *Annunciation* panel from the Mérode Triptych, c. 1425–30.
New York, The Metropolitan Museum of Art, The Cloisters Collection (56.70).

with Christian iconography. Writing about the Annunciation lily in his sixteenth-century treatise on religious imagery, Molanus explains that such lilies function symbolically because the Virgin did not have artificial flowers and real lilies do not bloom in March (when the Annunciation was believed to have taken place).[10] The success of modern horticulture in coaxing plants to flower out of season may cause us to forget something so basic, but the fact remains that a vase of lilies in an early Netherlandish Annunciation must have seemed as incongruous in the fifteenth century as a decorated Christmas tree would be for us in the context of the Fourth of July. It would thus appear that modern iconographers have inverted the symbolic perspective shared by Van Eyck and his contemporaries: to them it

was the incongruous and anomalous—lilies blooming out of season or bishops carrying tongues in forceps and wagon wheels with lighted candles—that functioned as symbols, whereas what was normative and commonplace in their experience cannot be presumed to have been endowed with symbolic meaning without substantive and convincing documentation.

Notwithstanding a few protesting voices,[11] Panofsky's legacy remains a pervasive force in current criticism of the double portrait in that discussion has continued to center on complex explanations of presumed symbolic or hidden meaning. Some writers have simply assumed that the picture's enigmatic character is intrinsic to the work and was consciously intended by the artist, but others have further dehistoricized the painting by highly speculative arguments that either manipulate historical documentation in unacceptable ways or claim that the meaning of the London panel has changed and become more complex with the passage of time because of inherent qualities that neither the painter himself nor his contemporaries fully realized.

These trends in scholarship and criticism can be illustrated by a sampling of writing about the picture since about 1980. The most recent general monograph on the painter, Elisabeth Dhanens's *Hubert and Jan van Eyck,* published that year, still closely follows Panofsky's original presentation of disguised symbolism, reminding the reader with respect to the London panel that "nothing in the picture is without significance" and "even the simplest of household objects used in daily life have their symbolic significance."[12] Discussing the painting in his 1989 book *The Medieval Idea of Marriage,* Christopher Brooke pushes the presumed inscrutable character of the panel to its logical conclusion when he jestingly complains that Panofsky's "inspired success has largely hidden one crucial element in the picture: that it is meant to puzzle . . . us," while the various enigmatic objects in the work are said to "enforce this fundamental point."[13] And a 1990 study by Myriam Greilsammer on marriage and maternity in medieval Flanders summarizes approvingly all the basic elements of Panofsky's thesis, including the supposedly clandestine nature of what is depicted, adding only some personal observations about "the preeminence of patrimony and the male sex" in the panel and the implied psychological overtones of a picture that in the author's view "presents us with the choice made by urban elites, in conflict with the wish of the church to control the sacrament of marriage."[14]

Other studies over the past decade have suggested further symbolic meanings for objects in the double portrait. An article of 1984 by Robert Baldwin relates the mirror's imagery to Panofsky's assumption about the sacramental character of the painting.[15] Challenging

Panofsky on an important point, Jan Baptist Bedaux rejects the idea of disguised symbolism in a study first published in 1986, but then, under the rubric "the reality of symbols," he proceeds to relate various objects in the picture symbolically to marriage ritual, including the male figure's clothing, which is interpreted as symbolic of the husband's power over and protection of his wife.[16] In the larger context of symbolic readings of early Netherlandish painting in general, others since Bedaux have also challenged Panofsky on essentially semantic grounds, arguing that although symbolic elements are present in these works, the symbols would not have been disguised.[17] Recent interpretations of the London panel by Craig Harbison and Linda Seidel require more extensive comment. Although both authors offer complex symbolic readings of the picture and in this sense remain under Panofsky's influence, they also move beyond the norms within which Panofsky operated, further alienating the picture from its historical context in the process.

In an essay on the Arnolfini double portrait first published in 1990 and then revised for a book that appeared the following year, Harbison begins by approaching the painter's work straightforwardly enough. Expressing his "determination to see with the eyes of a fifteenth-century artist," he disagrees with the "deceptive notion that symbolism can be disguised, or hidden, within realism" and rejects the idea that the double portrait has a theologically complex meaning. The reader is soon surprised to discover, however, that hidden significance abounds in the picture. Because Harbison believes "one likely function" of the painting "was to act as a kind of fertility device," he assigns many of the objects depicted therein—the dog, the bed, the shoes, bare feet ("an almost universal symbol of fecundity"), the fruit, and the candle—a sexual meaning. Yet given the "ambivalent" character of symbols—and the author apparently sees no need to decide in favor of any particular alternative when there is more than one—these same objects might also have, he suggests, a "more pious significance," as in Panofsky's classic interpretation. And although he does not interpret the picture as a contemporary record of an actual marriage ceremony, he nonetheless describes the couple's gestures as having a "calm, even sacramental quality," which is then related to the man's "controlling gesture," as "he calls forth his wife's fecundity."[18]

Harbison's essay concludes with some general remarks about the character of early Netherlandish painting. Since such works "can have multiple meanings for the various audiences for which they were created," Harbison thinks they should be read "as continuing dialogues between art and reality," suggesting that the meaning of a painting may change and grow in complexity with the passage of time, the more so since the implications inherent in any particular image "may not always have been totally intentional or apparent to artist and

patron."[19] Such views, however appropriate to the criticism of modern art, are of dubious application to the works of a fifteenth-century painter like Van Eyck: they can never be historically verified and provide only an ideological basis for saying whatever one wants about a given picture.[20] Moreover, save for the Ghent Altarpiece and possibly the Van der Paele Madonna, Van Eyck's portraits and small devotional panels were created for the private needs of individual patrons, and the mentality of the artist in approaching a commission of this sort must have been more akin to that of a manuscript painter than to that of an artist executing a public monument.

Seidel's highly imaginative approach—expounded in articles published in 1989 and 1991, and the subject of a forthcoming book—eschews any "attempt to reconstruct the original intent" of the Arnolfini double portrait, hoping rather to stimulate readers to come to their own interpretations of a painting that is said to be "a visual enigma, a riddle in which nothing is as it appears to be." Labeling Panofsky's reconstruction "consummate fiction" and adopting the point of view that one "story" about the picture is as good as another, Seidel proceeds to create one of her own.[21] The approach is novel and potentially of great interest in that the argument is developed within a rich historical matrix. But unfortunately, whenever this information is directly related to what is depicted in the panel, the historical component is lifted out of context and misapplied in a way that is analogous to iconographic explanations based on the misunderstanding or misappropriation of theological texts.

According to Seidel, Van Eyck's paintings "do not record events" but "are parts of ongoing transactions." Or again, with specific reference to the double portrait, the panel is said to be "the conflated 'reflection' of . . . a sequence of events." Nonetheless her presentation begins concretely enough, explaining what is depicted on the basis of "Tuscan marriage material," which "emphasizes the domestic ceremony" before a notary and required the consummation of the marriage as a precondition for the payment of the dowry: "We can readily imagine," she says, "that it is Ring Day, around noon." Arnolfini has entered Giovanna's room, leaving his pattens at the door, to consummate the marriage, while the "ruby bedclothes" are said to remind the viewer of the "impending carnal transaction." Extending his hand to his bride, Arnolfini prepares—in Florentine parlance—to "lead her away" (i.e. consummate the marriage), but before proceeding he promises by his right-hand gesture "to uphold the terms of the prior negotiations his family has set."[22]

Seidel's hypothetical reading of the double portrait misuses or misinterprets historical information at every turn. Despite the presumed Italian background of the sitters, Italian

marriage customs, for reasons discussed above, cannot be extrapolated and applied indiscriminately to the northern circumstances of the double portrait. A characteristic example of how Seidel does this will serve to exemplify the problems inherent in her speculative approach.

Central to the argument is the mistaken idea that consummation of the marriage was a precondition for the payment of the dowry, a practice peculiar to Florence in the fifteenth century and not a "Tuscan" tradition, as Seidel claims. What led some Florentines by the middle of the quattrocento to abandon the ancient custom of paying the dowry on the day of the marriage, or ring ceremony, was the establishment of a state dowry fund known as the *Monte delle doti* as a way of financing the mounting public debt of the Florentine commune. In anticipation of a daughter's eventual marriage, fathers were invited to deposit funds with the *Monte* for a specified period, at the end of which the principal and accrued interest were available as a dowry payment to the husband, but—according to the regulations of the *Monte*—only after the marriage had been consummated. In the second half of the century it thus became common practice in Florence among the upper class to consummate a marriage in the bride's family home shortly after the domestic ring ceremony before the notary so that the dowry could be paid to the husband before the *nozze*, or ceremonious transfer of the bride to her new home.

Although founded in 1425, the *Monte delle doti* did not become a successful institution until 1433, when more favorable regulations were instituted, including a lowering of the minimum deposit period to five years. Because there were only two depositors in 1425 and none thereafter until 1429, and since the minimum term for a deposit in this initial period was seven years, only the two dowries covered by the original depositors of 1425 could possibly have been available for payment by the time the double portrait was painted in 1434.[23] The foundation on which Seidel's argument rests is thus undermined for two reasons. The practice of consummating the marriage in the bride's father's home before the payment of the dowry had not yet been established when the double portrait was painted. Furthermore, the practice stemmed from a Florentine institution and is thus irrelevant to the circumstances of families like the Arnolfini and Cenami whose origins were in Lucca, with whom Florence was at the time engaged in a disastrous war that led to a revolution which brought Cosimo de' Medici to power in the very year the double portrait was painted.[24]

What gives meaning to the Arnolfini double portrait is not some hypothetical reading of imagined symbols or postmodern conjecture, but rather the couple's hand and arm gestures, which established the betrothal context of the picture just as clearly for the contem-

FIGURE 48. Jan van Eyck, *Saint Catherine,* detail from the right wing of the Dresden Triptych, 1437. Dresden, Gemäldegalerie Alte Meister— Staatliche Kunstsammlungen.

porary viewer as the Mérode *Annunciation* reveals its unambiguous subject to us. And because the panel represents the formalizing of financial arrangements associated with a marriage alliance, the many readings based on the mistaken assumption that it depicts instead a sacramental marriage rite are without justification.

The comparative approach I advocate for elucidating the meaning of the London panel is readily exemplified with reference to the female figure's supposedly pregnant state. Documented as early as the Spanish royal inventory of 1700, this mistaken inference continues to be drawn by modern viewers seeing the picture for the first time. But among those familiar with Franco-Flemish works of the fifteenth century a consensus has developed that this is not the case, for virgin saints, who obviously cannot be pregnant, also appear gravid in many contemporary representations. The woman in the London panel has thus often been compared with the Saint Catherine in the right wing of Van Eyck's Dresden Triptych, who is similarly portrayed (Fig. 48), as is the bride in the marriage vignette of Rogier's

Seven Sacraments Altarpiece (see Fig. 21) as well as the Virgin and one of her attendants in Israhel van Meckenem's *Marriage of the Virgin* (see Fig. 50). And a protruding belly is seen in many female nudes, including again virgin saints, as in a depiction of the martyrdom of Saint Catherine in the *Belles Heures* (Fig. 49).[25] Whether or not this feature is explained by fifteenth-century perceptions of idealized feminine beauty, these images clearly reflect some contemporary Flemish convention whose precise meaning is no longer readily apparent.

A chapter in Christine de Pisan's *Le livre des trois vertus* devoted to women "who are extravagant in gowns, headdresses, and clothing" provides a useful social context for understanding Giovanna Cenami's attire. Christine, who was familiar with both the French and Burgundian courts earlier in the fifteenth century, regrets that the old rules governing dress were at the time in disarray. Whereas formerly, she says, a duchess would never have dared wear the gown of a queen, just as no countess would have dressed like a duchess, or any ordinary woman like a countess, women (as well as men) now follow the dictates of extravagance, wearing whatever they can afford, no matter how grand or inappropriate to their status: "For no one is satisfied with his estate, but everyone would like to appear as a king" ("Car a nul ne souffist son estat, ains vouldroit chasun ressembler un roy"). Using language that could apply just as well to the gown in the double portrait, Christine epitomizes this sorry state of affairs with an anecdote about a provincial woman of no particular status who had a Parisian tailor make her an extravagant garment of wide Brussels cloth with "bombard sleeves that came down to the feet" and a train so long that three-quarters of its length was on the ground.[26]

Although Christine considered such attire unduly ostentatious, her account makes it clear that by the fifteenth century what was formerly a royal and noble prerogative, with connotations closely related to those of the hung bed as furniture of estate, had been appropriated by the upper middle class as a sign of their own rising social status. The gown's excessive fabric in particular conveyed the message of status. Much like *poulaines,* the extravagantly pointed shoes of the period that served no purpose other than to hinder walking (in extreme instances it was necessary to secure the points by cords to a belt around the waist), the gown, with its voluminous folds, had to be gathered up and held with one hand, thus greatly restricting the wearer's freedom of movement. The purpose behind these conceits of late medieval dress was to emphasize that whoever wore such clothing did not have to engage in any especially strenuous physical activity, let alone do anything that might needlessly be construed as work.[27]

In contrast to Panofsky's familiar interpretation, the wooden clogs or pattens in the lower left corner of the London panel appear to have had a similar function at the time the picture

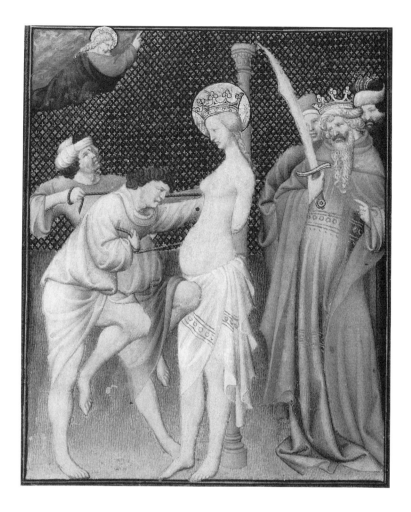

FIGURE 49. Limbourg Brothers, *The Martyrdom of Saint Catherine of Alexandria, Belles Heures,* 1406–9, fol. 17r. New York, The Metropolitan Museum of Art, The Cloisters Collection (54.1.1).

was painted. Because the room depicted in the double portrait was supposedly hallowed by a sacramental rite, Panofsky saw an analogy between the man's discarded wooden pattens and God's command to Moses from the burning bush to take off his shoes because he stood on holy ground, citing in support the Washington *Nativity* of Petrus Christus and Hugo van der Goes's Portinari Altarpiece, where presumably Joseph has removed his clogs for the same reason.[28]

Clogs are in fact a quasi-attribute of Saint Joseph in early northern works, and although they have been removed in the pictures Panofsky cites, Joseph wears them in the *Adoration of the Magi* of Rogier's Columba Altarpiece and in the *Nativity* of the Bladelin Altar, in the Washington *Presentation in the Temple* by the Master of the Prado *Adoration of the Magi,*

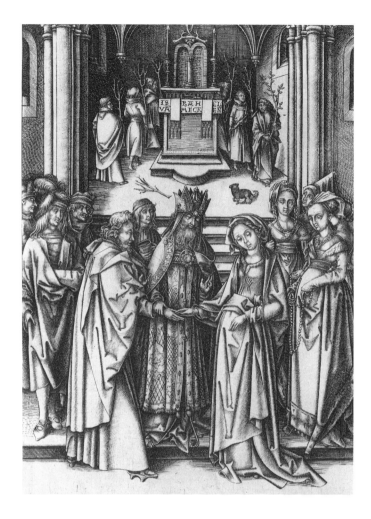

FIGURE 50. Israhel van Meckenem, *The Marriage of the Virgin,* 1490–1500. Washington, D.C., National Gallery of Art, Rosenwald Collection.

in the Berlin *Nativity* of Hugo van der Goes, and in many contemporary depictions of the Marriage of the Virgin, for example an engraving by Israhel van Meckenem (Fig. 50).[29] Even donors are shown with clogs in representations of the most sacred scenes of the Christian tradition: in Rogier's Bladelin *Nativity* and London *Pietà,* for example. No fifteenth-century viewer can be expected to have considered the ground any less holy in these instances than in the examples mentioned by Panofsky, and if sacramental rites so hallow a place that wearers of pattens ought to remove them, what then of Rogier's Seven Sacraments Altarpiece, where both the godfather holding the child over the font in the baptism scene (Fig. 51) and the bridegroom in the representation of the sacrament of marriage (see Fig. 21) wear pattens?

The Arsenal Boccaccio is helpful in understanding what connotation pattens may have had in fifteenth-century Netherlandish society. That only nine of the hundreds of male

FIGURE 51. Rogier van der Weyden, *The Sacrament of Baptism,* detail from the Seven Sacraments Altarpiece, c. 1448. Antwerp, Koninklijk Museum voor Schone Kunsten. Photo copyright A.C.L. Brussels.

figures depicted in the manuscript are associated with pattens suggests that their use was not common. In contrast to short, sturdy clogs like those worn by Joseph (in Fig. 50 or the right wing of the Mérode Triptych), which presumably functioned as practical footgear for workers and peasants, the Arsenal manuscript illustrates another type of patten worn by men of the upper class: like the pattens in the London double portrait, these have a narrow, more elongated shape and sometimes extend far beyond the end of the foot. In one miniature (5.5), a man embroiled in street fighting involving swordplay has removed his clogs for greater mobility, and the depiction of Teodoro's betrothal to Violante (see Fig. 31) indicates that what is represented in the Arnolfini double portrait did not in itself provide any rationale for the removal of pattens. A young Neapolitan nobleman, described by Boccaccio (3.6) as blue-blooded and extremely rich, who was about to enjoy (through a complex ruse of mistaken identity) the favors of a certain married lady who had long resisted

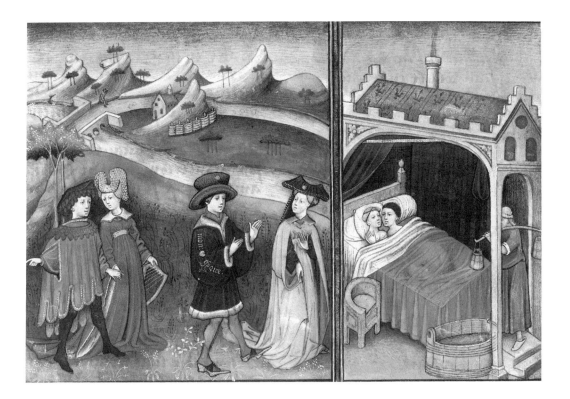

FIGURE 52. Arsenal Boccaccio (3.6), fol. 116r. Photo: Bib. Nat. Paris.

his advances, was portrayed by the Arsenal miniaturist in a large black straw hat and pattens (Fig. 52), suggesting how elegantly attired the man in the London panel must have seemed to the fifteenth-century viewer. It is noteworthy that the outfitting of this figure is an invention of the Arsenal illuminator, for neither the hat nor the pattens are found in the prototype miniature of the Vatican Boccaccio, which in fact contains no illustrations of wooden clogs.[30]

The upper-class fad of wearing pattens seems to stem from a fashion set by the duke of Burgundy himself, in much the same way that Louis XIV's example popularized high-heeled shoes for men in the seventeenth century. Court painters often depict Philip the Good with wooden clogs in formal interior settings, even when he is enthroned in a chair of state; the duke is also known to have had a small portable workshop in which he soldered broken knives, mended glasses, and himself either made or repaired such wooden clogs. After his father's death Charles the Bold destroyed this workshop, and not surprisingly the clogs disappear from Burgundian court manuscripts.[31] But particularly in presentation min-

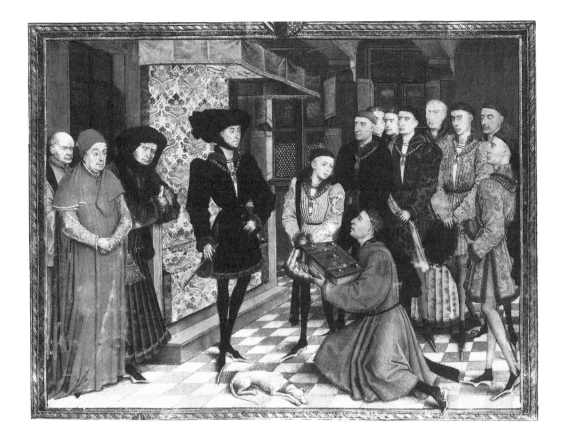

FIGURE 53. Jean Wauquelin presenting his translation of the *Chroniques de Hainaut* to Philip the Good, Mons, 1448. Brussels, Bibliothèque Royale Albert Ier, ms. 9242, fol. 1r.

iatures made during Philip's lifetime (see Plate II), most notably the famous *Chroniques de Hainaut* frontispiece group portrait in ms. 9242 of the Bibliothèque Royale in Brussels (Fig. 53), the duke as well as his principal courtiers, including the chancellor Rolin and the duke's heir and successor, the count of Charolais, sport these more refined pattens indoors, where the awkward footgear could have served no practical use. As the occasion depicted is ceremonial and formal, with most of those present also wearing the insignia of the Order of the Golden Fleece, the clogs are apparently an honorific accoutrement with a value inversely proportional to their cumbersomeness and lack of purpose when worn indoors, although it is amusing to contemplate the clatter that must have accompanied the passage of these courtiers through the ducal residence.[32]

The pattens in the double portrait thus evidently are a footgear of estate, underscoring the status of the male figure, a connotation that apparently lingered on into the sixteenth century, as exemplified by the principal figure in the *Invidia* vignette of Bosch's Prado Table Top, or the left foreground figure in the January miniature of the Grimani Breviary, who

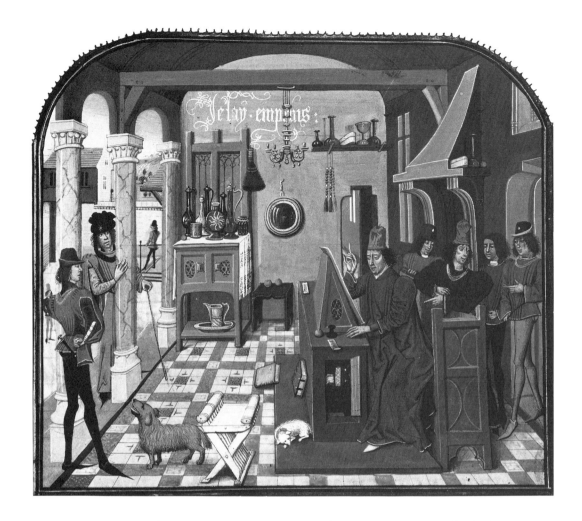

FIGURE 54. Charles the Bold visiting the study of David Aubert. *Histoire de Charles Martel,* vol. III, Bruges, 1468–70. Brussels, Bibliothèque Royale Albert Iᵉʳ, ms. 8, fol. 7r.

holds a falcon and wears the collar of some chivalric order. And because a pair of similarly discarded clogs is also found in the same corner of the pictorial space in the *Birth of John the Baptist* miniature of the Turin-Milan Hours (see Fig. 41)—although it is not so evident in this instance to whom they belong—presumably their removal on entering a house was no more than a matter of convenience.

The traditional and conventional nature of the various objects depicted in the Arnolfini double portrait becomes readily apparent in a comparison with two later representations of Netherlandish interiors: a miniature of about 1470 by Loyset Liédet commemorating a visit of Charles the Bold to the study of the romancer David Aubert (Fig. 54) and Crispijn van de Passe the Elder's engraving *Concordia,* portraying Dutch middle-class domestic harmony

FIGURE 55. Crispijn van de Passe the Elder, *Concordia,* c. 1589. Amsterdam, Rijksmuseum.

at the end of the sixteenth century (Fig. 55). Although the engraving is separated from the double portrait by a century and a half, the continuity in the objects the two works depict is striking. In both the canopied bed and the father's chair of authority as head of the household are prominent elements in the main room of the house. On the wall next to the bed, the brush and mirror found in the London panel are again to be seen, as is the dog in the foreground, now sharing the household's affection with a cat; and an orange (or at least a piece of fruit) is on the buffet. In Aubert's chamber the buffet with its display of plate replaces the bed and chair as furniture of estate, but other objects familiar from the double portrait are also found in the writer's studio: the mirror, the brush, the rosary hanging on the wall, the chandelier, and the oranges as well as two dogs, and on the shelf and mantel-

piece are various glass vessels similar in form to those that have been routinely interpreted by iconographers as Marian symbols in early Netherlandish paintings.

As these comparisons suggest, the crux of the problem of symbolism (whether disguised or not) in early Netherlandish painting is that symbolic value has been placed on commonplace things that were so much a part of everyday life for several centuries that they reappear continuously in Dutch and Flemish paintings and prints. There is no substantive evidence from the fifteenth century that any of these things were understood symbolically, nothing even comparable to the emblem books of the sixteenth century and later, which are the source of present controversy over meaning in Dutch painting of the seventeenth century. It is also fair to say that save for Meyer Schapiro's mousetrap reading of the Mérode Triptych,[33] none of the many symbolic interpretations advanced during the second half of the twentieth century has enjoyed anything like the consensus that has long supported Panofsky's. The reason is clear: because Panofsky's explanations, even when poorly documented, appear rational or at least plausible, they are intellectually persuasive. Thus it is easier to accept, for example, that Arnolfini has removed his pattens because he is standing on holy ground than to be told that the table in the Mérode *Annunciation* is an altar or that the towel is a prayer shawl. Although I do not deny that there are symbolic elements in early Netherlandish art, I also do not think that most of the anecdotal details in such works had any symbolic meaning for Van Eyck and his contemporaries. My purpose in what follows is to give a methodological and historiographic critique of three elements in the double portrait that are still widely presumed to have symbolic meaning: the dog, the single candle in the chandelier, and the mirror.

Panofsky's reading of the little terrier as a symbol of "marital faith" is one of his most successful interpretations, for it has acquired a validity quite independent of the London panel, being applied widely and without reference to Panofsky to almost any dog that is associated with a female figure in both earlier and later works.[34] Yet it rests on little more than an undocumented statement that "the dog, seen on so many tombs of ladies, was an accepted emblem of marital faith."[35] The basis for this seems to have been an inference of Emile Mâle with respect to the possible meaning of dogs at the feet of women in thirteenth-century effigy tombs. But Mâle himself went on to recognize that this presumed convention was already breaking down by the fourteenth century, suggesting that such animals might be merely ornamental, and he concluded with the observation that much writing about animal symbolism on tomb sculpture was no more than a "tissu de rêveries."[36]

Both visual and written sources, in fact, indicate that dogs were virtually everywhere in northern Europe during the fourteenth and fifteenth centuries (see Plate 9 and Figs. 3, 41,

FIGURE 56. Hans Memling, *Vanitas,* c. 1490.
Strasbourg, Musée des Beaux-Arts.

50, 53, 54). If the duke of Berry, who is said to have had 1,500 dogs, seems happy to share his dinner table with two small dogs in the January miniature of the *Très Riches Heures,* René of Anjou felt compelled to construct a special fence to keep dogs off his bed.[37] Dogs are particularly common in Flemish manuscript illumination, where one or more often fill what would otherwise be an empty area in the foreground of the pictorial field, exactly as in the double portrait, suggesting that a primary function of the animals is compositional.[38] Two dogs are depicted fighting over a bone in a *Last Supper* miniature in the Hours of Catherine of Cleves,[39] and another dog indifferently witnesses the martyrdom of Saint Ursula in Memling's famous shrine in Bruges. In addition to two greyhounds, a terrier similar in breed to that in the London double portrait accompanies Memling's *Vanitas* in Strasbourg (Fig. 56), and what could be its sibling attends the same painter's Stuttgart

Bathsheba. Dogs frequently even went to church, as can be seen in Rogier's *Seven Sacraments Altarpiece* (see Fig. 51) as well as many other works; and, to the consternation of bishops, who waged a futile battle to rid convents of dogs, some nuns were so inseparable from their pets that they took the dogs with them into the choir for the monastic offices.[40] Because they were so common, it would be hard to find anything more antithetical to the out-of-season lily in the iconography of the Annunciation, and thus less likely to have symbolic meaning, than these ubiquitous animals in Franco-Flemish works of the fifteenth century.

Various explanations, none satisfactory, have been proposed for the chandelier's mysteriously lighted candle. Compounding the enigma, particularly since the subject matter of the two works is so entirely different, a candle also burns for no apparent reason in the daylit chamber of Campin's London *Virgin and Child in an Interior* (Plate 15). Panofsky's evocative interpretation of the candle in the double portrait as a "symbol of the all-seeing wisdom of God" almost compels intellectual assent and is often repeated as established fact, although in truth it is no more than Panofsky's invention.[41]

Comparative evidence again suggests a very different interpretation for what is seen in the London panel. Chandeliers in other contemporary Netherlandish works are frequently without candles, as in the *Last Supper* of Dieric Bouts, the Kansas City Petrus Christus (Fig. 40), or the miniature of Aubert's study (see Fig. 54), and many additional examples can be found in Dutch painting as late as the seventeenth century, documenting that the empty chandelier was a commonplace in Netherlandish households for hundreds of years.[42] Sometimes, as in Rogier's Louvre *Annunciation* (Fig. 57), or in the Turin *Virgin and Child* (see Plate 12), the chandelier has a single candle, just as in the London double portrait, although it is not lighted, and other candle holders in fifteenth-century works are often either entirely without candles or else have less than a full complement of them, as in the Ghent Altarpiece *Annunciation,* the Lucca Madonna, or the central panel of the Mérode Triptych, where only one of the two identical fireplace sconces is outfitted with a candle (see Fig. 47; cf. Plate 12).

The explanation is simple and practical: whether made of wax or tallow, candles were expensive in the fifteenth century, and good household management dictated that they should be used as sparingly as possible. Even the price of tallow (which was far less desirable for candles than wax because of its sooty smoke and unpleasant odor) could be four times that of meat; thus an early writer on husbandry recommends that a family retire early rather than waste money on candles.[43] The candles used for a procession in Perugia celebrating Saint Bernardino's canonization in 1450, when later melted down to provide funds for a

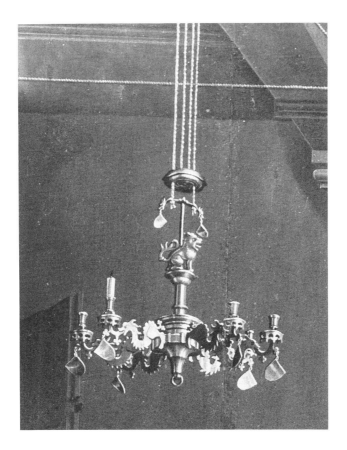

FIGURE 57. Rogier van der Weyden, detail from
The Annunciation, c. 1435. Paris, Louvre.
Photo: Musées Nationaux, Paris.

suitable monument to the saint, yielded wax valued at 200 florins.[44] And Giovanni Arnolfini's will, in providing for a requiem mass in his sepulchral chapel annually on the anniversary of his death, specifically limited the lights on the catafalque to four wax candles weighing one pound each,[45] in stark contrast to the many candles burning on the hearse in the *Messe des Morts* miniature of the Turin-Milan Hours or the corresponding illustration in the *Belles Heures.* The lighted candle in the double portrait may well have some elusive symbolic meaning that remains to be rediscovered, but the fact that it stands alone in an otherwise empty fixture, so accentuating its enigmatic quality for us, is apparently the consequence of nothing more than good bourgeois thriftiness.

Among the objects depicted in the double portrait, the mirror now shares most closely with the lighted candle this heightened sense of enigma, partly at least because enlarged

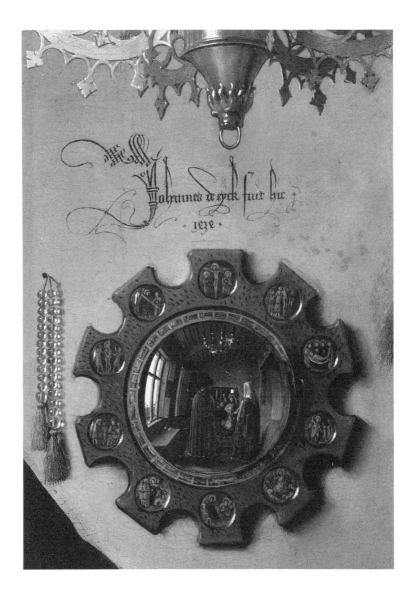

FIGURE 58. Detail of Plate I.

photographs of this detail are constantly reproduced (Fig. 58). Because the mirror is also a relative parvenu as a "disguised symbol," how it acquired its present significance makes an interesting chapter in the historiography of the picture's evolving symbolic interpretation.

In Panofsky's original interpretation of the London panel the mirror was so unimportant as to be passed over without notice. But after disguised symbolism was constituted a "principle," some meaning for so prominent an element in the picture had to be found, and accordingly in *Early Netherlandish Painting,* by way of analogy with the "spotless mirror,"

or "speculum sine macula," of Wisdom 7:26, the mirror became a symbol of "Marian purity."[46] And once canonized by Panofsky's authority, mirrors in other Netherlandish paintings were promptly, if even more dubiously, interpreted in the same way.[47] As tenuous as this proposition was from the beginning—for the mirror in the double portrait is obviously not "spotless"—it goes without saying that any connection between Marian symbolism and a mirror reflecting individuals formalizing the financial arrangements for a future marriage is contextually untenable. What initially gave some measure of credibility to the reading was Van Eyck's known predilection for the Wisdom text, which he took over, together with its application to the Virgin, from liturgical usage, inscribing three of his Madonnas with the passage (it appears as well in the Ghent Altarpiece) extolling her as "the brightness of eternal light and the spotless mirror of God's majesty."[48] Moreover, the *speculum sine macula* did eventually become a common Marian symbol as an emblem of the Immaculate Conception.

The problem again here is methodological, for the *speculum sine macula* as an allusion to Marian purity was not current in the 1430s. The meaning of the earlier liturgical imagery—and thus of Van Eyck's inscriptions as well—is that the Virgin herself is a mirror that reflects the majesty of God. Indeed, in Nicolas Froment's *Burning Bush* of 1476 in Aix-en-Provence, the Virgin and Child have been substituted for God himself in the theophany of the burning bush, and the mirror held by the Child reflects their images. Even as late as about 1480 Bernardinus de Busti makes no mention of the *speculum sine macula* in his long office for the feast of the Immaculate Conception, approved by—and apparently written at the request of—Sixtus IV (himself a strong advocate of the still controversial doctrine), although Busti's texts, rich in Marian imagery, frequently refer to the Virgin's purity and the idea that she was *sine macula*.[49]

The association of the mirror with the Virgin's purity or sinlessness arose only with a new composite iconography of Marian symbols early in the sixteenth century, as in a Parisian Book of Hours printed by Thielman Kerver in 1505 (Fig. 59). Although some of these symbols, such as *stella maris* and *hortus conclusus,* were traditional, others were newly extrapolated from various sources. In the process of accommodating the "spotless mirror of God's majesty" to the new iconography, the last part of the verse was suppressed, significantly changing the traditional meaning as found in Van Eyck's inscriptions. No longer reflecting divine majesty, the mirror now became simply "spotless" or "stainless" and, as a metaphor of being without sin, was appropriated as a symbol of the Immaculate Conception.

FIGURE 59. The Virgin with emblems. *Heures à l'usage de Rome*,
Thielman Kerver, Paris, 1505. San Marino, California,
The Huntington Library.

The *Litaniae Lauretanae* associated with the cult of the Santa Casa of Loreto soon made this imagery a commonplace, but in the first decade of the sixteenth century that was not the case, and hence in early representations these Marian symbols are invariably identified by banderole inscriptions, even in a work such as the Grimani Breviary, which presumably was intended for the use of a theologically learned person.[50] This example shows quite clearly that when symbolic imagery was novel or unfamiliar, even if based on a commonplace text, there was no presumption that the viewer would grasp the intended significance without a written explanation.

What further allegorizes the mirror for many modern writers is the Passion iconography of the miniature roundels that decorate the frame. The presumption is that these images refer to the use of Ephesians 5:22–33 in both Catholic and some Protestant marriage services. The argument might be plausible save for two reasons that effectively undermine its validity. Because a betrothal ceremony, not a marriage, is depicted, text and imagery properly associated with marriage as a sacrament are inappropriate to the circumstances of the couple's action in the London panel. For as previously noted, even when a betrothal was witnessed by a priest, there were normally no prayers. A betrothal was, in short, no more a religious rite in the fifteenth century than an engagement to be married is today. And although Ephesians 5:22–33 became the standard epistle for the nuptial mass in 1570, the normative reading earlier throughout Latin Christendom was taken from 1 Corinthians 6. Among a handful of exceptions to this general rule over the course of many centuries, the Ephesians 5 lesson does appear in two service books from Reims of the twelfth and thirteenth centuries, but only to be replaced subsequently by the conventional reading from 1 Corinthians. Thus any connection between the liturgical use of Ephesians 5 and the religious imagery of the mirror in the double portrait is unlikely.[51]

The mirror in the London double portrait performs several functions, none of which suggest any need for a symbolic interpretation. The mirror's ordinary function as a looking glass finds confirmation in the Hans Paur woodcut (see Fig. 27), where a convex mirror set in a simple rectangular frame shares a border compartment with a comb and a wooden bathtub. By the fifteenth century mirrors were apparently also valued as costly objects, used primarily for decorative effect. An extreme instance of this use is found in a border miniature of the Vienna *Girart de Roussillon* from Philip the Good's library, which depicts a convex mirror suspended on a hung bed against the *dossier* (i.e. the fabric against the back wall). Because one would actually have to stand on the bed to look into this mirror, it cannot have been intended as a looking glass.[52]

The painted roundels decorating the frame of the double portrait mirror would clearly have enhanced its intrinsic value. Their religious content, which doubtless strikes modern viewers as oddly out of place on a seemingly secular object, is nonetheless well within the norms of contemporary convention as part of a long tradition of the moralizing use of mirrors in northern art. The purpose was to diminish thereby the mirror's potential for eliciting vain thoughts. Thus in fifteenth-century miniatures a mirror sometimes reflects a skull, reminding the viewer of death and the corruption of mortal flesh.[53] Similarly, the Crucifixion vignette at the top of the Arnolfini mirror may be compared to an early sixteenth-century woodcut depicting the idealized wise woman as Prudentia (Fig. 60), who, looking into the mirror, sees not her own image but a reflection of the Crucifixion. Often described somewhat inaccurately as a Passion cycle, the ten minuscule medallions embellishing the frame include as well the Harrowing of Hell and the Resurrection, and thus the imagery really epitomizes the central Christian mystery of Christ's triumph over sin and death. In this sense the mirror is a devotional object expressive of middle-class piety, not unlike simple woodcuts (see Plate 12) or small panel paintings that often decorated Netherlandish interiors of the time.

In reflecting the painter's image, the mirror also confirms what the signature above it tells us, namely that "Jan van Eyck was here." But without the inscription even that function of the mirror would remain obscure. By removing both from their context, the modern viewer can easily make more of the inscription and the painter's reflected image than is warranted. The graffito-like signature inscription would not originally have seemed as incongruous as it does today, for manuscript miniatures suggest that mottoes and pious invocations were sometimes actually painted on the interior walls of Flemish houses (see Fig. 54).[54] And even as an artist's signature authenticating a work, the wall inscription of the London panel is comparable to that of Israhel van Meckenem on the altar cloth in his *Marriage of the Virgin* (see Fig. 50) or, for that matter, to the unusual signature inscription on the Vatican *Pietà*, which is Michelangelo's only signed work. Instead of indicating an artist's new perception of rising social status in the fifteenth century, these and other similar inscriptions would seem to represent continuity with an earlier medieval tradition, as found in the bold thirteenth-century relief lettering across the base of the south transept portal of the cathedral of Paris identifying Jehan de Chelles as the architect, or the famous inscriptions of Gislebertus on the tympanum of Autun and Giovanni Pisano on the Pisa pulpit.[55]

As for the mirror image of the double portrait, it most closely parallels Van Eyck's painted reflection of himself two years later in the armor of Saint George in the Van der Paele

FIGURE 60. Cornelis Anthonisz. (?), *The Wise Man and
the Wise Woman,* early sixteenth century.
Amsterdam, Rijksmuseum.

Madonna. These images manifest something about the artist's personality that is inherently
more playful than profound. And that view of what the painter was like is confirmed by
the 1436 inscription on the frame of the Jan de Leeuw portrait, where Van Eyck painted a
small heraldic lion following the "Jan de" to complete the sitter's full name (Fig. 61). Rather
than enigmatic or cryptic, the meaning of the lion is still humorously transparent, for it is
no more than a rebus substituted for the man's surname. The older view—to which Panof-
sky lent his support—that the inscription on this work constitutes a complex chronograph,
is really not credible.[56]

Circumstances peculiar to the twentieth century have helped to form an intellectual en-
vironment conducive to the symbolic reading of early Netherlandish works. The influence

FIGURE 61. Jan van Eyck, detail of the frame inscription of the *Portrait of Jan de Leeuw,*
1436. Vienna, Kunsthistorisches Museum.

of Freud in particular has predisposed us all toward a symbolic view of common things based on free association, especially with respect to the unconscious. It is noteworthy in this regard that in a general reference work like the *Encyclopaedia Britannica* the earliest notice of Sigmund Freud appeared only in the thirteenth edition of 1926, a quarter century after the publication of Freud's seminal *Die Traumdeutung* in 1900.[57] The popularization of Freud's ideas by the 1920s thus corresponds in time with Friedländer's symbolic inferences about the double portrait, mentioned at the beginning of this chapter, which in turn prepared the way for Panofsky's tentatively expressed views of 1934 about disguised symbolism in Van Eyck's double portrait: that he would not even dare to assert that the viewer is "expected to realize such notions *consciously*" (emphasis added). Indeed, the very concept of disguised or hidden symbolism is more akin to the twentieth century than the fifteenth, and iconographic studies based on similarity of form between one object and another owe more to modern psychoanalytic theory than to modes of thought familiar to Van Eyck and his contemporaries.[58]

Complex symbolic readings of Van Eyck's works have also been supported by the modern view, once again fostered by Panofsky's influential remarks, that Van Eyck was a man of wide literary culture and learning.[59] This opinion rests largely on two fifteenth-century texts, only one of which originates with a contemporary who actually knew Van Eyck. In a letter of 1435 Philip the Good reprimanded his financial officers in Lille for their failure to implement an earlier mandate granting Van Eyck an annual pension for life. Because these funds were not being disbursed, Van Eyck had evidently threatened to leave the duke's service, and thus in this letter Philip expresses his apprehension that should this happen, no other painter equally to his taste or "so excellent in his art and science" could be found.[60] The nouns in the phrase "son art et science" apparently refer simply to Van Eyck's skill and

expertise as a painter, which is indeed the context of the passage. And even in modern French, *science* continues to connote "skill" or "ability." In any case, the duke's vague remark does not justify the view that Van Eyck was learned in a broad general sense.

Bartolomeo Fazio's *De viris illustribus* contains the earliest extant biographic notice of Van Eyck and provides the second fifteenth-century text adduced in support of the painter's erudition. Written during the 1450s when the Genoese humanist was in the service of Alfonso of Naples, this short account of the artist begins by lauding Van Eyck as "the foremost painter of our time." Fazio continues by saying that Van Eyck was "not unlearned in letters, especially in geometry and those arts which relate to the embellishment of painting," on which account he was thought to have discovered what the ancients knew "about the properties of colors" by reading Pliny and other authors.[61] Phrases like "the embellishment of painting" and the "properties of colors" are characteristic humanistic circumlocutions; precisely what they meant is now difficult to say. Panofsky took the latter to be an "obvious allusion" to Van Eyck's "technical innovations" in painting. Although he may well have been correct, neither he nor any other modern art historian would credit these innovations to Van Eyck's reading of Pliny's *Natural History.*[62] The point is that Fazio's account is of little value in this regard. And since his brief comments seem to deal only with the technical elements of painting, they do not sustain Panofsky's larger claim that in Fazio's biography Van Eyck "is praised for his scholarly and scientific accomplishments."[63]

The most interesting aspect of Fazio's comment about the painter's intellectual background is the implicit assumption that Van Eyck was enough of a Latinist to have read Pliny's *Natural History.* Pliny's voluminous encyclopedia was widely used during the High Middle Ages as a source of practical knowledge. It was thus a book that Van Eyck might well have read, provided Fazio's presumption about the painter's proficiency in Latin is correct. As for the actual level of Van Eyck's literary culture, all that can be said with any assurance is that he was familiar with the everyday Latin of his time, but the inscriptions on his works do not in themselves support the idea that his learning was profound. Virtually all these texts are religious and are taken either from the Bible—often via liturgical usage—or from hagiographic sources. The only exception is the banderole inscription of the Erythraean Sibyl in the Ghent Altarpiece, which is derived from Vergil, although it is unlikely to have been based directly on the painter's reading of the *Aeneid.*

If no complex symbolic reading is superimposed on the anecdotal elements in the double portrait, the painting can be seen as a studied depiction of upper-middle-class affluence: the hung bed and other furniture of estate in the background; the costly chandelier and mirror; the prayer beads of rock crystal; the oranges on the chest and window ledge, which

are known to have been extremely expensive in northern Europe during the fifteenth century;[64] the small carpet near the bed;[65] the opulent vesture of the woman and the fashionable attire of the man, whose discarded clogs also signified status; and finally the woman's little terrier, which Baldass perceptively called the earliest extant portrait of a dog, imbued with "pulsating life" by the artist.[66] It is certainly a pet animal, with no function other than to give pleasure to its owner, who must also have seen in possessing it yet another way to emulate upper-class society, where keeping pet dogs was a common practice by the fourteenth century.[67]

Van Eyck, it has been suggested, attempted the ultimate conceit of an illusionistic painter by denying, in effect, the distinction between the painted image and what it represents, as if to claim that what the viewer sees is not some "fictive image but the real subject of the painter's brush."[68] The objects depicted in a painting by Van Eyck are also key elements in the artist's illusionistic construction of pictorial space, and that is, I believe, their primary function from the painter's point of view. In his multiple-figure compositions Van Eyck first creates the illusion of a central empty interior space by an empirically understood perspectival system.[69] This imaginary, often boxlike, space is then filled with a profusion of objects, each conceived as a real entity with physical extension in all directions. What gives this plasticity to Van Eyck's objects is his astonishing skill as a naturalistic painter combined with his exploitation of the full range of possibilities inherent in the oil medium as he manipulates gradations of color, light, and shadow to enhance the three-dimensional quality of his images.

In the double portrait the various objects have been skillfully and rationally deployed so that from front to back, as well as from top to bottom, the imaginary pictorial space is occupied almost everywhere by some element of these palpably rendered three-dimensional entities or the complex interplay of their cast shadows and reflected highlights. The obliquely disposed foreshortened clogs, the dog, and the train of the woman's gown in the foreground give way to the two central figures, who in turn are succeeded in space by the chest, the oranges, the window and its foreshortened shutters, the carpet, the bed, and the chandelier. The casually placed women's slippers then move the eye into the penultimate plane, where the furniture with its pillow and fabric covering, the rosary, and the mirror are tangible objects that project out into the room and toward the viewer, casting shadows against the rear wall of the room to form a final plane of the pictorial space.[70]

Van Eyck's intentions and even something of the creative process whereby he achieved these remarkable illusionistic effects are discernible from pentimenti that have come to light

FIGURE 62. Infrared detail photograph of Plate 1.

by the scientific examination of his works. A major pentimento disclosed by infrared photography of the double portrait (Fig. 62) shows that in rethinking the configuration of Arnolfini's raised right hand, Van Eyck sharply foreshortened it and placed a ring on the first finger. These alterations in no way affect the meaning or significance of the oath-swearing gesture, which remains unchanged in its essentials. Visually, however, a relatively flatly rendered hand close to the man's chest has been reworked into a strongly three-dimensional image, thus introducing into the structure of the picture an additional spatial plane between the viewer and the figure itself. The enhanced plasticity of the hand is further accentuated by the ring, with its carefully painted accent of reflected light. By including the ring—which is not present in the underdrawing—Van Eyck departed from his normal practice of omitting, rather than adding, such details in the final execution of a painting.[71]

Similar pentimenti have recently been found in the Thyssen-Bornemisza *Annunciation* (Plate 16). A cleaning and scientific examination begun in 1988 by Emil Bosshard has revealed that the diptych is not a grisaille painting at all, but a highly naturalistic representation of limestone statues against a polished black marble background, with the figures rendered in a colored palette so as to suggest the structural characteristics of the stone as well as the weathering that might be found in real statues exposed to the elements. Pentimenti indicate that the octagonal plinths on which the statues rest originally began at the bottom edge of the panel, but Van Eyck ultimately repainted the pedestals, extending them out over and actually onto the surface of the frame to enhance the sculptural, three-dimensional effect of the painting.[72] Unlike the similar statues in wings of the Dresden Triptych, where the figures are placed within Van Eyck's most characteristic boxlike spaces, the Thyssen-Bornemisza statues project out from—and seemingly stand in front of—the pictorial plane, thus sharing the viewer's space, casting their shadows back upon the frames. Completing the illusion, Gabriel's head and the entire figure of the Virgin are reflected in the simulated polished stone background in a painterly feat reminiscent of the mirror reflections in the Arnolfini double portrait. Particularly because of their restrained palette, the Thyssen-Bornemisza panels present the viewer with a virtuoso display of the painter's craft and are thus about as close as one can come in the fifteenth century to bravura painting for its own sake.

In a work like the *Madonna of Chancellor Rolin,* the central perspective of the painting has been opened out to infinity, but in the London panel, with astonishing ingenuity and inventiveness, Van Eyck introduced the convex mirror to create a related but far more original effect. Functioning like a wide-angle lens reflecting an inverted view of much of the interior space of the picture, the mirror also extends a reverse perspectival system out beyond the picture's surface into the space originally occupied by the painter and his companion, as well as—forever after—by every viewer who stands before this extraordinary work.

If Van Eyck really did read Pliny's *Natural History* as Fazio suggested, he would doubtless have appreciated the anecdote about the voyage Apelles made to visit Protogenes of Rhodes. Upon arriving at the artist's studio, Apelles found only an elderly woman, who informed him that Protogenes was out and asked who the visitor was. Rather than giving his name, Apelles painted a single colored line of extreme fineness on a sizable panel in the studio and left. When Protogenes returned, he realized at once that only Apelles could have painted so perfect a line. But so as not to be outdone, he painted an even finer line over that of Apelles,

telling the woman to show it to the visitor if he came back again. When Apelles did indeed return to the studio, he was embarrassed by what had happened and in Protogenes' absence proceeded to split the double line already on the panel with a third of yet another color, leaving no room for further display of technical skill. Protogenes thereupon acknowledged his defeat and decided the panel should be preserved, just as it was, for posterity. According to Pliny, this large panel, bearing no more than the three superimposed and almost invisible lines of the two painters, eventually belonged to Augustus and—until it was destroyed by fire in the emperor's Palatine residence—was regarded, especially by artists, as the outstanding work in a collection of important pictures.[73]

In confronting the genius of Van Eyck, we sometimes forget that virtuosity can be so enthralling an experience for performer and audience alike as to become an end in itself. The inscription of the Arnolfini double portrait encourages us to look even more closely at the mirror, which by its distorted reflection draws the viewer further into the picture while at the same time extending our vision out from and beyond the frontal plane of the panel. Van Eyck's technical skill in executing the mirror as a painterly tour de force is further manifested in the ten minuscule medallions that embellish the frame. It was this technical virtuosity that the earliest writers like Fazio, who was especially impressed by a mirror in another of Van Eyck's panels,[74] admired and other painters sought to imitate. And it was in this way that Van Eyck also gave visual expression to his modest—but also proud and confident—motto "Als Ich Can," showing us by his illusionistic description of commonplace objects of the real world what he as a painter could indeed do.

A FIFTEENTH-CENTURY FLORENTINE MARRIAGE SERVICE BEFORE A NOTARY

Formularium diversorum contractum, Florence, Francesco di Dino
[c. 1487], (Goff F-249), fols. 80v–81v.

Matrimonium vulgare

Alnome sia dellomnipotente idio et della sua madre Madonna Sancta Maria sempre uergine & di tutta la celestiale chorte del paradiso & nominatamente del precursore di Christo Messer Sancto Giovanni baptista singularissimo aduocato protectore & defensore di questa alma cipta: & di Madonna Sancta Chaterina aduocata di tutte le uergine & pulzelle: Si uis inuocare alios sanctos potes Non est bonum hominem esse solum faciamus ei adiutorem similem sibi Genesis secundo capitulo: Esi leggie nel gienesi al secondo capitulo: che hauendo lo Omnipotente idio facto il nostro primo Padre Adam dellimo della terra uide & conobbe non esser buono & utile lhuomo essere solo ad habitare & godere il mondo per lui ordinato: & pero dilibero fargli uno adiutorio allui simile: & creo la femina che fussi propria chompagnia del huomo: Et quasi questo medesimo habbiamo nel genesi capitolo primo doue dice: Creauit Deus hominem ad inmaginem suam: creauit Deus marem & feminam: Creauit eos benedixitque illos & dixit eis: Crescite & multiplicate & replete terram &c. Dipoi fu per li sacri sancti pontefici & pastori della militante ecclesia Romana ordinato il sancto matrimonio & nel numero de septe sacramenti collocato: elquale chome

chosa sacratissima e per modo indissolubile: che per niun modo e lecito diuidere el marito dalla mogle: & quello giamai uiolare Iuxta illud Mathei Capitulo. xviiii. Quos deus coniunxit homo non separet: Et chome chiaro uedete il matrimonio e di tanta forza che il buono sposo & marito debbe lasciare il proprio padre & la propria madre per istare cholla sua chara & dilecta sposa: Iuxta illud Pauli apostoli Propter hoc relinquet homo patrem & matrem & adherebit uxori sue: Venendo adunche a questo acto matrimoniale & richordandomi dun decto di San Pagolo a cholo .xii. capitulo. Omne quodcunque facitis in uerbo aut in opere in nomine Yhesu Christi facietis gratias agentes deo patri &c. exponas si placet cioe &c. Apresso riducendomi a memoria lauctorita dalchuni gentili poeti chome Seneca nelle tragedie doue dice: Non ante uestes induat numptiales coniunx: quam thure flammas spargat et poscat deos &c. & Virgilio dixe: Imprimis uenerare deos: & per tanto inuocheremo laiutorio dello omnipotente & eterno iddio & della sua gloriosissima madre madonna sancta Maria sempre uergine & di tutta la celestiale chorte del paradiso: & nominatamente de beatissimi apostoli Sancto Piero & san Paolo: & di san Giouanni baptista singularissimo aduocato: & protectore di questa nostra cipta &c. quegli diuotamente pregando che per loro infinita miserichordia ci uoglino concedere gratia che il presente matrimonio sia & possa essere a loro laude & riuerentia: Possa essere & sia fausto & felice & in congugnimento damore acrescimento dauere consolatione di figluoli & di tutto el parentado fra questi dua nouelli sposi nuouamente congiunti per matrimonio con ogni prospera & buona fortuna: & finalmente saluatione dellanime loro & delle nostre doppo lunga uita: Perla qual cosa uolendo le infrascripte parte quanto fu in cielo ordinato da dio & da sancti pontefici chomandato in terra legiptimamente obseruare: Vengono allo presente infrascripto acto matrimoniale al quale ui priegono & io per loro parte siate testimoni.

Mona Marietta siate uoi chontenta di consentire qui in .L. chome in uostro legiptimo sposo & marito: & dallui riceuere lanello matrimoniale in segno di legiptimo matrimonio secondo che chomanda la sancta madre ecclesia romana. Rispondi Messer si.

L. siate uoi contento di consentire qui nella Marietta chome in uostra legiptima sposa: & a lei dare lanello in segno di legiptimo matrimonio secondo che comanda la sancta madre chiesa romana. Messer si.

Datio anuli.

Constituta in presentia mei Iohannis notarii infrascripti & testium suprascriptorum Domina Marietta filia Dominici &c. legiptime interrogata per me Iohannem notarium antedictum & infrascriptum utrum uelit consentire in .L. Mattei tanquam in suum sponsum et legiptimum uirum & maritum: & ab eo anulum matrimoniale recipere: atque cum illo matrimonium contrahere de presenti animo & proposito illud nunquam separandi: sed perpetuo conseruandi? Libere respondit quod sic: Et econuerso dictus .L. interrogatus per me Iohannem notarium antedictum et infrascriptum an uelit consentire in dictam Dominam Mariettam tamquam in suam sponsam & legiptimam uxorem? & eidem dare anulum matrimoniale in signum ueri et legiptimi matrimonii? sponte respondit quod ita. Atque hoc ordine premisso per uerba de presenti mutuo consensu ad inuicem matrimonium legiptime contraxerunt: Postque statim in signum & obseruationem actus predicti .L. suprascriptus: dictam .D. Mariettam anuli datione desponsauit Rogantes me Iohannem quatenus de predictis publicum conficerem instrumentum uel dicas breuius.

Matrimonium & datio anuli.

Domina Marietta & Laurentius ambo simul inter se per uerba de presenti & anuli dationem & receptionem ad inuicem mutuo consensu matrimonium legiptime contraxerunt Rogantes &c.

NOTES

Introduction

1. Brooke, 281–84; Brundage, caption to pl. 6; see also Brucker, 126–27.

2. See for example David Carrier, *Principles of Art History Writing,* University Park, Pa., 1991, 7. Carrier thinks "a good interpretation must be true to the facts, plausible and original" and is much concerned about the problem of conflicting interpretations of the same work. At one point (92–93) he rejects Panofsky's criterion of common sense (attributing it mistakenly to Julius Held) as "an ahistorical notion," substituting for it the consensus of "serious" art historians or scholars (6, 36). These views can be compared with those of E. de Jongh about sense, nonsense, and consensus; see "Some Notes on Interpretation," in *Art in History: History in Art,* ed. David Freedberg and Jan de Vries, Santa Monica, 1991, 119–36, esp. 122–23. The crux of the problem, as I see it, for those who would deny the validity of any historical approach, is that the only way to determine whether an interpretation of something like a fifteenth-century painting is, in Carrier's words, "true to the facts" is careful historical analysis. Other useful recent discussions of methodological problems include the essays in the Peter Burke volume cited below in n. 11 and Philippe Carrard, *Poetics of the New History,* Baltimore, 1992.

3. Roskill, 62.

4. Seidel, 1989, 78.

5. Brooke, 286.

6. Panofsky set forth his methodology in a well-known passage in *Early Netherlandish Painting* (Panofsky, 1953, 1:142–43). His criteria for determining whether a still-life object had symbolic meaning included asking if "the symbolical significance of a given motif is a matter

of established representational tradition" and if "a symbolical interpretation can be justified by definite texts or agrees with ideas demonstrably alive in the period and presumably familiar to its artists." Ironically, by these standards no symbolic reading advanced by Panofsky for the double portrait was adequately documented.

7. See for example Baldass, 72–73, whose formal analysis of the painting is based on this premise.

8. Campbell, 135; Harbison, 1990, 265.

9. Alistair Smith, "The Arnolfini Marriage by Jan van Eyck," *Painting in Focus,* no. 8, unpaginated, National Gallery, London, 1977.

10. The author justifies his transition to an ahistorical mode of exposition by historical argument. Van Eyck, he says, first dated his pictures to the day as early as 1432 and continued with this habit "to the end of his life," thus "precisely indicating the moment which the painting pretends to reproduce" when a work was so inscribed. The claim is then advanced that because the inscription on the double portrait gives only the year, the subject matter depicted "does *not* therefore refer to one precise day, *nor* to a specific event taking place at one moment." In fact, however, only three of the painter's surviving works are dated to the day—one each in the years 1432, 1433, and 1439—and in the first and last instances, the inscription explains the date, implying that the picture was actually finished on that particular day. During the intervening period 1433–39, five of Van Eyck's extant pictures, including the double portrait, are dated: in each case the year alone is given. Thus all that can reasonably be inferred from the available evidence is that the dating of the Arnolfini portrait fully conforms to Van Eyck's customary practice at the time the picture was painted.

11. See Giovanni Levi, "On Microhistory," in *New Perspectives on Historical Writing,* ed. Peter Burke, Cambridge, 1991, 91–113, esp. 97. My own views about methodology in the study of iconography are similar to those expressed by Carlo Ginzberg, *The Enigma of Piero,* London, 1985, 11–13.

12. E. H. Gombrich, *Symbolic Images: Studies in the Art of the Renaissance,* Oxford, 1972, 21.

Chapter 1

1. For a detailed discussion of the painting with technical data, documents, and references to earlier bibliography, see Davies, 1954, 117–28, and Davies, 1968, 49–52. For additional bibliography through 1974, see the English edition of Friedländer, "Supplements," 2 (published with vol. 14). More recent studies are discussed in Chapter 4.

2. Of Van Eyck's signed pieces, only this and the double portrait are signed directly on the pictorial surface, in both instances with a cursive script that differs markedly from the carefully lettered inscriptions on the original frames surviving for other works. For the notarial use of the *actum* formula the painter employed when dating the Timotheos portrait, see Boüard, 1:295–96.

3. Davies, 1954, 125.

4. For a document two years later than the double portrait, see *Inventaire sommaire des archives départementales antérieures à 1790, Nord,* série B, 4 (Lille, 1881), 176: "Jean Arnoulphin, marchand de Lucques, demeurant à Bruges"; see also Mirot and Lazzareschi, 86. For additional citations from the Lille archives by Léon de Laborde and others, see Schabacker, 390 n. 4. Despite much speculation to the contrary, circumstantial evidence makes an original frame inscription unlikely. The inventories of 1516 and 1523/24 both correctly transcribe the Latin form of the painter's name (Johannes) from the signature on the pictorial surface; thus presumably whoever wrote these entries would not have been confounded by a simple Latin phrase such as "Johannes Arnolfini et coniux eius Johanna Cenami" on the frame. Had the hypothetical inscription been in the vernacular (which seems unlikely, since all of Jan's inscriptions are in Latin, save for the Dutch text on the Jan de Leeuw portrait and the French motto on the "Timotheos" panel), surely Van Eyck, who also painted the male sitter of the London panel a second time in the portrait now in Berlin, would have been familiar enough with the common local name of so important a man not to have used either of the inventories' variant forms in one of his meticulously crafted frame inscriptions. See also n. 9 below.

5. J. A. Crowe and G. B. Cavalcaselle, *Lives of the Early Flemish Painters,* 3d ed., London, 1879, 100. The first edition was published in 1857.

6. Mirot and Lazzareschi, 84–87, 93–101.

7. Davies, 1954, 126–27.

8. For the relevant passages from Van Vaernewyck and Van Mander, see ibid. and Weale, lxxxv. For these two authors' accounts of the painting, see also Panofsky, 1934, 117–18. I examine Van Vaernewyck's description of the picture more fully in Chapter 3 at n. 35.

9. Davies, 1954, 126–27. It should be noted that while the phrase "cómo se engañan el uno al otro" has sometimes been mistranslated (e.g., Dhanens, 197), the meaning of the Spanish verb *engañar* is not in any sense ambiguous. Derived from the medieval Latin *ingannare*—"to deceive, trick, or swindle"—the word passed from the vulgar Latin directly into most Romance languages, preserving in each instance the connotation of the Latin root; see, for example, J. Corominas and J. A. Pascual, *Diccionario crítico etimológico castellano e hispánico,* 2 (Madrid, 1980): 618. Because so many of Van Eyck's works have marbleized frames, the statement in the inventory of 1700 that the double portrait's wooden shutters (also mentioned in the inventories of 1516, 1523/24, and 1556) were marbled ("jaspeado") suggests that these shutters (and presumably also the frame) may have been an integral part of the picture's Eyckian mounting. But if the verses from Ovid really implied what the redactor of the inventory assumed, their inappropriately satirical character seems to exclude the possibility that they were part of an original frame inscription.

10. Davies, 1954, 121, 127. Gallery archive: 6 February 1843 Board meeting minutes.

11. *A Catalogue of the Pictures in the National Gallery,* London, 1843, 48, no. 186.

12. Louis Viardot, *Les musées d'Angleterre, de Belgique, de Hollande et de Russie,* 2d ed., Paris, 1855, 29–30.

13. Léon de Laborde, *La renaissance des arts à la cour de France,* Paris, 1850–55; reprint, New York, 1965, 1:601–4.

14. Crowe and Cavalcaselle (as in n. 5 above), 100–101.

15. Ralph N. Wornum, *Descriptive and Historical Catalogue of the Pictures in the National Gallery,* revised by C. L. Eastlake, London, 1847, 76–77.

16. *The Quarterly Review* 82 (1848): 394; the remark appears in a long review by Ruskin of Eastlake's *Materials for a History of Oil-Painting.*

17. Laborde (as in n. 13 above), 1:603.

18. Gustav Friedrich Waagen, *The Treasures of Art in Great Britain,* London, 1854, 1:348.

19. For this controversy, see nos. 21–24, 26–28, 39 in the bibliography of Davies, 1954, 124–25.

20. Weale, 72.

21. Friedländer, 1934–37, 1:57 (the first volume was originally issued in 1924). Fierens-Gevaert, in his posthumous history of early Flemish painting (1:92) of 1927 (the author died in the preceding year), also correctly understood the inscription as meaning "Jean van Eyck fut ici" and recognized the painter as one of the figures seen reflected in the mirror.

22. Panofsky, 1934, 117–27; Panofsky, 1953, 1:201–3.

23. For example Jean Lejeune, "La période liègeoise des Van Eyck," *Wallraf-Richartz-Jahrbuch* 17 (1955): 66–67, presents valid arguments that the picture does not represent a clandestine marriage to justify his own theory that the artist and his wife are portrayed in the picture, not as they appeared in 1434 when the work was executed, but as they looked years earlier, at the beginning of their marriage. For Lejeune's further elaboration of this theory (a sculptural model of the London *Man in a Red Turban* was prepared and then photographed in a convex mirror to approximate the "distorted" features seen in Van Eyck's two Arnolfini portraits), see his "A propos de Jean et Marguerite Van Eyck et du 'Roman des Arnolfini,'" *Bulletin monumental* 134 (1976): 239–44. More recently, Bedaux, 29, who argued against the ceremony's being clandestine, still believed the picture depicts a marriage. Those who have questioned Panofsky's view only in passing include M. Nédoncelle, "La structure esthétique du 'Portrait des Arnolfini' de Jan van Eyck," *Revue d'esthétique* 10 (1957): 147 n. 2; and Kelly, 174 n. 40.

24. The iconographic interpretations in Lotte Brand Philip, *The Ghent Altarpiece and the Art of Jan van Eyck,* Princeton, N.J., 1971, and some of the reactions to the book conveniently epitomize the two points of view as they had developed by the 1970s; see e.g., the reviews cited in "Supplements" (as in n. 1 above), 1. Negative reactions in print have often been presented in muted tones, but see the more general remarks of Marrow, 151–52, relative to the long-held private opinion of a famous art historian. Leo van Puyvelde's early and un-

equivocal rejection of Panofsky's symbolic reading of the double portrait is noteworthy: "In order to understand this painting there is no need to look for complicated explanations of the individual symbols, as Dr. Erwin Panofsky has attempted to do" (*Flemish Painting from the Van Eycks to Metsys,* New York, 1970, 55; the original French edition appeared in Brussels in 1968).

25. Campbell, 53–54, 115, 135–36, discusses some of the problems of the London double portrait briefly and with much common sense. I basically agree with his position, but take exception to the idea that it is "inadvisable" to see in the painting, as in a photograph, the "record of a significant moment" in a specific ceremony. I do not claim that everything in the London panel is as in a photographic image, for clearly this is not the case: a pentimento, for example, shows that Van Eyck changed the shape of the frame of the mirror, which may well not even have been in the room where the commemorated event took place; see Davies, 1954, 118. But this commemorative intent on the part of the artist, underscored by the mirror image and inscription and the couple's stylized gestures distinguishes the London panel from images like Figs. 2–5 as well as from other fifteenth-century double portraits cited by Campbell, such as Joos van Ghent's painting of Federico da Montefeltro and his son Guidobaldo. Contemporary presentation miniatures (see Plate II; Fig. 53) are analogous to the London double portrait in that living persons are portrayed in full-length figure compositions that apparently memorialize a specific historical event, but because these illuminations appear in the very manuscripts intended for subsequent presentation, they anticipate rather than record what is represented and thus constitute a different genre.

26. Two examples will suffice. In a well-known study of 1972, Schabacker, while not otherwise challenging Panofsky's basic assumptions (see especially 376), sought to explain the linking of the couple's left and right hands by arguing that the panel depicted a morganatic marriage. Earlier, just prior to Panofsky's definitive presentation in *Early Netherlandish Painting,* Baldass (73–74) accepted the idea that the painting depicted the specific "action" of a marriage but confronted the problematic gestures with the untenable suggestion that the man is about to place his raised right hand in the woman's hand "as a symbol of his binding vow of fidelity."

Chapter 2

1. For the general recognition of civil marriage in the early modern period and the development of jurisdiction by civil courts over matrimonial cases based on a distinction between marriage as a civil contract and marriage as a sacrament of the church, see Esmein, 2:35–59.

2. *Digest* 50.17.30.

3. Adolf Berger, *Encyclopedic Dictionary of Roman Law,* Philadelphia, 1953, s.vv. "Affectio

maritalis," "Divortium." See also Brundage, 33, 35, 41–42; and John T. Noonan, Jr., "Marital Affection in the Canonists," *Studia Gratiana* 12 (1967): 481–509.

4. *De bono conjugali,* 32; *Patrologia latina,* 40:394. For Augustine's views on marriage, see in particular Emil Schmitt, *Le mariage chrétien dans l'oeuvre de S. Augustin,* Paris, 1983.

5. A constitution issued in 428 by Theodosius II and Valentinian III (*Codex* 5.4.22 or *Theodosian Code* 3.7.3) recognized the validity of a marriage even without written betrothal instruments or any marriage rites or ceremonies, provided the parties were of equal rank and their consent was confirmed by the testimony of friends.

6. *Digest* 23.1.1. and 23.1.2.

7. Ritzer, 71–73, 77–79, 128, 291.

8. See *Theodosian Code* 3.5.1–3.6.1. The constitution of Constantine is 3.5.6, later codified in the Justinian corpus as *Codex* 5.3.16.

9. Leclercq, cols. 1891–92.

10. *Lex Burgundionum,* 34.1; *Pactus Legis Salicae,* 20.

11. Rouche, 837–43; Gaudemet, 34–39, 164–66.

12. See for example F. L. Ganshof, "Le statut de la femme dans la monarchie franque," *Société Jean Bodin, Recueils* 12 (1962): 5–58, especially 26–29. See also Ritzer, 270–72.

13. Gaudemet, 351–52; Diane Owen Hughes, "From Brideprice to Dowry in Mediterranean Europe," *Journal of Family History* 3 (1978): 262–96, especially 265–68.

14. The classic study is A. Lemaire, "Origine de la règle, 'Nullum sine dote fiat conjugium,'" *Mélanges Paul Fournier,* Paris, 1929, 415–24.

15. *Decretum* C. 30 q. 5 c. 6.

16. *Patrologia latina,* 119:979–80. Passages from this letter were later codified in Gratian's *Decretum* C. 27 q. 2 c. 2 and C. 30 q. 5 c. 3.

17. Ritzer, 229–32, 276–77.

18. B. Kötting, "Dextrarum iunctio," *Reallexikon für Antike und Christentum,* 3 (Stuttgart, 1957): 881–88. See also n. 23 below.

19. Harold Mattingly, *Coins of the Roman Empire in the British Museum,* London, 1968, 4:198–99, no. 1237, pl. 28.

20. Reekmans, 31–37, has convincingly argued that the personified figure represents Concordia rather than Juno Pronuba as has been commonly held since the seventeenth century. For the two reliefs illustrated, see ibid., 40, 48.

21. See Susan Treggiari, *Roman Marriage: Iusti Coniuges from the Time of Cicero to the Time of Ulpian,* Oxford, 1991, 149–51, 164–65, 251–53. As this author makes clear, there is little evidence besides two obscure passages in Tertullian that the ritual of joining hands was actually performed.

22. Ernst H. Kantorowicz, "On the Golden Marriage Belt and the Marriage Rings of the Dumbarton Oaks Collection," *Dumbarton Oaks Papers* 14 (1960): 3–16. See also Carola Reinsberg, "Concordia: Die Darstellung von Hochzeit und ehelicher Eintracht in der

Spätantike," *Spätantike und frühes Christentum: Katalog zur Austellung im Liebighaus in Frankfurt am Main,* Frankfurt, 1983, 312–17. For these matters the most important discussion is still that of Reekmans, especially 76–85.

23. Joining right hands to seal a conspiracy is mentioned in a capitulary of Charlemagne; see *Capitularia,* 1:124: "Si vero per dextras aliqua conspiratio firmata fuerit." Tertullian, in the texts cited by Treggiari (as in n. 21 above), also uses "per dexteras" to describe what is now called the *dextrarum iunctio.* These examples conform to classical usage where *per dexteram* commonly means hands clasped as a sign of agreement; see *Oxford Latin Dictionary,* s.v. "dext(e)ra."

24. "Fides autem consensus est, quando, etsi non stringit manum, corde tamen et ore consentit ducere, et mutuo se concedunt unus alii, et mutuo se suscipiunt." The text appears twice in medieval canon law, once in the *Decretum* as a *palea,* or addition to Gratian's original compilation (C. 27 q. 2 c. 51) and again in *Decretales* 4.4.1. For its spurious character, already noted in sixteenth-century editions of the *Decretum,* see Friedberg, 1:1077. Although of obscure origin, this text provides useful evidence that the *dextrarum iunctio* had fallen into disuse in a matrimonial context, for the text itself was well known at least as early as the twelfth century, that is to say before the joining of right hands reappears as a European marriage gesture. See also nn. 60 and 65 below.

25. Ritzer, 273–79. The Bobbio missal, the only surviving Gallican liturgical manuscript of this early period to contain a marriage blessing, has two prayers for the blessing of the couple in the nuptial chamber, one for first and another for second marriages.

26. *Capitularia,* 1:98. To discourage incestuous marriages, this legislation of Charlemagne envisioned an investigation of possible consanguinity by local clergy and elders before the couple were "joined together with a blessing." Granted that law and practice are often far apart, there is still a striking disparity between the capitulary, which presumes the nuptial blessing for everyone, and a comment of approximately the same date by Jonas of Orleans (*De institutione laicali,* 2.2, *Patrologia latina,* 106:170) that a marriage is only rarely blessed at mass because most couples are already "corrupted" by the time of their marriage. Jonas is clearly referring to the Roman marriage rite that the Carolingians took over with the Roman liturgical books, whereas the capitulary may refer instead to the blessing of the marriage in the nuptial chamber, since that form of blessing survived in France for centuries (see Molin and Mutembe, 255–69) as an adjunct to the church ceremony and from an early date, as evidenced by the Bobbio missal, did not require the virginity of the spouses. According to Ritzer, 389–90, the Merovingian *benedictio in thalamo* was supplanted in the Frankish kingdom by the introduction of the Roman marriage rite, but there does not seem to be any firm evidence to support this claim.

27. Ritzer, 334–45; for the "nights of Tobias," ibid., 281–82. For developing notions about consanguinity and spiritual affinity, see Rouche, 857–67.

28. Molin and Mutembe, 32–37. See also Martène's *ordo* II and *ordo* III (ibid., 284–87) and

Martène, 2:355–57. Martène's *ordo* II from a Rennes missal of the twelfth century is perhaps the earliest extant text of the new marriage service at the church door.

29. See the marriage rites cited in the preceding note for references to the venue of the ceremony. The expression *in facie ecclesiae,* which has survived in the Book of Common Prayer as "in the face of this congregation," was already used in the second half of the twelfth century by Alexander III in a decretal later codified as *Decretales* 4.16.2.

30. For references to early synodal statutes that insist on marriage at the church door so as to discourage clandestine marriage, see Molin and Mutembe, 37.

31. "Ut omnes homines laici publicas nuptias faciant tam nobiles quam innobiles" (*Capitularia,* 1:36).

32. These texts, respectively known as the decretals of the pseudo-Evaristus and pseudo-Hormisdas, are *Decretum* C. 30 q. 5 c. 1 and c. 2.

33. *Decretum* C. 30 q. 5 c. 6 and c. 8. For the distinction between marriage that is *ratum et legitimum* and clandestine marriage as *ratum et non legitimum,* see C. 28 q. 1 c. 17. From the thirteenth century, this distinction is found in almost any discussion of clandestine marriage, whether in academic treatises, such as the *Summa* of Hostiensis (ed. 1537, fol. 198r), or in popular handbooks for ordinary priests, as for example the fourteenth-century *Manipulus curatorum* of Guido de Monte Rochen, one of the most often printed and widely disseminated books of the fifteenth century, which notes (fol. g5r) that matrimony contracted between marriageable Christians "without the accustomed solemnities" is "ratum et non legitimum."

34. For the Roman law, see *Digest,* 23.2.2; in general, and for the canon law in particular, see the important study of Donahue, esp. 254, 259, 271–73.

35. Dauvillier, 17–59, 76–101; Le Bras (1968), 197–98.

36. Hefele and Leclercq, 5:1373–74. The canon was codified as the decretal *Cum inhibitio, Decretales* 4.3.3. A further provision of this canon suspends from priestly functions for three years any priest who participates in a clandestine marriage. *Cum inhibitio* was the classic place for the discussion of clandestine marriage by medieval canonists; the *glossa ordinaria,* ad v. *clandestina,* enumerates the three basic conditions that made a marriage clandestine: the absence of witnesses; the omission of the requisite formalities as in *Decretum* C. 30 q. 5 c. 1, in particular the priest's blessing; and failure to publish the bans prior to the marriage ceremony. Hostiensis, *Summa* (ed. 1537, fol. 200v), added to this several other circumstances that made a marriage clandestine because the canon law had been infringed (e.g. a marriage without prior episcopal sanction where one of the spouses had previously been betrothed to a third party), and this expanded list is commonly cited thereafter, as in Antoninus, *Summa,* Pars tertia, t. 1 c. 16 (ed. 1740, 3:62).

37. Dauvillier, 105–16.

38. Mansi, 25:93; for the correct date of this council, see Hefele and Leclercq, 6:466. For a recent study of excommunication as a disciplinary action for clandestine marriage in the

neighboring diocese of Utrecht prior to the Council of Trent, see A. G. Weiler, "De ontwikkeling van de middeleeuwse kerkelijke rechtspraak in het bisdom Utrecht inzake excommunicatie belopen wegens clandestine huwelijken tot aan het Concilie van Trente," *Archief voor de Geschiedenis van de Katholieke Kerk in Nederland* 29 (1987): 149–65.

39. Aquinas, *Summa theologiae,* Supplementum, Q. 45 a. 5; Antoninus, *Summa,* Pars tertia, t. 1 c. 16 (ed. 1740, 3:59).

40. Martène, 2:343.

41. Brooke, 57, 141–42, has expressed a similar view.

42. For some representative cases, see *Calendar of the Papal Registers,* 4:413; 5:261; 7:41, 567; 8:165.

43. *Paston Letters and Papers of the Fifteenth Century,* ed. Norman Davis, parts 1 and 2, Oxford, 1971–76, nos. 203, 245, 332, 861. Bennett, 42–46, refers loosely to the exchange of promises between them as a betrothal, but the couple clearly considered they had been married clandestinely: Calle (no. 861) speaks of the "great bond of matrimony that is made betwixt us" and refers to Margery as his "before God very true wife." When examined by the bishop (no. 203) to determine from the tense of the words of consent "whether it made matrimony or not," Margery replied that "if the words made it not sure . . . that she would make it sure before she went thence." For another case, see Donahue, 269–70.

44. *Lexikon des Mittelalters,* Munich, 1 (1980): 1980–81.

45. *Decretales* 4.3.2 established the procedure for "publicizing" a clandestine marriage by repeating the ceremony *in facie ecclesiae;* see also the *glossa ordinaria,* ad v. *a principio.*

46. *Summa theologiae,* Supplementum, Q. 46 a. 2.

47. Antoninus, *Summa,* Pars tertia, t. 1 c. 24 (ed. 1740, 3:114), denounces precisely what Mozart's Don Giovanni attempts: to propose marriage "not intending to contract marriage, but rather to deceive, so as to extort sexual intercourse."

48. Vleeschouwers-Van Melkebeek, 43–50, 61.

49. See n. 33 above.

50. Vleeschouwers-Van Melkebeek, 62–63.

51. Ibid.

52. Ibid., 64–65. For other studies of local records concerning litigation involving clandestine marriage, see Sheehan and Donahue. Beatrice Gottlieb, "The Meaning of Clandestine Marriage," in *Family and Sexuality in French History,* ed. Robert Wheaton and Tamara K. Hareven, Philadelphia, 1980, 49–83, an analysis of officiality records from the dioceses of Troyes and Châlons-sur-Marne for the second half of the fifteenth century, is unfortunately seriously flawed; see Brundage, 501. For additional bibliography and some important general observations, see Charles Donahue, Jr., "The Canon Law on the Formation of Marriage and Social Practice in the Later Middle Ages," *Journal of Family History* 8 (1983): 144–58. A consensus is developing that clandestine marriage, while relatively common in the fourteenth century, became far less so in the fifteenth century. See also R. H. Helmholz,

Marriage Litigation in Medieval England, Cambridge, 1974, 128–29, 166–67. Particularly significant for understanding the double portrait are the different consequences of clandestine marriage for different social classes. Like dying intestate, clandestine marriage caused far greater problems for the wealthy than for the poor.

53. For twelfth-century discussion about the formation of the sacramental marriage bond, see Gérard Fransen, "La formation du lien matrimonial au moyen âge," *Revue de droit canonique* 21 (1971): 106–26.

54. Le Bras (1968), 193–94.

55. Le Bras (1927), 2196–219; Dauvillier, 12–13; see also Seamus P. Heany, *The Development of the Sacramentality of Marriage from Anselm of Laon to Thomas Aquinas,* Washington, 1963.

56. Ritzer, 384–85.

57. This idea of mutual *traditio* seems to have been first developed by Vacarius in the second half of the twelfth century; see F. W. Maitland, "Magistri Vacarii Summa de Matrimonio," *Law Quarterly Review* 13 (1897): 133–43, 270–87, especially 274 for the passage quoted below. *Traditio* as the transfer of property in Roman law is Vacarius's point of departure, but on the basis of the spurious Augustinian text discussed above in n. 24 Vacarius relates this to a mutual *traditio* of the spouses to each other: "Quod autem corporalis etiam traditionis et quasi possessionis sit coniunctio matrimonii probatur in uerbo decreti [i.e. the spurious Augustinian text]. . . . Ergo re, id est, mutua susceptione contrahitur coniugium."

58. Dauvillier, 77–84; Le Bras (1927), 2184–86; Molin and Mutembe, 102. For a succinct statement by Aquinas, see *Summa theologiae,* Supplementum, Q. 45 a. 2. Scholarship on the Arnolfini double portrait has been characterized by considerable confusion about how the marriage bond was constituted. Although the consummation of a marriage remained of great importance in popular custom—see e.g. Le Bras (1927), 2186—from the early thirteenth century on, as far as canon law was concerned, the indissoluble sacramental marriage bond was formed solely by the consent of the parties in the present tense, and consummation added nothing but an "accidental perfection" to the marriage. The only possible exception was that an unconsummated marriage under certain conditions could be dissolved if one or both parties wished to enter a religious order; for a summary, see Donahue (1976), 252 n. 2. See also Chapter 3, n. 4.

59. Le Bras (1927), 2204; Dauvillier, 99.

60. The common assumption of modern writers (e.g. Molin and Mutembe, 89) that from the beginning the marriage rite "in the face of the church" was characterized by a joining of right hands is at variance with the evidence. None of the early marriage *ordines* from northern France published by Molin and Mutembe (II–V as well as VIII and XIV) mention a joining of right hands. The woman is simply given ("datur") or turned over ("tradat") to her husband, first by relatives or friends, and then by the priest. In *ordo* III the husband

holds his wife by the right hand ("per manum dexteram teneat eam") after the *traditio,* and in *ordo* V the one who is to give the bride takes her by the right hand to effect the *traditio,* but these texts make no reference to a joining of hands, nor do they mention which hand the groom is to use in receiving the bride. Since the same ambiguity is reflected in depictions of marriage well into the fourteenth century, where left and right hands of the bride and groom are used variously to effect the *traditio* / consent gesture (see Fig. 16 and n. 65 below), evidently a fixed usage had not yet been established. The earliest specific reference in the Molin and Mutembe *ordines* to a joining of right hands by the priest is found in *ordo* XI, a ritual of the second half of the thirteenth century from the Paris region, where the gesture accompanies a betrothal rather than a marriage and symbolizes the giving of *fides* as a promise of future marriage. *Ordo* XIII, a Parisian ritual of the early fourteenth century, is the earliest example I have found where the priest actually joins the right hands in a marriage rite "as they do who bind themselves by a solemn promise"—"sicut faciunt qui fide se obligant" (Molin and Mutembe offer two very different translations of this passage; that on 101 is correct, whereas that on 85 and 92 is not). During the fourteenth century the joining of right hands became the standard marriage gesture almost everywhere in northern Europe, and its widespread adoption is reflected in marriage iconography of the fifteenth century. Use of the wedding ring was never standardized, however, and thus even in the twentieth century, as in the fifteenth, it is placed on either the right hand or the left according to regional custom.

61. A Rouen missal said to be of the fourteenth century, first published by Martène (*ordo* VII) and now lost, has both the closing formula and the blessing; the same text is *ordo* XIV in Molin and Mutembe, 303–5.

62. For this panel, see Elfriede Baum, *Katalog des Museums mittelalterlicher österreichischer Kunst,* Vienna, 1971, 76–78.

63. Conversely, when an Austrian painter worked in northern Italy, he also depicted the ring ceremony rather than the hand-joining gesture; see ibid., 180 and fig. 169, for a *Marriage of the Virgin* painted in Bolzano c. 1450–60 by Lienhard Scherhauff. In the 1470s a Florentine miniaturist depicting the *Marriage of Hosea* in the Bible of Federico da Montefeltro (Vatican Library ms. Urb. lat. 2, fol. 151v) did show the high priest about to join the couple's right hands; see Annarosa Garzelli, *Miniatura fiorentina del rinascimento 1440–1525,* Florence, 1985, fig. 467. Presumably his intent, under the influence of humanistic ideas, was an "authentic" representation of a biblical marriage, based on the Vulgate text of Tobit 7:15, rather than the depiction of a contemporary Italian ceremony as in the other examples cited here.

64. Max Sander, *Le livre à figures italien depuis 1467 jusqu'à 1530,* Milan, 1942; reprint Nendeln, Liechtenstein, 1969, nos. 1215, 3263, 3281.

65. The earliest isolated examples appear in northern Europe toward the end of the thirteenth

century. Cf. also the investigations of Andrzej Grzybkowski, "Die Dextrarum iunctio auf dem Grabmal in Löwenberg," *Zeitschrift für Kunstgeschichte* 47 (1984): 59–69. In Byzantine art too the *dextrarum iunctio* disappears after the sixth century and is replaced by an entirely different matrimonial gesture; see Reekmans, 88. That the linking of right hands had not yet definitively established itself as the characteristic northern European marriage gesture would seem to provide the best explanation for early fourteenth-century miniatures that indifferently depict the linking of the spouses' left and right hands; e.g. Melnikas, 3:986, fig. 32; 1040, fig. 17; 1041, fig. 18; 1156, figs. 19–20; 1157, fig. 21. Molin, 357 n. 16, lists other examples but in some cases mistakes the Italian ring ceremony for a linking of hands. Bedaux's supposed examples of right/left-handed marriages in the fifteenth century (24–25) are generally based on a misunderstanding; e.g. his fig. 3, a miniature from British Library ms. Add. 10043, illustrates chapter 8 of the Book of Tobit and does not relate to the marriage of Tobias and Sarah (see fig. 4 of the original publication in *Simiolus* 16 [1986]: 9, where the text has not been cropped); see n. 73 below for an Oxford Bible moralisée illumination. See also the two notes (both concerning miniatures of the fourteenth century) of Lucy Freeman Sandler in *Art Bulletin* 66 (1984): 488–91, and 68 (1986): 326; the latter is particularly interesting, but it illustrates the marriage of a centaur to Vain Glory and is thus not really comparable to what might be presumed normal practice.

66. Frugoni, 926–27, 932–33.

67. The gesture is described in a well-known passage in Galbert of Bruges (see F. L. Ganshof, *Feudalism*, London, 1952, 65–67) in which a new count of Flanders received the hommage of his vassals in 1127. See also ibid., 26–28; and Jacques Le Goff, *Pour un autre moyen âge,* Paris, 1977, 351.

68. Although written in Italy, Vat. lat. 1370 was illuminated in France, probably in Paris; see Kuttner, 1:146–47.

69. Panofsky, 1934, 125; Panofsky, 1953, 1:438.

70. For the date of Vat. lat. 2491, see Kuttner 2:60–61. Molin, 356 n. 15, cites other thirteenth- and fourteenth-century miniatures of this type and, like Panofsky, attempts to relate the gesture to the swearing of an oath, but his only supporting evidence is drawn from rituals of the sixteenth century. For further discussion of this mistaken idea, see below, Chapter 3, n. 37. It is well to bear in mind that fourteenth-century miniaturists still had great difficulty knowing what to do with hands, and consequently what may appear a meaningful gesture is often no more than the result of the artist's failure to resolve this technical problem; for many examples, see Melnikas.

71. On this manuscript and its uncertain date (which is in any event no earlier than c. 1260), see Nigel Morgan, *Early Gothic Manuscripts (II), 1250–1285,* London, 1988, cat. no. 119. I know of no other example before the very end of the century. The service book held by the acolyte in the Hereford miniature is inscribed with the opening words ("Deus Abraham,

Deus . . .") of an oration known (because it was taken from the Vulgate text of Tobit 7:15) as the "blessing of Tobit": "The God of Abraham, and the God of Isaac, and the God of Jacob be with you, and may he join you together, and fulfill his blessing in you." This blessing of the spouses often concluded the church-door ceremony in the earliest rituals for marriage "in the face of the church" (e.g. in Martène's *ordines* II–IV; Martène, 2:356–57, 360). As previously mentioned, however, these rituals make as yet no reference to the joining of right hands. The Hereford miniature is thus of great interest as perhaps the earliest known instance where this blessing is associated with the joining of right hands.

72. Goff A-1122.

73. The iconography of the marriage of Adam and Eve as studied by Adelheid Heimann, "Die Hochzeit von Adam und Eva im Paradies nebst einigen anderen Hochzeitsbildern," *Wallraf-Richartz-Jahrbuch* 37 (1975): 11–40, follows a similar evolution. The subject first appears in a series of related Bible moralisée illuminations of the thirteenth century, the best known of which is the often reproduced imagery of Bodleian Library ms. Bodl. 270b, fol. 6r (see e.g. Bedaux, *Simiolus* 16 (1986): 8, fig. 2). The accompanying text identifies the image as the "matrimonium" of Adam and Eve, seen as a prototype for the marriage of Christ to the Church. In the Adam and Eve medallion God takes each by *both* of their hands to bring them together (the text for this reads: "adduxit eam [i.e. the woman] ad Adam"); the same two-handed *deductio* of Eve to Adam is repeated in British Library ms. Add. 18719, fol. 7v, of around 1300. The iconography then changes abruptly (although Heimann does not note the change) and remains constant thereafter in Heimann's many examples, with the Creator instead joining the right hands of Adam and Eve in what had become the conventional northern European marriage gesture by the fourteenth century, as in Plate 5, where the marriage of Adam and Eve, no longer a foreshadowing of the marriage of Christ to Ecclesia, is rather the Old Testament archetype for the sacrament of matrimony.

74. On this *rituale,* which is Martène's *ordo* XIII (2:382–84), see Aimé-Georges Martimort, *La documentation liturgique de Dom Edmond Martène,* Studi e testi, 279, Vatican City, 1978, no. 252, 179–80.

75. For this *rituale* and missal (Ville Cod. 13), one of the few manuscripts saved from a fire that destroyed the Bibliothèque centrale of Tournai in 1940, see Paul Faider and Pierre Van Sint Jan, *Catalogue des manuscrits conservés à Tournai,* Gembloux, 1950, 42–44.

76. Ghent *rituale* of 1576 and *Manuale pastorum per diocesim Tornacensem,* Louvain and Tournai, 1591. Under the heading "Ordo celebrandi Sacramentum Matrimonii," this passage in the 1576 *rituale* (54–57) reads: "coniunctis dextris ambarum, eas stola inuoluet." The words of consent follow, after which the priest says: "Et ego tanquam Ecclesie minister vos coniungo in Matrimonium, in nomine Patris, et Filii, et Spiritus Sancti. Amen." The stole is then removed, and the ring ceremony ensues. Efforts to find an earlier Flemish marriage

ordo have been unsuccessful; e.g. an incunabulum missal for the diocese of Tournai, the *Missale Tornacense* of Johannes Higman, Paris, 1498 (Goff M-727), has the nuptial mass and blessing but no *ordo* for the marriage service itself, and a fifteenth-century *rituale* in the Stedelijke Openbare Bibliotheek of Bruges (ms. 316) also lacks a marriage service.

77. The numerous other representations of this stole-binding rite in Netherlandish works of the fifteenth and sixteenth centuries indicate that regionally it was considered the proto-typical marriage gesture.

78. Panofsky, 1934, 125, and Panofsky, 1953, 1:439 nn. 3, where reference is made to H. Rosenau, "Some English Influences on Jan van Eyck, with Special Reference to the Arnolfini Por-trait," *Apollo* 36 (1942): 125–28, for tomb slabs with the "somewhat unorthodox" linking of left and right hands. All of Rosenau's English tomb effigies, however, as she herself notes, depict the *dextrarum iunctio,* nor is there any example of the linking of left and right hands among the nearly 450 plates in *Monumental Brasses: The Portfolio Plates of the Monumental Brass Society, 1894–1984,* London, 1988.

79. Panofsky, 1953, 1:536; for rituals where left and right hands are joined, see Molin and Mutembe, 97, 246–47.

80. Panofsky, 1953, 1:202. Friedländer, 1967–76, 1:41, Weale, 71.

81. Davies, 1954, 125. Panofsky, 1934, 117, refers to this inventory description of the gesture as "joining hands."

82. Ibid., 117–18.

Chapter 3

1. *Oxford English Dictionary,* 2d ed., Oxford, 1989, 5:396. Cf. the definition s.v. "espouse" in John Kersey, *Dictionarium Anglo-Britannicum,* London, 1708: "to Betroth, Wed, or take in Marriage."

2. Panofsky, 1934, 123. The confusion stems from nineteenth-century works cited by Panofsky that were based largely on twelfth-century sources. These authors in turn naturally reflect the controversies of their own time rather than the more fully developed medieval ideas about marriage found in writers of the thirteenth century and later.

3. From the thirteenth century on, legal treatises analyze whether the tense is present or future in sample expressions of consent; see for example Durantis, *Speculum iudiciale,* 4.4.1 (ed. 1574, 2:438–39). In 1310 the bishop of Cambrai amended the marriage legislation of the provincial council of 1304 (see text of Chapter 2 at n. 38), prescribing for his diocese specific words of future consent "in sponsalibus seu fidedationibus" to avoid possible confusion among simple persons, whether clergy or laity; Edmond Martène and Ursin Durand, *Ve-terum scriptorum et monumentorum amplissima collectio,* Paris, 1724–33; reprint, New York, 1968, 7:1338.

4. *Decretum* C. 27 q. 2 c. 34; see also Gaudemet, 379–91, and Brundage, 235–36. Later writers, particularly from the time of Hostiensis, adjusted Gratian's terminology to suit the consensualist position; Antoninus provides a convenient fifteenth-century example. The contracting of matrimony, he says, is initiated by "sponsalia with words of the future," ratified "by words of the present or other signs expressing consent" and consummated by sexual union. Noting that this sequence of actions constitutes common practice, he adds it is not necessary that "sponsalia" precede, because matrimony can be "immediately contracted by words of the present," or that sexual union follow, since (and this was the standard reason) the marriage of Mary and Joseph was perfect with respect to the "essence" of matrimony; *Summa,* Pars tertia, t. 1 c. 18 (ed. 1740, 3:64–65). It should be noted that neither here nor elsewhere does Antoninus refer to "verba de praesenti" as *sponsalia.* See also n. 13 below.

5. Ives of Chartres is said (see Ritzer, 374) to have been the first to distinguish between *fides pactionis* and *fides consensus;* the same distinction is also found in the writings of his contemporary Anselm of Laon; see Le Bras (1927), 2142. These ideas continued to be advanced by twelfth-century theologians in Paris, including Hugh of St. Victor and Peter Lombard. See also Esmein, 1:134–36, and Gaudemet, 40–41. For the spurious Augustinian text in the canon law that similarly juxtaposes the two terms, see above, Chapter 2, n. 24. The fundamentally important distinction between future and present consent was based on this difference between betrothal and matrimonial *fides.*

6. Raymond of Peñafort's usage is typical of that found from the thirteenth century on, as for example in the following passage (the omissions are various illustrations of future and present consent): "Quoniam matrimonium sponsalia praecedere consueverunt, ideo primo loco de sponsalibus est agendum. . . . et ista sunt vera sponsalia, quando sic per verba de futuro contrahuntur; si vero per verba praesentis temporis contrahuntur. . . . talia dicuntur sponsalia de praesenti, sed improprie, quia vere est matrimonum" (*Summa* 4. t. 1 [ed. 1725, 739–41]).

7. On this Italian marriage rite, see Klapisch-Zuber, 178–212, and the collected studies of Brandileone, which are particularly useful for the documents included.

8. Altieri, 49–53, 67–69 (see also Brandileone, 291–307).

9. As for example in the *Rituale romanum,* Bologna, 1487 (Goff R-201), fols. 10v–14v.

10. Brandileone, 102–3.

11. The *Formularium diversorum contractum secundum stilum et modum florentinum* containing the text of this marriage ritual was printed a number of times in the fifteenth century, beginning with Florentine editions of c. 1487 and 1488; see Goff F-249–F-252. The full text from the earliest printed edition is given in the Appendix. As the short form of the notarial instrument stresses, the consent was symbolized by the mutual *giving* and *receiving* of the ring; Klapisch-Zuber's interpretation of the ring (39) is not compatible with this text.

12. There may be a simple explanation for the omission of the religious ceremony in Florence.

By the second half of the fifteenth century upper-class Florentine marriages were often consummated in the house of the groom's father-in-law the day the marriage was contracted by the *subarrhatio anuli* ceremony, or shortly thereafter. The reason for this practice was that many Florentine dowries were financed through a state dowry fund known as the *Monte delle doti,* whose regulations stipulated that the marriage must be consummated before the dowry could be paid (see below, Chapter 4 at n. 23, and Klapisch-Zuber, 189–91). Because the bride was thus no longer a virgin when conducted to her husband's house, there could be no nuptial blessing in a religious service, which elsewhere was normally part of the *nozze.* The great emphasis Altieri places on the virginity of the bride when she was taken to her husband's house underscores a major difference between marriage customs in Rome and Florence.

13. Antoninus, *Confessionale,* says (fols. 60v–61r) that "questo sacramento del matrimonio quanto a la essentia sua, allhora e perfecto quando . . . secondo che comunemente si usa il notaio . . . domanda l'huomo se vuole tale donna per mogliera, et lui risponde si, dippoi domanda la donna se vuole tale huomo per suo legitimo sponso, similmente risponde de si, con parole, o altri segni sufficienti a dichiarare loro consentimento. . . . Et tale matrimonio cosi contratto per parole de presenti in caso nessuno si puo dissoluere." As for the religious ceremony, he says (fols. 61v–62r): "se e primo matrimonio da l'una parte et dal'altra non debbe menare la moglie se prima non ode la messa del coniugio et faccendo il contrario dove che e la consuetudine di udire tale messa, et di aspettare la benedittione del prete avanti la consumatione del matrimonio peccherebbe mortalmente. Ma quando da l'una parte et l'altra fusse secondo matrimonio, non debbono udire tale messa et il sacerdote che benedice le seconde nozze, pecca mortalmente et da le leggi canonice e punito."

14. For this miniature, see *Medieval and Renaissance Miniatures from the National Gallery of Art,* Washington, D.C., 1975, 50–52. A closely related miniature from another manuscript (which unfortunately is not identified) is reproduced in *Studia Gratiana* 12 (1967): pl. IV.

15. Castiglione alludes to this practice of holding a falcon in book 2 of *Il Cortegiano,* noting that it was formerly acceptable to carry a sparrow hawk on the wrist for no other reason than to cut a good figure.

16. For an example of a marriage conducted in the street before the bride's house, see Brandileone, 108, and for a *sponsalia* instrument in which the groom agrees to pay an additional sum "for the honor of the first kiss" at the marriage, ibid., 111.

17. The considerable confusion in recent scholarship seems to stem from Brandileone's frequent antithetical juxtaposition (e.g., 302–3) of what he anachronistically calls the "cerimonia civile" (i.e. the ring ceremony before the notary) and the "cerimonia ecclesiastica" (i.e. the nuptial blessing as part of the *nozze*). From a theological or canonical perspective the former, and not the latter, created the matrimonial bond and constituted the sacrament of matrimony, and thus it was certainly not a "civil ceremony" in the sense that term has

had since marriage rites were secularized in modern times. Klapisch-Zuber, 185–87, 195–96, understands that notaries and canonists refer to the ring ceremony as *matrimonium*, but there is a certain ambiguity about her presentation that leads Brundage, 497, citing these pages of Klapisch-Zuber, to conclude erroneously that the ring ceremony was "a formal betrothal . . . during which they [the couple] exchanged future consent." Elsewhere Klapisch-Zuber refers to the ring ceremony before the notary as "the preliminary exchange of consent" (190–91), but it was in fact the sacramental consent; see also n. 11 above. There is similar confusion in the attempt of Brucia Witthoft, "Marriage Rituals and Marriage Chests in Quattrocento Florence," *Artibus et historiae* 5 (1982): 56 n. 27, to differentiate between "actual marriage ceremonies" (i.e. the ring giving before a notary) and "pictures of the sacrament of marriage" (i.e. works like Raphael's *Sposalizio*); actually they are the same. In n. 26 Witthoft confuses betrothal and marriage rites and on 45 conflates northern and southern marriage ceremonies to introduce a spurious hand-joining rite into the Italian ring ceremony before a notary.

18. Altieri, 51.

19. Martin Davies, revised by Dillian Gordon, *The Early Italian Schools before 1400,* London, 1988, 86–88. For a similar example, see the "Marriage of Anna and Joachim" miniature in the *Visconti Hours;* Millard Meiss and Edith Kirsch, *The Visconti Hours,* New York, 1972, BR fol. 1r.

20. For a short introduction to these matters, see C. R. Cheney, *Notaries Public in England,* Oxford, 1972, 1–11. See also Boüard, 2:216–17, as well as pl. 39 in the accompanying album of illustrations. For Flemish notaries by papal and imperial commission, see Murray, 158–59.

21. For the full text of Alexander III's letter, codified in abbreviated form as *Decretales* 4.4.3, see Friedberg 2:681: "praesente scilicet sacerdote aut etiam notario, sicut etiam in quibusdam locis adhuc observatur." The notary as witness to matrimonial consent has been studied in detail by Peter Leisching, "Eheschliessungen vor dem Notar im 13. Jahrhundert," *Zeitschrift der Savigny-Stiftung für Rechtsgeschichte: Kanonische Abteilung,* 94 (1977): 20–46.

22. Mansi 35:247.

23. Brucker, 16.

24. For a poor girl whose ring ceremony was witnessed by the clergy of Santa Trinità in Florence, see Klapisch-Zuber, 196 n. 65. In those parts of Italy where the present consent was exchanged before a priest *in facie ecclesiae,* the consent was also commonly recorded in a public instrument drawn up by a notary; see Brandileone, 111–12.

25. This is a reasonable assumption based on the presence of the ring ceremony (it follows immediately after the binding of the joined hands with the priest's stole) both in Martène's *ordo* XIII and in the Ghent *rituale* of 1576 (see Chapter 2, nn. 74 and 76).

26. *Digest* 23.1.1 and *Institutes* 1.9.1, the latter sometimes conflated with *Digest* 23.2.1. From the

thirteenth century these definitions are standard in canon law commentaries; see for example Hostiensis, *Summa* (ed. 1537, fols. 193r, 194v).

27. These various ways to dissolve a betrothal constitute a conventional list found in popular handbooks on the sacraments like the *Manipulus curatorum* of Guido de Monte Rochen or the *Confessionale* of Antoninus as well as in academic works such as the *Summa* of Hostiensis (ed. 1537, fol. 194r). See also Antoninus, *Summa,* Pars tertia, t. 1. c. 18 (ed. 1740, 3:67–68). Although modern writers on late medieval marriage often state that *sponsalia* were binding, they were not as far as canon law was concerned. According to the acts of a Florentine provincial council in 1517 (Mansi, 35:247), for instance, "sponsalia de futuro . . . si possono dissolvere di consentimento delle parti" with the bishop's approval. Even when other approaches failed, it was still possible to break a betrothal promise by exchanging *verba de praesenti* with a third party, for when such cases came before ecclesiastical courts, words of present consent almost invariably took precedence over *sponsalia.* Important persons nonetheless often sought to have *sponsalia* that did not lead to marriage formally dissolved by the pope to ensure there would be no complications if other matrimonial arrangements were made later; see *Calendar of Papal Registers* 12:150–51 for a case where a countess claimed to have feigned betrothal to a knight to secure protection for herself during the Wars of the Roses; see Bennett, 37–39, for another example.

28. See W. L. Schreiber, *Handbuch der Holz- und Metallschnitte des XV. Jahrhunderts,* 4 (Leipzig, 1927): 125, no. 1991, where the inscription is transcribed.

29. The four ways to contract *sponsalia* are a commonplace, found in virtually any discussion of marriage during this period, whether that of theologians like Aquinas and Antoninus, canonists like Hostiensis and Durantis, or popular handbooks like those mentioned in n. 27 above. In the early 1240s Goffredus de Trano (*Summa,* ed. 1519, fol. 175r) distinguished the matrimonial *subarrhatio anuli* (both in its Italian and northern European "in the face of the church" form) from the betrothal *subarrhatio anuli* on the basis of the tense of the words accompanying the giving of the ring. For Hostiensis's use of *fides* to mean a betrothal oath, see *Summa,* ed. 1537, fol. 193r: "alia fide interposita seu iuramento quod idem est." For Antoninus (actually quoting Richardus de Mediavilla) on *fides* as a unilateral betrothal oath, see *Summa,* Pars tertia, t. 1 c. 18 (ed. 1740, 3:69): "quando datur fides ab alterutro, quod pertinere videtur ad juramentum." For a similar usage equating a betrothal oath with *fides,* again in the context of the four ways to contract *sponsalia,* see the *Dialogus de septem sacramentis,* probably by Guillelmus Parisiensis, a pastoral manual for priests written about 1300 and often reprinted in the fifteenth century, e.g. the Mainz edition c. 1492 (Goff G-720), fol. 54r: "Primo nuda promissione, ut dicendo accipiam te. Secundo datis arris sponsaliciis, sicut pecunia vel aliquo alio. Tercio anuli subarratione. Quarto iuramento interueniente vel fide."

30. Molin and Mutembe, *ordo* XI, 298–99.

31. Martène, *ordo* IX, 2:372.

32. Ghent *rituale* of 1576, 52–53. The essential formula of this "rite for solemnly celebrating *sponsalia*" is given in both Latin and the vernacular: "promitto me daturum fidem meam tibi N. quam hic manu teneo" becomes in the Dutch "mijn trauwe te gheuen . . . die ic haude metter handt." Conversely, in the "order for celebrating the sacrament of matrimony" (ibid., 54–55) the Latin form is "do tibi N. fidem meam maritalem," which becomes in the vernacular "mijn mannelicke trauwe" for the groom and "mijn vrauwelicke trauwe" for the bride.

33. Martène, *ordo* IX, 2:372.

34. Molin and Mutembe, 53.

35. Davies, 1954, 126; cf. also the text as given by Weale, lxxxv.

36. It is noteworthy, for example, that the Ghent *rituale* (see n. 32 above), published only eight years later, uses "trauwe" without further qualification for the *fides* of betrothal.

37. To justify *fides levata* as "the forearm raised in confirmation of the matrimonial oath," Panofsky cites only a text in Du Cange (3:490) that refers to the giving of *fides* by raising a finger in a context unrelated to marriage (see also Kelly, 174 n. 40). The assertion that "the *dextrarum iunctio* was called *fides manualis*" rests on a passage in Leclercq, 1895, where that author (not realizing that the pseudo-Augustinian text cited in the following note was spurious) specifically declined to equate the matrimonial *dextrarum iunctio* of antiquity with *fides manualis* as the medieval practice of agreeing to a contract by a handclasp. All modern references to *fides manualis* in the context of medieval marriage stem either from Leclercq or Panofsky (see for example Molin, 355, where Leclercq is quoted verbatim without acknowledgment). Molin and Mutembe (100, 117) have further complicated the issue by calling attention to the marriage service in late rituals from Thérouanne (1557) and Arras (1600) where the priest, while the couple's right hands are joined, tells them to "Levez la main aux saints" (obviously this could only be done with the left hand). These rituals are then used to explain miniatures like Figures 16 and 17, which are two to three centuries earlier (see also Molin, 356 n. 15). Although betrothal oaths are commonplace, these sixteenth-century "marriage oaths" are highly unusual—"tout à fait extravagant," as Molin and Mutembe (117) themselves note—and without medieval precedent; because of their rarity as well as their late date, they have no bearing either on the London double portrait or on miniatures of the late thirteenth or early fourteenth century. Furthermore, "Levez la main aux saints" has reference to a corporal oath (discussed later in this chapter) and not to an oath of the type seen in the double portrait; see Du Cange, 4:456, for several examples of oaths where the oath taker "leva sa main" toward the relics of saints. In a few late rituals (e.g., Martène, *ordo* IX, which Molin and Mutembe, 12, date to the fifteenth or sixteenth century) the words of consent are followed by a promise of fidelity linked with forms of *iurare,* but according to canonists, the use of *iurare* alone, without specific reference to God

or the touching action of a corporal oath, did not constitute an oath; see Ferraris, s.v. "juramentum," art. I, 39–42 (ed. 1782, 5:187). Cf. the usage in Martène, *ordo* X, where "jurez" is used synonymously with "promettez," and "fianciez."

38. *Decretales,* 4.4.1, gloss ad v. *pactionis et consensus:* "Hoc est dicere, una est fides desponsationis de futuro, et altera consensus de praesenti."

39. For example, in Molin and Mutembe, *ordo* X (a thirteenth-century pontifical from Arras), "date invicem fidem" refers to matrimonial consent, but in *ordo* XI (a thirteenth-century missal from Paris), "fidem super hoc ad invicem prebentibus" refers to the betrothal promise.

40. See *Oxford Latin Dictionary,* 697–98; and Niermeyer, 424–25.

41. For this document, see *The Secular Spirit: Life and Art at the End of the Middle Ages,* New York, 1975, cat. no. 249. It was not uncommon in Flanders for a notary to be also a priest; see Murray, 161.

42. Besides the *ordines* cited in nn. 30–33 above, the right hands are joined by the priest in the betrothal ceremonies of Martène's *ordines* XI–XIV, but some of these are later than the double portrait.

43. Bartholomaeus Caepolla, *Consilia ad diversas materias,* Venice, 1575, consilium VI, fols. 25v–27r. Maria, Sempronius, and Titius are conventional fictitious names used in legal literature of the time to designate the bride, her father or guardian, and the groom. At issue was whether Maria's actions constituted *de praesenti* consent; Caepolla concluded that it did not, making this a "sponsalia de futuro" and not a "matrimonium."

44. Altieri, 51; after a kiss the two men touch hands: "dunandose lo baso della bocca col toccarsece la mano." See also Klapisch-Zuber, 183. In modern Italian *toccamano* has come to mean a handclasp or handshake, but as the etymology of the word (from *toccare,* "to touch") indicates, this was not originally the case; in general, and for the definition quoted, see *Dizionario delle lingue italiana e inglese,* ed. Vladimiro Macchi, 2d ed., Parte prima, Florence, 1985, 1365.

45. See for example Oscar Bloch and Walther von Wartburg, *Dictionnaire étymologique de la langue française,* Paris, 1968, 640.

46. Gloss ad v. *percussit* to *Digest* 50.15.1: "vel dicitur pactum a percussione palmarum."

47. Larivey's *La Constance* is reprinted in Emmanuel Louis Nicolas Viollet-le-Duc's *Ancien théâtre français,* Paris, 1854–57, 6:195–302; for the passage cited (act 1, scene 2), 212.

48. For the text of Bernger's poem, "Wie solte ich armer der swaere getrûwen," see Hugo Moser and Helmut Tervooren, eds., *Des Minnesangs Frühling,* Stuttgart, 1977, 1:227–28; for the Codex Manesse, ibid., 2:44–47.

49. See the facsimile version edited by Ingo F. Walther, *Sämtliche Miniaturen der Manesse-Liederhandschrift,* Aachen, 1981, fols. 146r, 251r, 371r, 407r, 413v. This book is a good illus-

tration of Panofsky's pervasive influence: the author of the entry on the Von Horheim miniature (text to fol. 178r) speculates that it may, like the Arnolfini double portrait, represent a "secular" marriage. The right-hand gesture of the miniature is described as the "conjunctio per fidem manualem"; the requisite "fides levata" is noted as missing, but the hand on the sword is suggested as a substitute gesture; and the dog on the woman's arm is said to be a "Symbol der Treue." All these comments are made without specific reference to Panofsky.

50. Raymond of Peñafort, *Summa* 4. t. 1, gloss ad v. *illa respondet* (ed. 1725, 740). The description of the gesture reads as follows: "Quid si quis injecta manu, vel innexa manu mulieris dicat, do tibi fidem de te accipienda in uxorem."

51. Antoninus, *Summa,* Pars tertia, t. 1 c. 18 (ed. 1740, 3:65): "Unde si ante fidem sic datam tractabatur de sponsalibus vel matrimonio inter eos, et ipsa requisita sponte manum dedit ad fidem recipiendam et hujusmodi; tunc essent contracta sponsalia."

52. Ferraris, s.v. "sponsalia," 44 (ed. 1782, 8:463): "per porrectionem manus ab uno factam, et ab altera sine renitentia, et contradictione acceptatam censentur, et praesumuntur contracta sponsalia."

53. For the Arsenal and Vatican *Decameron* manuscripts, see the Bibliothèque Nationale exhibition catalogue *Boccace en France: De l'humanisme à l'érotisme,* Paris, 1975, 58–60; Dogaer, 14, 33, 43; Meiss (1967), 56–61; and Eberhard König, *Boccaccio Decameron,* Stuttgart, 1989, which illustrates all the Vatican Palatinus miniatures in color.

54. Boccaccio's usage, consistent throughout the *Decameron,* is exemplified by the tale of Alessandro and the "abbot" in 2.3. The couple's clandestine marriage takes place in the "abbot's" bed, before an image of Christ, as Alessandro places a ring on the woman's hand and "gli si fece sposare." Later, when relating to the pope what happened, the "abbot" refers to that episode as "il contratto matrimonio" between herself and Alessandro, made "solamente nella presenza di Dio." Because the first marriage was clandestine, the ceremony had to be repeated in the pope's presence ("e quivi da capo fece solennemente le sponsalizie celebrare") and was followed by the *nozze,* or marriage festivities. In 10.10, Griselda—wearing a bridal crown—exchanges words of present consent with Gualtieri, who thus "in presenza di tutti la sposò"; the bride then mounts the traditional palfrey for the *deductio* to her husband's house, where the "nozze belle e grandi" were worthy of a daughter of the king of France. Modern critics have sometimes misunderstood Boccaccio's terminology; see for example Vittore Branca's edition of the *Decameron,* Florence, 1965, 156 n. 1, 626 n. 1, 656 n. 1. Contemporary French usage is illustrated by Martène's *ordo* IX, which begins with a formal betrothal rite in the presence of a priest. A rubric then introduces the marriage ceremony proper, which follows at some later date: "On the day of the nuptials [i.e. the *noces*] when the couple are before the entrance of the church the priest says, 'Bonnes gens, nous sommes icy assemblez pour faire le mariage de *N. & N.*'"

55. Laurent de Premierfait, *Le livre cameron,* Paris, 1521, fol. 135r.

56. Besides the three miniatures discussed here, further examples of betrothal gestures illustrate 5.4 and 10.6.

57. Significantly, in all the other *Decameron* betrothal miniatures the two right hands are used for the characteristic *sponsalia* gesture.

58. For this manuscript, see *Le siècle d'or de la minature flamande: Le mécènat de Philippe le Bon,* Brussels, 1959, 132–34.

59. Joseph Kervyn de Lettenhove, ed., *Oeuvres de Froissart—Chroniques,* 1867–77; reprint, Osnabrück, 1967, 15:237, 302–6. This marriage was highly unusual in that canon law prohibited marriage before puberty (reckoned at twelve years for females and fourteen for males); *Decretales* 4.2.2 made an exception on grounds of urgent necessity "pro bono pacis" to foster peace and prevent war, which was in fact why this Anglo-French marriage was arranged.

60. That the miniature in Fig. 33 is a composite can be confirmed by comparing it with the corresponding miniature in the famous Breslau Froissart (Arthur Linder, *Der Breslauer Froissart,* Berlin, 1912, pl. 47), which depicts in several scenes the events of the two-day encampment as described by the author. The illuminator of the Paris manuscript has conflated two of these scenes into one image: the initial meeting of the two kings between flanks of kneeling soldiers, which was the inaugural ceremony of the first day, with the delivery of Isabelle to Richard, the final event of the second day.

61. These details are from an eyewitness account of the Burgundian embassy, which included Van Eyck, that was dispatched to Portugal in 1428–29; for the two ceremonies, see Weale, lxii, lxxi–lxxii. The bride arrived on Christmas day, and the private ceremony took place on 7 January, i.e. immediately after Twelfth Night and the end of the Christmas festivities.

62. Ferraris, s.v. "juramentum," art. I, 5 (ed. 1782, 5:180); see also N. Iung, "Serment," *Dictionnaire de théologie catholique,* 14 (1939): 1940–56, especially 1943; and Bernard Guindon, *Le serment: Son histoire, son caractère sacré,* Ottawa, 1957, 126–29. When verbal formulas were combined with gestures, the oath was termed "mixed."

63. Pelbartus of Themeswar, *Aureum sacrae theologiae rosarium iuxta quattuor sententiarum libros quadripartitum,* Venice, 1586, 3:178v. Aquinas makes the same point in *Summa theologiae,* 2a-2ae, q. 89, a. 6.

64. See for example Brandileone, 105, 107.

65. Antoninus, *Summa,* Pars secunda, t. 10 c. 5 (ed. 1740, 2:1076). Canon law required physical contact with the Gospels; see the gloss ad v. *tacta* to *Constitutiones Clementinae* 5.3.1.

66. The window is illustrated in Prevenier and Blockmans, fig. 128.

67. For examples of oaths sworn in this fashion, see Du Cange, 4:456–57, in one instance with specific reference to the biblical text: "Extendamus dexteras nostras ad justum judicium Dei, et tunc manus dextras uterque ad coelum extendat."

68. The authenticity of the picture's representation of two forms of the solemn oath is verified by Johan Cools's eyewitness account of the ceremony, which notes that the Spaniards swore by placing their right hands on the Gospels and then kissing a crucifix, while the Dutch swore by raising their right hands; see the National Gallery exhibition catalogue, *Art in Seventeenth Century Holland,* London, 1976, 24.

69. For other modern survivals, see *Encyclopaedia Britannica,* 11th ed., 19:940. A French clerical canon law handbook of the nineteenth century notes simply that the laity swear by raising the right hand: "en levant la main droite comme font les séculiers"; see Michel André, *Cours alphabétique et méthodique de droit canon,* 2 vols., Paris, 1844, 2:1064.

70. For further examples of both forms, see Frederick van der Meer, *Apocalypse: Visions from the Book of Revelation in Western Art,* London, 1978, figs. 59, 106, 147. The open-hand gesture also appears in the Angers Apocalypse tapestries, woven in Paris in the 1370s for Louis of Anjou, the brother of Jean de Berry and Philip the Bold of Burgundy.

71. It should be further noted that in the Ghent *rituale* of 1576 (see n. 32 above), printed less than a decade after Van Vaernewyck's description, "trauwe," used without further qualification, refers to the betrothal promise and not the matrimonial consent, and since Van Vaernewyck capitalizes other common nouns, it is not necessarily significant, as Panofsky argued, that he used a majuscule for *fides.*

72. Derived from Panofsky, these ideas were elaborated by others—for example Baldass, 74, who linked the supposed nuptial chamber with the mistaken idea that consummation was necessary "to complete the validity of the marriage," and those who anachronistically read sexual symbolism into the bed; see the cautionary remarks in Mercer, 63 and 74. See also Chapter 2, n. 58.

73. Eames (reprinting as an appendix a lengthy extract of Aliénor's *Les honneurs de la cour* from La Curne de Sainte-Palaye, *Mémoires sur l'ancienne chevalerie,* Paris, 1759), 260. Because of the obvious incongruity between the object and its setting, the Boucicaut Master's use of the hung bed is particularly striking, for twice in the Boucicaut Hours an elaborately hung bed is introduced into the otherwise rustic surroundings of the Nativity stable: first it serves as a *lit de repos* for the Child, and then, in the *Adoration of the Magi* miniature, it becomes a thronelike seat of estate for the Virgin and Child; see Millard Meiss, *French Painting in the Time of Jean de Berry: The Boucicaut Master,* London, 1968, pls. 31 and 33.

74. Eames, 75–78, 85–86, 181, 198, 240–42; for the chair, 258: "une grande chaise à hault dos par derriere, comme ces grandes chaises du temps passé."

75. For this picture, sometimes attributed to Petrus Christus, see C. Aru and Et. de Geradon, *La Galerie Sabauda de Turin (Les Primitifs Flamands,* I.2), Antwerp, 1952, 1–5.

76. Many other early Netherlandish works document this location for the hung bed, for example the left wing of Rogier's Saint John the Baptist Altarpiece or the *Annunciation* panel in the Berlin altar wing of Petrus Christus. Van Eyck has apparently given a simplified

representation of the chamber in the double portrait, limiting himself to the portion of the room that is reflected in the mirror. A comparison with other contemporary depictions of Flemish interiors suggests that a room with so much furniture for sitting disposed along the back wall, as well as such an elaborate chandelier, probably also had a fireplace.

77. Eames, 86.

78. Altieri, 50–51; Klapisch-Zuber, 184–85; see also Brandileone, 105, 107.

79. Léon Mirot, "Etudes Lucquoises," *Bibliothèque de l'Ecole des Chartes,* 88 (1927): 78–80, 83–86; 91 (1930): 103–14.

80. C. A. J. Armstrong, "La politique matrimoniale des ducs de Bourgogne de la maison de Valois," *Annales de Bourgogne* 40 (1968): 5–58, 89–142, especially 42–43. Sample forms for such documents are given by Durantis, *Speculum iudiciale,* 4.4.1 and 4.4.19 (ed. 1574, 2: 440, 471). For a short summary of fifteenth-century law on both the dowry and the dower, see Antoninus, *Summa,* Pars tertia t. 1 c. 23 (ed. 1740, 3:111–14).

81. The couple portrayed in the Dessau panel are commonly identified, on the basis of a copy made c. 1550, as Berthold Tucher and Christiana Schmidtmayerin, but for various reasons (e.g. Christina was born only in 1465) this identification requires rejection of the 1475 date on the panel; see Ernst Buchner, *Das deutsche Bildnis der Spätgotik und der frühen Dürerzeit,* Berlin, 1953, 176–78, 219–20, where there are numerous mistakes in transcribing the text on the copy. It is surely more plausible to accept the date on the panel as correct and to question instead the sitters' identity, which rests only on the testimony of the much later copy. For the Fürstenberg panel, see ibid., 170.

82. The standard work on German marriage rituals is Basilius Binder, *Geschichte des feierlichen Ehesegens,* Abtei Metten, 1938; the material discussed here is summarized by Kenneth Stevenson, *Nuptial Blessing: A Study of Christian Marriage Rites,* New York, 1983, 88–91.

83. Conversely, in the iconography of the mystic marriage of Saint Catherine in both northern and southern Europe the ring is placed on the saint's finger by the Child.

84. Altieri, 51.

85. Herlihy and Klapisch-Zuber, 226–28.

86. Mirot and Lazzareschi, 84–85.

87. Herlihy and Klapisch-Zuber, 210–11, 226–28; Brucker, 78.

Chapter 4

1. Disguised symbolism and Panofsky's views about iconography / iconology are now part of the much larger issue of Panofsky himself; see for example the papers of the Paris symposium, *Erwin Panofsky: Cahiers pour un temps,* ed. Jacques Bonnet, Paris, 1983; Michael Ann Holly, *Panofsky and the Foundations of Art History,* Ithaca, N.Y., 1984, with reference to earlier criticism; Silvia Ferretti, *Cassirer, Panofsky, and Warburg: Symbol, Art, and History,*

trans. Richard Pierce, New Haven, Conn., 1989, and the works cited by Bedaux, 19 n. 1. Anecdotes circulate that Panofsky was at times distressed by applications of his theory of disguised symbolism (see Holly, 164; Bedaux, 14).

2. Because the English edition renders these and other passages rather freely (e.g. the reference to the picture as "a kind of snapshot" is not justified by the German text), see Friedländer (1934–37), 1 (originally published Berlin, 1924), 56: "Stimmung sakramentaler Symbolik" and 1:57: "Auch dem geringsten Dinge wird . . . Bedeutung und Wert eines Kultgegenstandes verliehen." For a similar instance of the eclectic genesis of Panofsky's iconographic ideas, see Lubomír Konečný, "On the Track of Panofsky," *Journal of Medieval and Renaissance Studies* 4 (1974): 29–34.

3. Panofsky, 1934, 126.

4. Ibid.

5. Panofsky, 1953, 1:203, 180.

6. Ibid., 142.

7. For example, among the Romanesque capitals of Saint-Pierre in Chauvigny, one that depicts Saint Michael weighing a soul in a balance has inscriptions identifying the two main figures: "Micael Arcangelus" and "Hic est diabolus." Across the top of another portraying the Adoration of the Magi on its principal surface the artist has inscribed his name, "Gofridus me fecit," in letters that are clearly legible from the nave and choir. Both by content and grammatical construction, these simple inscriptions closely parallel those found on Van Eyck's works.

8. Panofsky, 1953, 1:137, 143.

9. This interpretation of the towel has become a commonplace, but see, for instance, Dhanens, 93; and Albert Châtelet, *Van Eyck,* New York, 1980, 22 and pl. 21.

10. Joannes Molanus, *De historia ss. imaginum et picturarum,* ed. Joannes Paquot, Louvain, 1771, 274–75.

11. See Chapter 1, nn. 23–24; the works cited in n. 1 above; and the review of Holly (cited in n. 1) by Paul Crowther in *American Historical Review* 91 (1986): 87: "The question of criteria for determining the validity of iconological interpretations is not given adequate consideration. Without such criteria, the way is clear for an empiricist scepticism toward the worth of iconology as such."

12. Dhanens, 198, 203.

13. Brooke, 282.

14. Myriam Greilsammer, *L'envers du tableau: Mariage et maternité en Flandre médiévale,* Paris, 1990, 46–49.

15. Robert Baldwin, "Marriage as a Sacramental Reflection of the Passion: The Mirror in Jan van Eyck's *Arnolfini Wedding,*" *Oud Holland* 98 (1984): 57–75.

16. Jan Baptist Bedaux, "The Reality of Symbols: The Question of Disguised Symbolism in

Jan van Eyck's *Arnolfini Portrait*," *Simiolus* 16 (1986): 5–26 (for the passage referred to, 13), now reprinted in Bedaux, 21–67. There is some confusion and ambiguity in Bedaux about the theory and practice of medieval marriage. For example, he misunderstands *arrha* (29), and his use of expressions like "to contract a marriage" are ambiguous in the context of the fifteenth century, for, as I have tried to explain, without further qualification it is not clear whether the reference is to a betrothal contract of future marriage or a marriage contract of present consent. Consequently, Bedaux is misunderstood by other writers, e.g. Harbison, 1990, 252 n. 7, and Roskill, 65, who both think he is writing about the picture as a betrothal. In his book, however, Bedaux is quite specific: his doubts about disguised symbolism, he says, developed "as it became increasingly clear that [the London panel] was fairly easy to interpret within the context of the contemporary marriage ceremony. In fact, it became more and more apparent that the *Arnolfini portrait* was an accurate depiction of a specific wedding" (11). In Bedaux's view, the ceremony depicted in the double portrait follows what he terms, on the basis of a lecture he attended, "the ancient codification of secular law," which, he says, did not preclude an ecclesiastical rite. He further suggests the ceremony was not clandestine and that Arnolfini likely "would have had his marriage consecrated afterward" (25, 29). Bedaux then proceeds to accommodate "the left-handed gesture" of the double portrait to what he presumes would have happened at such a ceremony by misreading various manuscript miniatures, including the Froissart illumination that is my Fig. 33 (see also the comments above in Chapter 2, n. 65). Although he does not say so explicitly and apparently is not fully aware of what he implies, Bedaux seems to interpret the picture as an instance of the Italian rite before a notary. If such is indeed the case, he misunderstands that by the twelfth century this was the equivalent of the northern ceremony *in facie ecclesiae* and constituted the sacramental rite that created the matrimonial bond. The only major difference between the two ceremonies in this regard was that in the north what Bedaux calls the "consecration" (i.e. the nuptial blessing of the old Roman liturgy) followed immediately inside the church, whereas in Italy the church rite, deferred to another day, remained part of the *nozze* and might even be omitted. And as I have explained, the gesture used in the wedding ceremony before the notary was not a joining of hands at all but rather the placing of a wedding ring on the bride's finger by the groom.

17. See for example Barbara G. Lane, "Sacred versus Profane in Early Netherlandish Painting," *Simiolus* 18 (1988): 106–15; and the reply of Craig Harbison in 19 (1989): 198–205.

18. For the passages quoted or cited, see Harbison, 1991, 16, 17, 36, 44; and Harbison, 1990, 261–64.

19. Harbison, 1990, 288; and Harbison, 1991, 46.

20. To suggest an analogy with the evolution of language, the interpretation of paintings, like the meaning of words, can change with the passage of time. For example, *egregious* was long

used in English with both good and bad connotations ("prominent," "remarkable" / "gross," "flagrant"). Although the Latin root and the modern Italian *egregio* have only positive connotations, in modern English the historical or etymologically correct meaning has been completely displaced, and only the antithetical negative meaning is now current. One can say therefore that the meaning of the word has changed, but surely no one would insist on applying the inverted English meaning to a Latin or Italian context or the etymologically correct usage to a modern English context.

21. Seidel, 1989, esp. 57–58, 78; and Seidel, 1991, esp. 26.

22. Seidel then moves on to new speculations that are better pursued in her own exposition. But the gist of the argument is that Giovanna might not have been of marriageable age when the picture was painted, and thus "the imminence of consummation . . . enshrined in the panel" was something hoped for in the future rather than realized in the present. The dowry might then have been advanced to Arnolfini as a disguised, and in some way irregular, loan for his commercial activities during the interval between "Ring Day" and the much later consummation of the marriage, in which case the panel, "as the clever commission of a shrewd banker," would become "a financial transaction that is enacted as a marriage ceremony." For the passages quoted and cited, see Seidel, 1989, 66–73, 77, 79; and Seidel, 1991, 34. As disguised loans were a commonplace of contemporary Italian mercantile practice, had the two men wished to negotiate such a contract, they could have done it with a simple notarial instrument; it is thus inconceivable that they would have indulged in the complex and legally invalid ruse Seidel suggests.

23. See Julius Kirshner and Anthony Molho, "The Dowry Fund and the Marriage Market in Early *Quattrocento* Florence," *Journal of Modern History* 50 (1978): 403–38. See also Klapisch-Zuber, 191–92.

24. Retaining Panofsky's notion that the panel was intended as a legal document, Seidel (1989, 68–69)—arguing that the mirror, "a seal-like object," functions as Van Eyck's seal—misappropriates information about the Flemish institution of the *erfachtige liede,* which required that a document, to be authenticated, be witnessed by two urban landowners (to own a house was not sufficient); (see Murray, 162). The document cited (Weale, xxxviii) to establish Van Eyck as a landowner concerns the annual *redditus,* or rent, he paid the Church of Saint Donatian in Bruges for a house. Van Eyck is believed to have owned this house, but the land on which it was built evidently belonged to the church; this explains both the rent and the amount of the *redditus,* which is too small for a year's house rent (cf. Weale, xxxvi, for the earlier rental of Van Eyck's house in Lille). Thus what evidence there is suggests than Van Eyck did not own land in Bruges. Seidel also conflates the two medieval ways to authenticate a document, by signature and by seal; normally the use of one precluded the use of the other by the same individual. A mirror, moreover, is not a seal, Van

Eyck was unqualified to authenticate a document in either way, and Italian merchants like the Arnolfini and Cenami, accustomed to notarial instruments for centuries, would hardly have considered the London panel an appropriate substitute.

For the latest version of Seidel's ideas, see her *Jan van Eyck's Arnolfini Portrait: Stories of an Icon,* Cambridge 1993. Since the publication of this book coincided with the typesetting of mine, I can add only one further comment on her methodology. Seidel notes at one point (255 n. 17) that she has "knowingly nudged the evidence" in her concern for "the plausible rather than the probable." One instance of such nudging exemplifies her approach. Arguing that the "intertwined design with crosses immediately above" Van Eyck's name in the signature inscription (i.e. the ornamental flourish of the inital letter) is Jan's sign as a notary, Seidel continues (132–33): "Shaped like a chandelier and furnished with a lighted candle, the sign additionally alludes to the contemporary adjudication of claims by fire, known in contemporary parlance as 'la chandelle éteinte,' the extinguished candle." Two documents are cited in support of this assertion from archival materials in Bruges published by Gilliodts-van Severen. At first it appears that Seidel has discovered more satisfactory evidence for an earlier interpretation of the lighted candle proposed by Dhanens (199) and Bedaux (60 n. 14). But what these documents refer to is "adjudication à la chandelle éteinte," a form of auction (as the editor explains in a footnote on one of the pages Seidel cites) common in northern Europe from the fifteenth to the eighteenth century: at such an auction bidding continued until a short piece of lighted candle went out, with the successful bid being the last made before the candle extinguished itself. For further reference to this practice, see Antoine Furetière, *Dictionaire universel,* The Hague, 1690, s.vv. "chandelle" and "adjudication"; and Jacob Grimm and Wilhelm Grimm, *Deutsches Wörterbuch,* 5 (Leizpig, 1873), 617; Samuel Pepys describes two sales of ships "by an inch of candle" (see his *Diary* for 6 November 1660 and 3 September 1662). Seidel's reference to "adjudication" by "la chandelle éteinte" is thus irrelevant to the double portrait, unless one wishes to argue that the woman is being auctioned by the man and the mirror reflects the images of two bidders. This example epitomizes what I see as a continuing methodological problem in the application of historical evidence to iconographic scholarship: the uncritical symbolic reading of something commonplace (taking a calligraphic flourish for a chandelier with a lighted candle); the application of that reading to circumstances that are historically untenable (the argument that Van Eyck was a notary and the painting a legal document); and the attempt to justify the argument by irrelevant historical documentation (the contextually meaningless reference to auction sales "by the candle"). It should also be noted that the jeweled pendant in Boston that Seidel (104–5) relates to the gesture in the double portrait is a nineteenth-century imitation; see Hanns Swarzenski and Nancy Netzer, *Catalogue of Medieval Objects in the Museum of Fine Arts, Boston: Enamels and Glass,* Boston, 1986, 152.

25. Kenneth Clark, *The Nude: A Study in Ideal Form,* Princeton, N.J., 1972, 317–21, sees this "curve of the stomach" as a characteristic of the International Gothic style. An often reproduced miniature from Brussels, Bibliothèque Royale ms. 9296 (Prevenier and Blockmans, fig. 98), depicts Margaret of York performing the seven corporal works mercy. Although in each scene the duchess wears the same gown, her appearance resembles that of the woman in the double portrait and the Dresden Saint Barbara only in the scene where the front of the gown has been drawn up to the waist and held with one hand.

26. Christine de Pizan, *Le livre des trois vertus,* ed. Charity Cannon Willard, Paris, 1989, 157–59. This chapter (11) is entitled "Ci devise de celles qui sont oultrageuses en leurs abiz, atours et abillemens."

27. An amusing reflection of these conceits is found in the Vienna *Girart de Roussillon,* ms. 2549, fol. 164r (Thoss, pl. 46), which illustrates the simultaneous building of several churches. The stone carvers assert their rank at the top of the hierarchy of workers depicted in the miniature by their fashionable clothing, including hats with feathers and *poulaines* with long points whose awkwardness they overcome by sitting down while working. By contrast, the footgear of the lowly assistant who mixes mortar is so worn as to reveal his bare heel and toes. For a similar miniature by the same master, see Dogaer, pl. 5, where the length of the shoes is inversely proportional to the mobility required by the work being done.

28. Panofsky, 1934, 126; Panofsky, 1953, 1:203.

29. Joseph continues to be portrayed wearing clogs in the Marriage of the Virgin until the end of the fifteenth century, as in a painting by the Master of the Tiburtine Sibyl in Philadelphia and in a number of anonymous panel paintings; for the latter, see the exhibition catalogue *Primitifs Flamands anonymes,* Bruges, 1969, nos. 55–56.

30. For the Vatican prototype without the pattens, cf. Meiss, 1967, figs. 7 and 10; all seven Arsenal miniatures depicting figures with pattens are by the Guillebert de Mets Master, who is known to have been a Fleming. Both the stylish straw hats and the selective use of these very elongated clogs by the duke himself and those closely associated with him can also be seen in the Eyckian painting in Versailles of some festivity at the court of Philip the Good; on this painting, see Anne van Buren Hagopian, "Un jardin d'amour de Philippe le Bon au parc de Hesdin," *Le Revue du Louvre* 35 (1985): 185–92.

31. Commission royale d'histoire, *Recueil des chroniques de Flandre: Corpus chronicorum flandriae,* ed. J.-J. De Smet, Brussels, 1837–65, 4:57; exactly what Philip did with the pattens is somewhat obscure from the chronicler's description: "à mettre sus et clouer pattins."

32. Philip wears pattens while seated in a canopied chair of state in the presentation miniature of the Vienna *Girart de Roussilon* (see Thoss, pl. 1) as well as in Brussels ms. 9095 (see Winkler, pl. 30); for other examples, see Georges Dogaer and Marguerite Debae, *La librarie de Philippe le Bon,* Brussels, 1967, pls. 42, 43, 47, 49.

33. Meyer Schapiro, *Late Antique, Early Christian, and Medieval Art,* New York, 1979, 1–19.

34. See for example Chapter 3, n. 49, and R.-A. d'Hulst, *Jacob Jordaens,* London, 1982, 280.

35. Panofsky, 1953, 1:203; Panofsky, 1934, 126, 118 n. 10, 125 n. 27.

36. Mâle, 426–27. Panofsky's citation of Barbier de Montault's *Traité d'iconographie chrétienne* leads to no more than a statement that the dog, as the most faithful of animals, is fittingly "le symbol vivant de la fidélité" because *fidelis* is derived from *fides.* Panofsky also cites Ripa's *Iconologia,* where the dog and lighted candle are attributes of the personified theological virtue *Fides,* but since the lighted candle does not appear as an attribute of *Fides* in this sense before about 1470 (see Mâle, 311–12) and the dog apparently not before the seventeenth century, Ripa's symbols are irrelevant to a picture painted in 1434. Eventually (though Panofsky makes no mention of it) the dog does appear as an emblem of wifely fidelity in Alciati's *Emblemata* (Emblem 191: "In fidem uxoriam," as in the Lyons edition of 1550, 205), while in a drawing by Maerten de Vos, *Fidelitas* is personified with a dog as an attribute (see E. de Jongh, *Portretten van echt en trouw: Huwelijk en gezin in de Nederlandse kunst van de zeventiende eeuw door,* Zwolle and Haarlem, 1986, 232, pls. 28c and 52c). But it would be impossible to infer the intended meaning of the dog in either case without the accompanying captions, and the imagery, because of its late date, is as anachronistic as Ripa for interpreting a work from the fifteenth century. Even when a dog appears in seventeenth-century double portraits, a symbolic reading based on Alciati is dubious because this emblem imagery also refers textually—and usually visually as well—to apples as the fruit of Venus (the couple often sit under an apple tree). Thus if a painter had really been inspired by Alciati, it seems likely that both aspects of the emblem imagery would have been incorporated into a picture.

37. Meiss, 1969, 31–32; see ibid., figs. 34 and 114, for representations of the duke, accompanied by small dogs, kneeling in prayer before the Virgin. See also Mercer, 21.

38. See for example Winkler, pls. 8, 12, 16, 18, 25, 27, 36, 38, 40, 43–45, 50, 52; and Dogaer, figs. 32, 33, 44, 47, 61, 63, 64, 67, 81.

39. Guennol volume, fol. 142v; John Plummer, *The Hours of Catherine of Cleves,* New York, n.d., pl. 77.

40. Eileen Power, *Medieval People,* New York, 1963, 90–91; see also the same author's *Medieval English Nunneries,* Cambridge, 1922, 305–7, 588, 662.

41. Panofsky, 1934, 126; or in Panofsky, 1953, 1:202: "symbol of the all-seeing Christ." Panofsky gives no documentation whatsoever for the candle as a symbol of God, and none of the sources he cites provides acceptable evidence linking the candle either to marriage customs or to fifteenth-century practice in swearing oaths. The much later custom of swearing an oath before a crucifix with lighted candles on either side is hardly analogous to what is seen in the double portrait. And since the phrase "iurare super candelam" can only refer to a corporal oath, this too is inapplicable to the London panel, for the male figure does not

touch the candle; moreover, since the expression comes from the satirical tale of the roguish fox, *Reinke de Vos,* "to swear on a candle" was apparently intended as a joke, which explains why the lexicographers of medieval Latin make no mention of such an oath (cf. Du Cange, 4:451–63). Bedaux, 60 n. 14, summarizes other suggestions, all very casually documented, none of which specifically concern marriage contracts. And although it seems plausible to relate the lighted candle to the swearing of a promissory oath, neither contemporary visual documentation (cf. Figs. 32–35 and Plate 10) nor any fifteenth-century texts known to me provide evidence for the use of a lighted candle in such a context. See also n. 24 above.

42. See for example the exhibition catalogue *Masters of Seventeenth-Century Dutch Genre Painting,* Philadelphia, 1984, pls. 52, 55, 71, 110, 122; a single candle in a chandelier is seen in the central panel of an eighteenth-century copy in the Rijksmuseum of a famous lost triptych of Gerard Dou (ibid., 186; for a better illustration, see Peter Thornton, *Seventeenth-Century Interior Decoration in England, France, and Holland,* New Haven, Conn., 1983, pl. 268).

43. Bennett, 67, 96.

44. For reference to the chronicler who mentions the sale of the melted-down wax, see Robert L. Mode, "San Bernardino in Glory," *Art Bulletin* 55 (1973): 62–64.

45. Mirot and Lazzareschi, 99.

46. Panofsky, 1953, 1:203, also linking the "crystal beads" with the mirror, both of which are said to be (although without any justification) "well-known symbols of Marian purity."

47. Heinrich Schwarz, "The Mirror in Art," *Art Quarterly* 15 (1952): 96–118; idem, "The Mirror of the Artist and the Mirror of the Devout," in *Studies in the History of Art Dedicated to William E. Suida on His Eightieth Birthday,* London, 1959, 90–105, especially 99–100 and 104. For early criticism of this tendency (but not with respect to Van Eyck's double portrait), see Peter Schabacker, "Petrus Christus' *Saint Eloy:* Problems of Provenance, Sources, and Meaning," *Art Quarterly* 35 (1972): 103–4.

48. Panofsky, 1953, 1:148.

49. Bernardinus de Busti, *Mariale,* Strasbourg, 1496 (Goff B-1334), fols. f7r–g6v. Elsewhere (fol. rrir) in this massive compendium of Marian theology drawn from patristic and scholastic sources, Busti says that the Virgin is the "speculum dei" because God's image, that is, Christ, shines forth from her, and he goes on to explain that just as a mirror receives into itself the image of its maker, "so the blessed Virgin received into her womb him who created her" ("Sicut autem speculum recipit in se figuram eius qui fecit illum, ita beata virgo in suo utero recepit euin qui creavit ipsam").

50. The Immaculate Conception is actually the central theme of this iconography, for a figure of Christ at the top of the composition is invariably accompanied by the text, "Tota pulchra est . . . et macula non est in te," taken from the Song of Songs. For the Grimani Breviary miniature, see Carol J. Purtle, *The Marian Paintings of Jan van Eyck,* Princeton, N.J., 1982, pl. 81. This imagery is found in various printed Parisian *Heures* for about two decades,

beginning in 1505, after which it disappears. Other early examples include a polychrome wood relief in the cathedral of Bayeux and a Tournai tapestry at Reims cathedral. It is found again, with the emblems still labeled, in a work of the Jesuit scholar Petrus Canisius, *De Maria virgine incomparabili, et Dei genetrice sacrosancta,* Ingolstadt, 1577, but later, as in paintings of this subject by Ribera, the identifying texts are omitted.

51. Ritzer, 251–52; Molin and Mutembe, 212–13, esp. 213 n. 14.

52. For this miniature, see Thoss, 177, and pl. 47.

53. For other examples of the moralizing use of mirrors, see Marrow, 162–64; and Ilja M. Veldman, "Lessons for Ladies: A Selection of Sixteenth and Seventeenth-Century Dutch Prints," *Simiolus* 16 (1986): 113–14.

54. For example a miniature by the Master of the Saint Bertin Altarpiece in the British Library's *Trésor des histoires* (Cotton ms. Augustus V., fol. 334v) depicts an interior with a motto written on the rear wall and the painted inscription "Ave Maria" on the fireplace canopy. Similar wall inscriptions, sometimes with dates, are so characteristic of another Flemish miniaturist active about 1480 that he is known as the Master with White Inscriptions; see Dogaer, 124–25.

55. See Andrew Martindale, *The Rise of the Artist in the Middle Ages and Early Renaissance,* London, 1972; and John Larner, *Culture and Society in Italy, 1290–1420,* New York, 1971, 264–84. For the Paris inscription, see Eugène Viollet-le-Duc, *Dictionnaire raisonné de l'architecture française du XI^e au XVI^e siècle,* Paris, 1854–68, 1:111.

56. A nineteenth-century survival, this forced and implausible chronographic reading requires the arbitrary suppression of one of three *D*'s in the first part of the inscription, that *W* be read as 10, and that *J, I,* and *Y* all count as 1. And because both dates are already given in Arabic numerals, the supposed chronograms would in any event be pointless. Panofsky's claim that "Leeuw," if written out, would have added an *L, V,* and *W,* thus destroying the chronographic reading, is taken from Weale, 87; Panofsky, 1953, 1:198.

57. The thirteen edition consists of three supplementary volumes to the twelfth edition of 1922; the biography of Freud is found in 2:116.

58. See for example Susan Koslow, "The Curtain-Sack: A Newly Discovered Incarnation Motif in Rogier van der Weyden's *Columba Annunciation,*" *Artibus et historiae* 7 (1986): 9–33. What the author calls a "curtain sack," i.e. the drapery panel of a hung bed rolled up for convenience' sake when not in use (the fabric of a hung canopy for a chair of estate was also sometimes folded up in exactly the same way; see Fig. 39), is interpreted symbolically on the basis of visual similarities with a curd sack and the shape of the womb.

59. See in particular Panofsky, 1953, 1:179–80.

60. Weale, xlii–xliii; see also lix for the description of Van Eyck as an "excellent maistre en art de painture" by the author of the eyewitness account of the Burgundian embassy that made the arrangements for the duke's marriage to Isabel of Portugal.

61. For the Latin text of Fazio's *De viris illustribus,* see Baxandall, 103.

62. Fazio's characterization of Van Eyck ("litterarum nonnihil doctus. geometriae praesertim et earum artium quae ad picturae ornamentum accederent") seems no more than a reminiscence of Pliny's comment on Pamphilus ("primus in pictura omnibus litteris eruditus, praecipue arithmetica et geometria, sine quibus negabat artem perfici posse"; *Historia naturalis* 35.76), with the important difference, however, that Pliny makes explicit his point about the learning of Pamphilus, whereas Fazio, writing of Van Eyck, does not.

63. Panofsky, 1953, 1:2, 179–80. Panofsky's translation of Fazio is unduly free so as to support his point of view; it should be compared with that of Baxandall, 102.

64. L. Bril and E. Lejour, "Les oranges dans nos provinces au XIVᵉ et au XVᵉ siècles," *Archives, bibliothèques et musées de Belgique* 26 (1955): 56–59.

65. On such carpets as symbols of status and the evidence that some at least were of European manufacture in the fifteenth century, see Walter B. Denny, "Rugs and Carpets," *Dictionary of the Middle Ages,* 10 (New York, 1988): 546–52.

66. Baldass, 76.

67. See for example Meiss, 1969, 31–32.

68. Marrow, 161.

69. Despite controversy about the details, there is general agreement that Van Eyck achieved his spatial constructions empirically rather than geometrically. For the recent literature, see James Elkins, "On the *Arnolfini Portrait* and the *Lucca Madonna:* Did Jan van Eyck Have a Perspectival System?" *Art Bulletin* 73 (1991): 53–62.

70. As is well known, Petrus Christus was the first northern painter to employ a single vanishing point, but he was also Jan's principal follower in the use of objects rationally disposed to create the illusion of pictorial space (see Fig. 40). Elements of the same technique are readily apparent in the anonymous Turin *Virgin and Child* (see Plate 12).

71. Scc for example, Bosshard (as in the following note), 10.

72. Emil Bosshard, "Revealing van Eyck: The Examination of the Thyssen-Bornemisza *Annunciation,*" *Apollo* 136 (1992): 4–11. For references to other examples of alterations by Van Eyck to enhance the three-dimensional quality of his works, see ibid., 11 n. 15.

73. Pliny, *Historia naturalis* 35.81–83.

74. Baxandall, 102–3.

BIBLIOGRAPHIC REFERENCES

The bibliography lists only works with multiple citations;
full references for other works are given in the notes.

Altieri, Marco Antonio. *Li nuptiali.* Edited by Enrico Narducci. Rome, 1873.

Andreae, Joannes. *In quartum decretalium librum novella commentaria.* Venice, 1581. Reprint. Turin, 1963.

Antoninus. [*Confessionale: Curam illius habe*], *Opera di Santo Antonino archivescovo Fiorentino utilissima et necessaria alla instruttione delli sacerdoti idioti.* Venice, 1536.

———. *Summa theologica.* 4 vols. Verona, 1740.

Aquinas, Thomas. *Summa theologiae.* 5 vols. Ottawa, 1941–45.

Baldass, Ludwig. *Jan van Eyck.* New York, 1952.

Baxandall, Michael. "Bartholomaeus Facius on Painting." *Journal of the Warburg and Courtauld Institutes* 27 (1964): 90–107.

Bedaux, Jan Baptist. *The Reality of Symbols: Studies in the Iconology of Netherlandish Art, 1400–1800.* The Hague, 1990.

Bennett, H. S. *The Pastons and Their England.* Cambridge, 1968.

Boüard, A. de. *Manuel de diplomatique française et pontificale.* 2 vols. Paris, 1929–48.

Brandileone, Francesco. *Saggi sulla storia della celebrazione del matrimonio in Italia.* Milan, 1906.

Brooke, Christopher N. L. *The Medieval Idea of Marriage.* Oxford, 1989.

Brucker, Gene. *Giovanni and Lusanna.* Berkeley and Los Angeles, 1986.

Brundage, James A. *Law, Sex, and Christian Society in Medieval Europe.* Chicago, 1987.

Calendar of the Entries in the Papal Registers Relating to Great Britain and Ireland: Papal Letters.

Edited by W. H. Bliss, C. Johnson, and J. A. Twemlow. 14 vols. Public Record Office, London, 1893–1960.

Campbell, Lorne. *Renaissance Portraits.* London, 1990.

Capitularia regum francorum. Edited by A. Boretius and V. Krause. 2 vols. Hannover, 1881–97 (*Monumenta germaniae historica,* Legum sectio II).

[*Codex*] *Codicis Justinianei libri IX cum Accursii commentariis.* Venice, 1569.

Dauvillier, Jean. *Le mariage dans le droit classique de l'église depuis le Décret de Gratien (1140) jusqu'à la mort de Clément V (1314).* Paris, 1933.

Davies, Martin. *The National Gallery, London,* vol. 2 (*Les Primitifs Flamands,* I. *Corpus de la peinture des anciens Pays-Bas méridionaux au quinzième siècle,* 3). Antwerp, 1954.

———. *Early Netherlandish School. National Gallery Catalogues.* 3d ed. London, 1968.

Decretales Gregorii IX cum glossis ordinariis. Venice, 1567.

Decretum Gratiani cum glossis. 2 vols. Venice, 1605.

Dhanens, Elisabeth. *Hubert and Jan van Eyck.* New York, 1980.

[*Digest*] *Digestum vetus, Infortiatum, Digestum novum [cum Accursii commentariis].* 3 vols. Lyons, 1551.

Dogaer, Georges. *Flemish Miniature Painting in the Fifteenth and Sixteenth Centuries.* Amsterdam, 1987.

Donahue, Charles, Jr. "The Policy of Alexander the Third's Consent Theory of Marriage." *Proceedings of the Fourth International Congress of Medieval Canon Law* (Toronto, 1972), 251–81. Edited by Stephan Kuttner. Vatican City, 1976.

Du Cange, Charles du Fresne. *Glossarium mediae et infimae latinitatis.* Edited by L. Favre. 10 vols. Niort, 1883–87.

Durantis, Guillelmus. *Speculum iudiciale, illustratum et repurgatium a Giovanni Andrea et Baldo degli Ubaldi.* 2 vols. Basle, 1574. Reprint. Aalen, 1975.

Eames, Penelope. *Furniture in England, France, and the Netherlands from the Twelfth to the Fifteenth Century. Furniture History* 13. London, 1977.

Esmein, Adhémar. *Le mariage en droit canonique.* 2d ed. Edited by Robert Génestal and Jean Dauvillier. 2 vols. Paris, 1929–35.

Ferraris, F. Lucius. *Prompta bibliotheca canonica, juridica, moralis, theologica nec non ascetica, polemica, rubricistica, historica.* 10 vols. Venice, 1782.

Fierens-Gevaert, Hippolyte. *Histoire de la peinture flamande des origines à la fin du XVᵉ siècle.* 3 vols. Paris and Brussels, 1927.

Friedberg, Emil. *Corpus iuris canonici.* 2 vols. Leipzig, 1879. Reprint. Graz, 1959.

Friedländer, Max. *Die altniederländische Malerei.* 14 vols. Leiden, 1934–37. Published in English as *Early Netherlandish Painting.* 14 vols. New York, 1967–76.

Frugoni, Chiara. "L'iconografia del matrimonio e della coppia nel medioevo." *Il matrimonio nella società altomedievale.* Settimane di studio del Centro Italiano di Studi sull'Alto Medioevo 24, Spoleto, 1977, 2:901–63.

Gaudemet, Jean. *Sociétés et mariage.* Strasbourg, 1980.

[Ghent *rituale* of 1576] *Liber ecclesiae Gandauensis ritus.* Ghent, 1576.

Goff, Frederick R. *Incunabula in American Libraries.* New York, 1964.

Goffredus de Trano. *Summa super titulis decretalium.* Lyons, 1519. Reprint. Aalen, 1968.

Guido de Monte Rochen. *Manipulus curatorum.* Strasbourg, 1490 (Goff G-599).

Harbison, Craig. "Sexuality and Social Standing in Jan van Eyck's Arnolfini Double Portrait." *Renaissance Quarterly* 43 (1990): 249–91.

———. *Jan van Eyck: The Play of Realism.* London, 1991.

Hefele, Charles-Joseph, and Henri Leclercq. *Histoire des conciles.* 8 vols. Paris, 1907–21.

Herlihy, David, and Christiane Klapisch-Zuber. *Tuscans and Their Families: A Study of the Florentine Catasto of 1427.* New Haven, 1985.

Hostiensis (Henricus de Segusio). *Summa.* Lyons, 1537. Reprint. Aalen, 1962.

[*Institutes*] *Institutiones Justiniani.* Lyons, 1551.

Kelly, Henry Ansgar. *Love and Marriage in the Age of Chaucer.* Ithaca, N.Y., 1975.

Klapisch-Zuber, Christiane. *Women, Family, and Ritual in Renaissance Italy.* Chicago, 1985.

Kuttner, Stephan. *A Catalogue of Canon and Roman Law Manuscripts in the Vatican Library.* Studi e testi, 322, 328. Vatican City, 1986–87.

Le Bras, Gabriel. "La doctrine du mariage chez les théologiens et les canonistes depuis l'an mille." *Dictionnaire de théologie catholique,* 9, 2ème partie (Paris, 1927), 2123–317.

———. "Le mariage dans la théologie et le droit de l'église du XIe au XIIIe siècle." *Cahiers de civilisation medievale* 11 (1968): 191–202.

Leclercq, Henri. "Mariage." *Dictionnaire d'archéologie chrétienne et de liturgie,* 10, 2ème partie (Paris, 1932), 1843–1982.

Liber sextus decretalium Bonifacii VIII, Constitutiones Clementinae, Extravagantes communes, haec omnia cum suis glossis. Venice, 1600.

Mâle, Emile. *L'art religieux de la fin du moyen âge en France.* 2d ed. Paris, 1922.

Mansi, Giovanni Domenico. *Sacrorum conciliorum nova et amplissima collectio.* 53 vols. Paris, 1901–27.

Marrow, James H. "Symbol and Meaning in Northern European Art of the Late Middle Ages and the Early Renaissance." *Simiolus* 16 (1986): 150–69.

Martène, Edmond. *De antiquis ecclesiae ritibus libri.* 2d ed. 4 vols. Antwerp, 1736. Reprint. Hildesheim, 1967.

Meiss, Millard. "The First Fully Illustrated *Decameron.*" In *Essays in the History of Art Presented to Rudolf Wittkower,* edited by Douglas Fraser, Howard Hibbard, and Milton Lewine. London, 1967, 56–61.

———. *French Painting in the Time of Jean de Berry: The Late Fourteenth Century and the Patronage of the Duke.* 2d ed. 2 vols. New York, 1969.

Melnikas, Anthony. *The Corpus of the Miniatures in the Manuscripts of the Decretum Gratiani.* *Studia Gratiani,* 16–18. 3 vols. Rome, 1975.

Mercer, Eric. *Furniture, 700–1700.* The Social History of the Decorative Arts. London, 1969.

Mirot, Léon, and Eugenio Lazzareschi. "Un Mercante di Lucca in Fiandra, Giovanni Arnolfini." *Bollettino storico Lucchese* 18 (1940): 81–105.

Molin, Jean-Baptiste. "L'iconographie des rites nuptiaux." *Actes du 102ᵉ Congrès National des Sociétés Savantes.* Section d'archéologie et d'histoire de l'art (Limoges, 1977), 353–66. Paris, 1979.

Molin, Jean-Baptiste, and Protais Mutembe. *Le rituel du mariage en France du XIIᵉ au XVIᵉ siècle.* Paris, 1974.

Murray, James M. "Failure of Corporation: Notaries Public in Medieval Bruges." *Journal of Medieval History* 12 (1986): 155–66.

Niermeyer, J. F. *Mediae latinitatis lexicon minus.* Leiden, 1976.

Oxford Latin Dictionary. Edited by P. G. W. Glare. Oxford, 1982.

Panofsky, Erwin. "Jan van Eyck's *Arnolfini* Portrait." *Burlington Magazine* 64 (1934): 117–27.

———. *Early Netherlandish Painting.* 2 vols. Cambridge, Mass., 1953.

Prevenier, Walter, and Wim Blockmans. *The Burgundian Netherlands.* Cambridge, 1986.

Raymond of Peñafort. *Summa de paenitentia.* Avignon, 1725.

Reekmans, Louis. "La 'dextrarum iunctio' dans l'iconographie romaine et paléochrétienne." *Bulletin de l'Institut Belge de Rome* 31 (1958): 23–95.

Ritzer, Korbinian. *Le mariage dans les églises chrétiennes du Iᵉʳ au XIᵉ siècle.* Paris, 1970.

Roskill, Mark. *The Interpretation of Pictures.* Amherst, 1989.

Rouche, Michel. "Des mariages païens au mariage chrétien. Sacré et sacrement." *Segni e riti nella chiesa altomedievale occidentale.* Settimane di studio del Centro Italiano di Studi sull' Alto Medioevo 32, Spoleto, 1987, 2:835–73.

Schabacker, Peter H. "*De Matrimonio ad Morganaticam Contracto:* Jan van Eyck's 'Arnolfini' Portrait Reconsidered." *Art Quarterly* 35 (1972): 375–98.

Seidel, Linda. "'Jan van Eyck's Arnolfini Portrait': Business as Usual?" *Critical Inquiry* 16 (1989): 55–86.

———. "The Value of Verisimilitude in the Art of Jan van Eyck." *Yale French Studies.* Special Edition. *Contexts: Style and Values in Medieval Art and Literature,* edited by Daniel Poirion and Nancy Freeman Regalado (1991): 25–43.

Sheehan, Michael M. "The Formation and Stability of Marriage in Fourteenth-Century England: Evidence of an Ely Register." *Medieval Studies* 33 (1971): 228–63.

Thoss, Dagmar. *Das Epos des Burgunderreiches.* Graz, 1989.

Vleeschouwers-Van Melkebeek, Monique. "Aspects du lien matrimonial dans le *Liber sentenciarum* de Bruxelles (1448–1459)." *Revue d'histoire du droit* 53 (1985): 43–97.

Weale, W. H. James. *Hubert and John van Eyck: Their Life and Work.* London, 1908.

Winkler, Friedrich. *Die flämische Buchmalerei des XV. und XVI. Jahrhunderts.* 2d ed. Amsterdam, 1978.

INDEX

Designer: Nola Burger
Compositor: G & S Typesetters
Text: 12/18 Adobe Garamond
Display: Adobe Garamond
Printer: Malloy Lithographing, Inc.
Binder: John H. Dekker & Sons